Philip D. Giacomo
170 Second Ave. Apt. 6D
N.Y. N.Y. 10003
477-5965

Abstract Expressionism

The Formative Years

By Robert Carleton Hobbs and Gail Levin

Herbert F. Johnson Museum of Art
Cornell University, Ithaca, New York

Whitney Museum of American Art, New York

Abstract Expressionism: The Formative Years was published in conjunction with an exhibition organized by the Herbert F. Johnson Museum of Art and the Whitney Museum of American Art, supported by a grant from the National Endowment for the Arts.

March 30-May 14, 1978

Herbert F. Johnson Museum of Art
Cornell University
Ithaca, New York

June 17-July 12, 1978

The Seibu Museum of Art
Tokyo, Japan

October 5-December 3, 1978

Whitney Museum of American Art
945 Madison Avenue at Seventy-Fifth Street
New York, New York

Library of Congress Cataloging in Publication Data

Hobbs, Robert Carleton, 1946-
Abstract expressionism, the formative years.

1. Abstract expressionism—United States—
Exhibitions. 2. Painting, American—Exhibitions.
3. Painting, Modern—20th century—United States—
Exhibitions. 4. Painters—United States—Biography.
I. Levin, Gail, 1948- joint author. II. Herbert F.
Johnson Museum of Art. III. Whitney Museum of
American Art, New York. IV. Title.
ND212.5.A25H63 759.13′074′014771 77-29204
ISBN 0-87427-017-0

Designer: Nathan Garland
Typesetter: Southern New England Typographic Service, Inc.
Printer: William J. Mack Company

Contents

Preface and Acknowledgments

In describing the customs of the mysterious realm Tlön, Jorge Luis Borges notes that books of a philosophical nature include both the thesis and the antithesis of a theory. "A book which does not contain its counterbook," he elaborates, "is considered incomplete." While the essays in this catalogue do not go to such extremes, they approach Abstract Expressionism in its formative years from different vantage points. Basically Robert Hobbs stresses those elements that differentiate this art from earlier European endeavors, while Gail Levin emphasizes the stylistic continuity between the two. Because the short essays on individual painters were written by both Hobbs and Levin, with the essays on Baziotes and Stamos contributed by Barbara Cavaliere, some artists are treated mainly from the point of view of their content, while others are described primarily in terms of their morphology.

In our efforts to be true to the nature of the period, we have refrained from establishing what could only be arbitrary beginning and ending dates. Traditionally historians have thought of Abstract Expressionism as beginning in 1945 with the resultant implication that this art is a postwar phenomenon. We hope this exhibition will prove that the contrary is true. The artists included in this exhibition approached an early Abstract Expressionist style at different times, and they did not begin to create later Abstract Expressionist work concurrently. For example, Pollock began what can be termed early Abstract Expressionist paintings in the late thirties and initiated his drip paintings in late 1946. Rothko first started using titles reflective of mythology in 1942 for his formative Abstract Expressionist paintings and turned to abstract names and multiforms in 1947. In order to give full representation to each artist's formative years—their first work that can be called Abstract Expressionist—we have chosen work based on individual development. The earliest painting in this exhibition is Clyfford Still's *Brown Study*, about 1935 (fig. 140), the latest Tomlin's *Number 12—1949* (fig. 150).

Of course the choice of works for this exhibition was necessarily limited to those which could be borrowed through the generosity of private collectors, dealers, and museums. We hope "Abstract Expressionism: The Formative Years," the first comprehensive exhibition to bring together many representative works of this important early period, will encourage a reassessment of the artists, their development, and the very meaning of the term Abstract Expressionism.

Without the generous help of a great number of individuals this exhibition could not have been realized. We are particularly grateful to the many public and private collectors who have been willing to lend such important works.

The artists Lee Krasner, Robert Motherwell, Richard Pousette-Dart, and Theodoros Stamos have been especially helpful, offering their invaluable time and cooperation. Other individuals have assisted in numerous ways with information, research resources, and in the location of works of art: Lawrence Alloway, Ethel Baziotes, Herbert Ferber, Betty Fiske, Marilyn Florek, Xavier Fourcade, Marjorie Freytag, Cynthia Goodman, Eleanor Green, Esther Gottlieb, Thomas B. Hess, Sanford Hirsch, Nathan Kaladner, Charlotte Kantz, Richard Madigan, Steven Mansbach, Jack Mognaz, George Neubert, Annalee Newman, Madeleine Oakley, Betty Parsons, Jeanne Chenault Porter, Evelyn Pousette-Dart, Cora Rosevear, Angelica Rudenstine, Irving Sandler, Lowry Sims, Mrs. Clyfford Still, Allan Stone, Jack Tilton, and Richard Tooke.

At the Whitney Museum of American Art, Anita Duquette, Barbara Haskell, Nancy McGary, Joan Pekie, and Patterson Sims deserve special thanks for their contributions. At the Herbert F. Johnson Museum, Marion Asnes, Jill Aszling, and Jill Chambers-Hartz were particularly helpful.

RCH and GL

Introduction

Until recently early Abstract Expressionist paintings have been largely neglected by historians in favor of later examples. Only once since the forties have the early works been shown as a group, and that was in a small exhibition, "Subjects of the Artist," initiated by Barbara Cavaliere and Robert Carleton Hobbs when they were Helena Rubinstein Fellows at the Downtown Branch of the Whitney Museum of American Art in the spring of 1975. The response to that exhibition was extremely rewarding: critics, curators, collectors, and artists came to see and discuss the works. The paintings were a revelation, for they showed that in the early forties the Abstract Expressionists, notably William Baziotes, Willem de Kooning, Arshile Gorky, Adolph Gottlieb, Hans Hofmann, Lee Krasner, Robert Motherwell, Barnett Newman, Jackson Pollock, Richard Pousette-Dart, Mark Rothko, Theodoros Stamos, and Clyfford Still, were reevaluating European aesthetics. In fact, these artists and Ad Reinhardt and Bradley Walker Tomlin had already summarized many European formal advances and were now searching for new subject matter within an abstract format.

With the general interest in twentieth-century art, it is almost inconceivable that this particularly productive period during the forties has been generally termed as an interim phase, thought of as merely a passing episode in which painters marked time until they arrived at what is considered Abstract Expressionism. But such has been the case. While the earlier paintings admittedly are neither as grand nor as bold as the later ones, they do exhibit a vitality that is manifested in moods as diverse as Rothko's gentle, half-lit tonalities and Pollock's highly charged eclectic works. Even more important, they document a period in which artists were obviously striving to arrive at universal statements through personal idioms.

We are pleased to organize jointly a first major step in the thorough study of this art. The primary intent of our enterprise is to provide a forum in which these works, and the ideas incorporated in them, are accessible to a large number of viewers who can evaluate their quality at first hand. It is undoubtedly difficult to understand these remarkable accomplishments, but the perceptive and scholarly insights in the essays by Robert Carleton Hobbs, Adjunct Curator of Modern Art at the Herbert F. Johnson Museum of Art, Cornell University, and Gail Levin, Associate Curator at the Whitney Museum of American Art, provide meaningful perspectives in reassessing this period. The two museums had each considered this timely exhibition separately, and by combining our efforts, we are pleased to be able to present a more comprehensive showing of early Abstract Expressionist works.

As is the case with so many major museum exhibitions in recent years, the support of the National Endowment for the Arts has been crucial to the realization of the exhibition. Artists and their families, collectors, and museums have responded generously to requests for loans and information, and the project is truly a collaborative effort. The representation of each artist's work is broad and carefully selected. A few of the most important monuments of early Abstract Expressionism are unfortunately too fragile to travel and could not be included, and a few paintings can be shown only at one institution. It is our hope that the range and depth of the formative period of Abstract Expressionism are powerfully conveyed in this exhibition.

Thomas W. Leavitt, *Director*
Herbert F. Johnson
Museum of Art, Cornell University

Tom Armstrong, *Director*
Whitney Museum of American Art

Early Abstract Expressionism:
A Concern with the Unknown Within

by Robert Carleton Hobbs

Breakthrough! The term "breakthrough" is often used to assess a major accomplishment of an artist, the works in which he first achieves an undeniable advance. But what does a breakthrough really signify? What does an artist leave when he begins a new style? Is he really leaving, so to speak, one room, closing and sealing the door to it when he enters another? Or is he remodeling, expanding, or merely redecorating the room in which he exists? A major intent of this essay is to look closely at the rooms occupied by the Abstract Expressionists during their formative years, the enclosures pejoratively designated Surrealist-Cubist, in order to understand exactly what sort of quarters they inhabited before their acclaimed breakthrough. Moreover, the essay will examine these spaces, the ideas expressed in them and the artistic and literary sources supporting them. It will imply ways the later style is incorporated in the earlier one, for the development of the New York painters in the late 1940s was from the complex to the simple, from an admittedly conflated ambiguity typifying their work in the late thirties and greater part of the forties to the more condensed forms that remained the distinctive characteristic of their later style. The early paintings explain the later ones: they provide the key to interpreting the significant content that preoccupied the Abstract Expressionists. As Mark Rothko said, "We assert that the subject is crucial and only that subject matter is valid which is tragic and timeless."[1]

Between some of the earlier and later examples of these artists the real difference is the intensification certain elements receive. Jackson Pollock used drips as a final gestural overlay in *Male and Female* (fig. 1); later they became the predominating elements. In many of his early watercolors, Rothko started with a subtly variegated background that later became the sole vehicle of his art. One segment of Adolph Gottlieb's pictographs could be regarded as the inspiration of his Bursts. By merely dropping the surrealist overtones of his early work, Clyfford Still achieved the abstractness of his later art. Willem de Kooning never really stopped painting women—he simply emphasized more and more the indeterminateness accentuating the joints and extremities of his figures of the forties. And several years before he started to paint Elegies, Robert Motherwell was working with verticals and ovoids. The artists represented in this exhibition did not experience what can be truly labeled a breakthrough. Instead they underwent a process of development in which they were assured their abstract shapes had meaning. Once convinced, they became increasingly abstract, more abbreviated, until the gesture and the medium itself coupled with the barest hint of a schema were sufficient.

Because Abstract Expressionism is not a movement in the sense we have come to understand vanguard groups in the twentieth century—it has no manifesto and can be bifurcated into field and gestural painters—and because the formative years witness even less cohesiveness than the later development, the overall structure housing them would not be marked by its unity. In fact, it would have less cohesiveness than an edifice denoting their shared interests in the fifties. The structure housing these diverse artists in the forties could perhaps be most clearly indicated by comparing it to a multi-chambered cave, a comparison substantiated by the mythic overtones and atavistic elements apparent in many of their paintings. The loose interconnectedness of the varied internal cavities, some joined by large tunnels, others by small rambling apertures, is analogous to the close bonds established by some Abstract Expressionists—as the rapport

1 Jackson Pollock
Male and Female, 1942
Oil on canvas, 73¼ x 49 inches
Collection of Mrs. H. Gates Lloyd

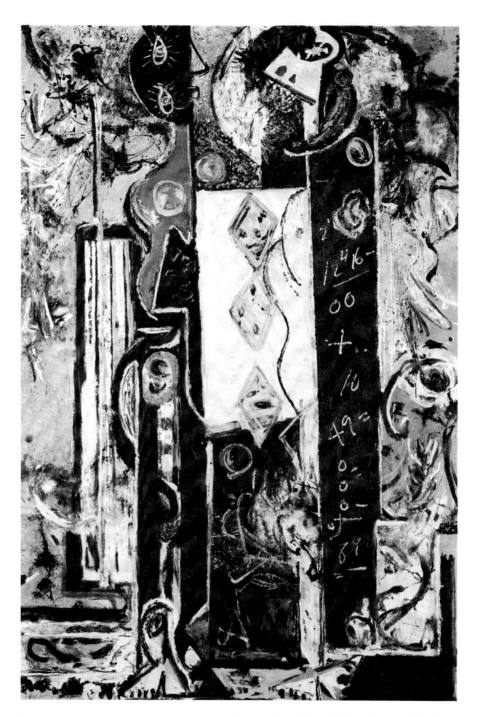

between Baziotes and Motherwell, Gottlieb and Rothko, de Kooning and Gorky, and also Krasner and Pollock—and conversely the fierce independence which others maintained, particularly Pousette-Dart, Reinhardt, and Still. All Abstract Expressionists, moreover, continuously safeguarded the autonomy of their work; but, it should be mentioned, they belonged to a cultural tradition, reinforced by their readings of philosophers like Kierkegaard and Nietzsche, that advocated independence as the only legitimate pursuit for responsible individuals.

Many of these artists created paintings with a dark, haunting, chthonic quality. Clyfford Still's tenebrous surfaces are thickly worked with heavy layers of brown, black, and gray pigment. A comparison between a Still painting and a wall in a cave indicates interesting parallels in terms of rough, almost relief-like surfaces, dark fuscous colors, and vocabulary of vaguely organic shapes. To Rothko, a close friend in the mid-forties, his works suggested the Persephone myth.[2] Gottlieb, who emphasized dun-colored hues in his early pictographs, even used the word "Persephone" as a title for two paintings. Paralleling

9

Cro-Magnon man who at times, as in Altamira, affixed his identity to the walls of a cave with hand prints, Gottlieb accented one painting with black and white impressions of his hand.[3] While Still and Gottlieb evoked elements of the Persephone myth, Pollock decided, upon the suggestion of James Johnson Sweeney, to rename *Moby Dick,* 1943, after the nymphomaniac wife of King Minos, Pasiphae, who according to Cretan legend descended into a cave to make love to a rumbling bull, a symbol no doubt of incipient volcanoes.[4] By giving this title to the painting, Pollock located the concerns of his art in a subterranean realm. Through the work's marked libidinous and conflated character, he implies

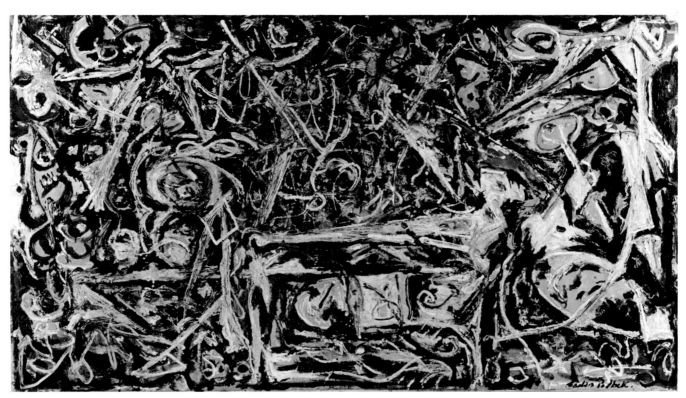

2 Jackson Pollock
Night Mist, c. 1944
Oil on canvas, 36 x 74 inches
Norton Gallery and School of Art,
West Palm Beach, Florida

an analogy between Pasiphae's lust for the bull and modern man's desire to come to terms with the chaotic darker forces within himself, his animal nature, his insticts, the id, which according to Freud can be indirectly understood in dream imagery where it escapes the censorship of the superego. In many early paintings Pollock manifested his concerns with the uncharted wilderness within. One might say *The Key* (fig. 35) stands at the threshold of this terrain; *Night Mist* (fig. 2) dimly surveys its atmosphere, while *Male and Female* (fig. 1) provides an understanding of ambiguous hybrids inhabiting it.

Many early Abstract Expressionists' works reflect a journey within. These generally tonal paintings, often characterized by a crepuscular light, suggest the twilight world of dreams. Motherwell's painting *The Homely Protestant (Bust)* (fig. 98), with its dark ochre color and figure defined with sgraffito markings, alludes to dimly-lit walls of caves. The diapered pattern in the background resembles ancient petroglyphs; the figure seems to be formed from undulations on a cave's wall, while red skeletal parts appear to have been rubbed on with a stick. The shapes that look as if they are part of the geological conformation of the cave's wall collaborate with drawn forms to suggest that what is presented in the painting is analogous to what one finds in the far recesses of the mind. With their skeletal fish forms and ritualistic rocks, Theodoros Stamos's early canvases point to a prehistoric event. Unlike most Abstract Expressionists, he continued in the tradition of Arthur Dove; only the light in his paintings is nocturnal, and the secrets he unravels are those of the rocks he penetrates.[5] Fascinated by the evolutionary cycle, he looked to stones as talismans, as inverted Rosettas whose secrets are locked inside, not inscribed on the surface. Barnett Newman's

10

Pagan Void (fig. 3) appropriately symbolizes the unconscious world as a black amoebic shape enclosing a ritualistic spear and a tiny flagellum, perhaps a biomorphic conflation of primitive archetypes with the fecundity of sexual imagery. William Baziotes seemed to turn his interior world into a primordial aquarium. Or else his realm resembles a piece of amber painted by a Venetian artist—amber encasing abstract figures which are evocative of the mysterious tonalities of another explorer of the internal frontier Edgar Allan Poe. In his paintings and watercolors Rothko veiled his hybrids in an atmosphere reflective of an underwater environment, keeping them diffuse, fluctuant, and

3 Barnett Newman
Pagan Void, 1946
Oil on canvas, 33 x 38 inches
Collection of Annalee Newman

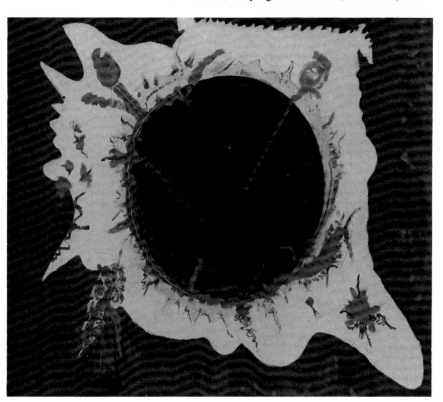

fluid to suggest rather than describe and to circumscribe not delineate his content. Regarding art as a religious or mystical experience, Richard Pousette-Dart often speaks of the edge, which connotes a narrow precipice separating the known from the unknown:

I want to keep a balance just on the edge of awareness, the narrow rim between the conscious and sub-conscious, a balance between expanding and contracting, silence and sound.[6]

Characteristically in his early paintings, line is diffused into an aura that surrounds figures without separating them from their ambience. The entire painting becomes a vibrating surface in which figures and fields are confluent, and the ensuing heavy atmosphere bespeaks an interior realm. Moreover his hieratic figures reside in a twilight atmosphere; the flecks of jewel-like colors peering out of a black network appear to have been lit by a flickering torch.

Ad Reinhardt appropriately defined his territory in the title to a painting of 1941, *Dark Symbol* (fig. 120). Predominately in the forties his terrain was an abstracted version of a Chinese landscape, rendered in saturated hues subtly diffused over the surfaces of his canvases. In his art there is a hermetic, secretive quality evidenced in dark tones and subtle nuances of paint. Formally, his works belong with early Abstract Expressionism even though Reinhardt separated himself from the attitudes that intrigued so many of his peers. He viewed art as a tautology and found the Abstract Expressionist emphasis on angst-ridden brush-strokes melodramatic. Perhaps, his position can be most clearly elucidated if one regards him as both a participant and the conscience of Abstract Expressionism, who pursued in painting what he rejected in words.

Some Abstract Expressionists during the forties painted compositions reflective of sun-drenched regions. But these bright tableaus look more like a secret ritual suddenly caught in mid-action by bright rays of sunlight—as if one has suddenly switched on the lights to a private orgy—than they do scenes whose normal arenas are sunny coastlands along the Mediterranean. Crouching low in the grass, Arshile Gorky found a world teeming with insects and plant life, which he turned into hybrids.[7] In his garden of delights, bones foliate botanical extremities and flowers sport proboscises. Briefly suspending his predominant concerns with landscapes and still lifes, Hans Hofmann flirted occasionally in the

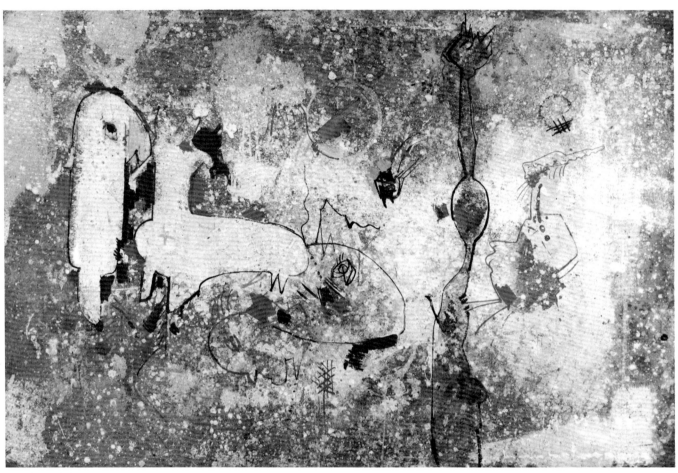

4 Hans Hofmann
Palimpsest, 1946
Oil on board, 39½ x 59½ inches
Andre Emmerich Gallery, New York, and
the Estate of Hans Hofmann

forties with an interior world, a world at times noted for riotous explosions of color and frenzied bacchanalia of paint as well as other times—in *Palimpsest* (fig. 4) for example—a world characterized by a mysterious undercurrent.

The struggle to come to terms with the dimensions of one's own room, its style and special flavor, is epitomized in Lee Krasner's work of the forties. After meeting Pollock, Krasner began to approach painting as a meditational experience: she has termed it a move from Hofmann's exterior cubist nature to Pollock's "I am nature."[8] From approximately 1943 to 1946 she consistently ended up with gray slabs, sometimes two and three inches thick. These gray paintings resulted from her attempts to find "the image," by which term she most likely means an intuitively conceived composition that would accord with her own internal nature. Usually destroyed, the gray paintings remind one of frustrations facing a Zen initiate who attempts to grasp intuition rationally. Finally, after several years of sustained difficulty, Krasner stormed the Bastille of her own rationality and evolved her Little Image series where nontranslatable hieroglyphs suggest a preconscious language, free and indeterminate, before it has assumed the stability of articulated thought. Her efforts—more perhaps than that of any of her peers—resemble a breakthrough, and yet a comparison of her Little Images such as *Abstract #2* (fig. 6) with works of the late thirties (fig. 5)

5 Lee Krasner
Untitled, 1938
Oil on paper, 19 x 24¾ inches
Collection of the artist

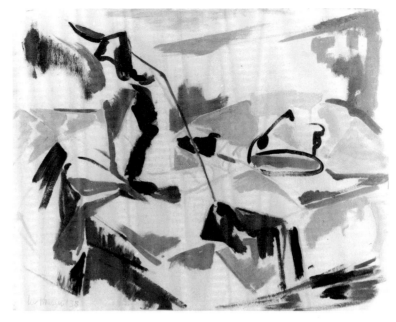

6 Lee Krasner
Abstract #2, 1946-48
Oil on canvas, 20½ x 23¼ inches
Collection of the artist

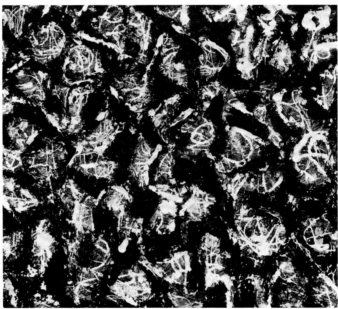

reveals amazing similarities, thus denying a complete renunciation of her earlier style. The change occurring between her work of the late thirties and the Little Image series involves getting rid of presuppositions regarding the nature of art and allowing improvisation and intuition to guide her through her own distillations.

Like Krasner's coming to terms with her own creative space, the Abstract Expressionists' acceptance of their own temperaments—which were usually expressed in styles reflective of the general modernist current—was for the most part an intuitive and individual enterprise. However, they were greatly aided in their endeavors by their interests in primitive and archaic art, which then seemed to exemplify an externalization of the internal sphere. Or as John Graham, a mentor in the thirties and early forties for many of these artists, thought:
The purpose of art in particular is to re-establish a lost contact with the unconscious . . . with the primordial racial past and to keep and develop this contact in order to bring to the conscious mind the throbbing events of the unconscious mind.[9]
Moreover, he believed that the unconscious was most apparent in primitive art.[10] Unlike many modernist groups, the Abstract Expressionists did not use primitive forms simply to enrich an overly refined Western tradition. Like the Surrealists,

13

theirs was a primitivism of the subconscious;[11] only their approach was more thoroughgoing and eschewed the clever humor of so many surrealist works for a serious tone and rigidly ethnical approach. Differing from Mondrian (whom they admired) and his followers in the American Abstract Artists group, they disbelieved in modern utopias. Their search for universals manifested itself in their desire to put themselves in touch with instincts and was abetted by studies of primitive art. In a fundamental sense, the early Abstract Expressionists can be regarded as initiators of a post-modernist movement.

Because of the nature of some exhibitions held at the Museum of Modern Art during the thirties and early forties, it was hardly necessary for artists to go uptown to the American Museum of Natural History to view tribal artifacts. Among the exhibitions emphasizing primitive art were the following: "American Sources of Modern Art," 1933, which included examples from Aztec, Mayan, and Incan cultures; "African Negro Art," 1935; "Prehistoric Rock Pictures in Europe and Africa," 1937; "Twenty Centuries of Mexican Art," 1940; and "Indian Art of the United States," 1941. While these exhibitions were few in number when compared to those devoted to modern art and its antecedents in the nineteenth century, several were among the most important of the period.

"Twenty Centuries of Mexican Art" included more objects than perhaps any exhibition to be staged at the museum. By surveying the broad spectrum of artistic activity from its early flowering to the twentieth century with a comprehensiveness bordering on the encyclopedic, this exhibition implied that the origins of the Mexican mural movement could be found on American soil. It tacitly suggested that the way for artists in the United States to achieve a distinctly original style was to look first to their own indigenous roots and then to transform them into a modern idiom. A way out of the dilemma of how to be modern, original, and American as well as how to use European vanguardist innovations without being stifled by them was exemplified in the work of Mexican muralists Orozco and Rivera. In 1940 it was thought that the triumph of North American painting had already occurred—but in Mexico, not the United States, and the Mexican show represented a straightforward admission of how far Mexico had outdistanced New York aesthetically. For Jackson Pollock, who regarded Orozco's murals at Pomona College as among the most important paintings of the century[12] and worked in the late thirties with Siqueiros, such an exhibition was most likely of great importance.

"Prehistoric Rock Pictures in Europe and Africa," 1937, was of inestimable value, for it translated cave and rock paintings to a smaller, two-dimensional format, thus making them available to New York painters. Facsimiles of pictures, with their randomly ordered compositions and textured surfaces, suggested possibilities for experimentation to New York painters. Pollock's *Wounded Animal*, 1943 (fig. 7), bears an astonishing likeness to one picture in this show, number 38, which depicts in the Franco-Cantabrian style a speared bison from a cave in northern Spain. If one were to make a generalization regarding the overall look of early Abstract Expressionism, the seemingly casual overlay and interpenetration of shapes are strikingly similar to the cave painter's lack of interest in compositional effects and reliance on chance to give any sense of order. Textured surfaces created by scumbling, dripping, smearing, and dragging paint over the canvas or alternating between wet and dry brush effects as well as gouging paper in watercolors[13] simulate roughly formed walls of caves, or even peeling plaster of aged frescoes. Many Abstract Expressionists' attitudes may have been reinforced by this exhibition, but some painters, particularly Baziotes, de Kooning, Gorky, and Rothko, were intrigued by the Metropolitan Museum's Pompeiian frescoes from which they gleaned stylistic characteristics similar to those encouraged by prehistoric rock pictures. Some artists who did not view the exhibition were also imbued with atavism. For example, Motherwell, who was not in New York when this exhibition was being shown, has long felt his art has an affinity with cave paintings as well as with prehistoric dolmens and megaliths. When he visited Spain in 1958, it is worth mentioning, one of his most moving experiences was touring the caves at

7 Jackson Pollock
Wounded Animal, 1943
Oil and plaster on canvas, 38 x 30 inches
Collection of Thomas B. Hess

Altamira by candlelight.[14]

For the 1941 exhibition on American Indian art a large facsimile, 12½ by 60 feet, of pictographs, made by members of the Basketmaker culture of Barrier Canyon, Utah, was commissioned. This picture is portentous of the enlarged scale of some Abstract Expressionist paintings of the late forties, even though it is much larger than anything attempted by them. It may, however, have had an immediate impact on Pousette-Dart who chose to cover a few large pieces of canvas in the early forties with figures, which are generalized statements on primitivism. But he eschewed the random order of this facsimile for a more structured grid pattern that ultimately originates in Cubism.[15] Surprisingly this facsimile was most likely unimportant to Gottlieb, who is often credited with an interest in Indian pictographs. According to Esther Gottlieb, the artist's widow, he was not exposed to them in the late thirties when he lived in Arizona.[16] Even if he saw the exhibition in 1941 at the Museum of Modern Art and was fascinated with this life-sized facsimile, his art does not develop from it. His grid pattern, but not his paint texture and colors, which are reflective of primitive art in general, was derived from Italian medieval panel painting[17] as well as, of course, the art of Mondrian and perhaps that of Torres García. But the definition of pictographs contained in the catalogue may have been important, for it stresses their mysterious qualities, an attitude congruent with Gottlieb's approach.

Petroglyphs and pictographs and also American Indian art in general were greatly admired in the forties. On a trip to the West in spring 1947, Stamos made a point of visiting ancient Indian petroglyphs. Pollock was intrigued by Navaho sand painting; and in the late thirties and early forties he read late nineteenth- and twentieth-century Reports of the Bureau of Ethnology to the Secretary of the Smithsonian Institution. For years Newman spoke movingly of the meandering Miami Indian mounds in Ohio and felt a great affinity to what he regarded as the primitive's terror of the unknowable.[18] Later in the forties, he even wrote forewords to catalogues accompanying exhibitions of American Indian (1946) as well as Precolumbian art (1944) at Betty Parsons Gallery.

In the early forties, the Abstract Expressionists had only a generalized and incomplete understanding of European developments. Looking at *Cahiers d'Art*, reading books by Herbert Read, Alfred Barr, Jr., Amédée Ozenfant, and John Graham, attending exhibitions both at galleries and museums, the Abstract Expressionists studied motifs and styles but had only a second-hand account of the culture in which these abstract forms exhibit meaning. One might say that before the second half of the forties they had excellent renditions of the opera constituting modern painting but only fragmentary copies of the libretto. Representative of the data circulated in the forties are catalogues produced for exhibitions at Curt Valentin's Buchholz Gallery. In these catalogues brief translated excerpts of artists' writings are included as forewords, which tantalize without expressing in depth attitudes toward modern art. Exhibitions as the important "Cubism and Abstract Art" and "Fantastic Art, Dada, Surrealism" at the Museum of Modern Art in 1936 and 1936-37 respectively served as broad summaries of European vanguard art and emphasized more the similarities than the differences between various European factions. To New York both before and during the war came renowned European artists: Bauhaus professors Josef Albers and Lyonel Feininger; Surrealists André Breton, Max Ernst, Matta, and Yves Tanguy; Purist Amédée Ozenfant; Cubist Fernand Léger; Constructivist Naum Gabo; and Neo-plasticist Piet Mondrian. But their appearance did not serve to emphasize the diverseness of various approaches to abstract painting, because European artists found in the United States that their common bond of being immigrants superseded their differences. On the whole Abstract Expressionists did not frequently associate with European artists; the two groups belonged to different social strata. Of course, a few did become friends with some European artists but the effect, excepting for Gorky who was received into the Surrealist camp, was diffuse and generally unaccompanied by conversions of Abstract Expressionists to specific styles of European painting. Even Gorky, an

15

acknowledged surrealist, continued to paint in a manner as reflective of Kandinsky as it was of Miró.

Even though they playfully shadowboxed with them, the Abstract Expressionists regarded European artists as spiritual allies, who had already won important victories for abstract art. On the whole they did not regard European modernist endeavors as a threat. Troubling to them was the parochialism of American art, the ascendency of regionalism and social realism in the thirties and consequent subservience of painting to chauvinistic and ideological aims.

From their sojourns to galleries and museums, Abstract Expressionists brought back motifs: black and white from *Guernica*, cubist infrastructure from Analytic Cubism, surrealist hybrids from André Masson and Joan Miró, Mondrian's grid, Kandinsky's broad washes, and Klee's squiggling biomorphic notations. When they painted, they used these motifs freely (without the stylistic constraints imposed on them by their originators) to create an art with a different focus.[19] Some motifs were chewed up and then spit out, others were thoroughly digested forming a background to new activities.

In themselves the motifs were important only as signposts marking a journey already taken, signaling for Abstract Expressionists a trail they would have to forge for themselves. American painters felt the momentousness of modern European painting; they intuited that unutterable poetic quality designating all great art, and yet were relatively unacquainted with the cultures making such works possible. They understood that this art was not simply a formalist endeavor, that it had subjects indirectly arrived at and seemed to embody feelings more directly than realistic painting. And so they decided to create an art in which significant meanings inhered in an abstract format. James Johnson Sweeney described a similar approach in his catalogue essay accompanying the Miró exhibition, 1941, at the Museum of Modern Art. This exhibition and its catalogue were important to early Abstract Expressionism. On the first page Sweeney affirmed Miró's primacy both in painting and in poetry. To corroborate his assertion he included the following quotation by Miró: *What really counts is to strip the soul naked. Painting or poetry is made as we make love; a total embrace, prudence thrown to the wind, nothing held back. . . . Have you ever heard of greater nonsense than the aims of the abstractionist group? And they invite me to share their deserted house as if the signs that I transcribe on a canvas, at the moment when they correspond to a concrete representation of my mind, were not profoundly real, and did not belong essentially to the world of reality! As a matter of fact, I am attaching more and more importance to the subject matter of my work. To me it seems vital that a rich and robust theme should be present to give the spectator an immediate blow between the eyes before a second thought can interpose. In this way poetry pictorially expressed speaks its own language. . . . For a thousand men of letters, give me one poet!*[20]

What the Abstract Expressionists hoped to create was a poetic art that did not smack of literary allusions but that did contain personal symbols and a method of application manifesting complex states of feeling, inklings of preconscious and unconscious contents of the mind.

In this habitat of early Abstract Expressionism walls and roofs are well supported with strong underpinnings of taking one's self on faith so that rumblings from beneath the earth, intuitions of activities in subterranean realms, would only cause tremors not disruptive shakings of the foundations. Some artists, like Jackson Pollock, however, were closer to the lava flow and felt each rumble and shift with more force so their paintings seem to echo vibrations of cataclysmic eruptions. Others, like Mark Rothko, further removed from the actual disturbances, were aware but not overwhelmed by them and brooded over the tragedy of man's fate in a suggestively evocative, deliberately ambiguous tonal poetry.

Within his area of self-imposed isolation, each early Abstract Expressionist began to listen to directives from within, or at least to whisperings he may well

have thought came from himself. The structure that was early Abstract Expressionism seems to have contained a barely audible Muzak that repeated unceasingly the words "unconscious," "atavism," "myth," "action," "sublime," "indirection," and "content" until the artists heard these messages and supposed they came from within. Each may have felt he arrived at this point individually, but many admonitions of artists, critics, and historians of the twenties and thirties suggested the way. If one takes time to retrace steps made by the Abstract Expressionists, investigate their libraries, and query them about important books, exhibitions, and conversations, it is apparent that wherever they turned, they found the direction leading to an investigation of the unconscious and to a way of painting in which the means would constitute part of the meaning of their work. The working method of the Surrealists, psychic automatism, became an initiatory procedure for many Abstract Expressionists since it provided them with a concrete way of approaching improvisation and hopefully rigging traps to bait preconscious contents. Also Cubism provided a rational compositional structure, a grid suitable for enclosing hybrid forms that, for the Abstract Expressionists, were embodiments of feelings and intimations of understanding.

In her book *The New York School: A Cultural Reckoning*, Dore Ashton mentions that some Abstract Expressionists experimented with psychic automatist techniques as early as the late thirties.[21] And certainly, as the recent exhibition at Rutgers University has pointed out, Surrealism in the United States was an important mode of thinking for artists even in the early thirties.[22] Perhaps the most authoritative documents on Surrealism and its concerns with the unconscious are the *Fantastic Art, Dada, Surrealism* exhibition catalogue with essays by Georges Hugnet and Herbert Read's catalogue *Surrealism*, 1936. In addition to its cogent text allying Surrealism with Romanticism and the individual and placing it in opposition to Classicism and the group, Read's book contains texts by André Breton, Hugh Sykes Davies, Paul Eluard, and Georges Hugnet. In both catalogues, it is worth emphasizing, Surrealism is not presented from a strictly doctrinaire point of view: it is considered the newest development of a basic way of approaching the world, the way of the isolated individual who views truth in a subjective as opposed to an objective fashion. Virtually regarded as required reading also were Herbert Read's general books on history and theory, particularly *The Meaning of Art*, 1931, and *Art and Society*, 1937, which stressed the unconscious as a most fecund path for artists to follow. The clearest and most succinct definition of psychic automatism in English is given in Nicolas Calas's book *Confound the Wise*, 1942, and the date of this book's publication convincingly establishes it as an important source for emerging Abstract Expressionism:

I distinguish three types of automatism, first poetic automatism *such as the one used by Chirico and Dali in their Surrealist period. This automatism is purely psychological as it is built on the dream pattern. Next comes* objective automatism *in which it is the invisible forms in a stain that are turned into a picture. Invisible form is the environmental counterpart of the unconscious and the process through which the image comes into existence, scratching or rubbing creates effects of objective hazard that is to the stain what automatism is to the dream; the* driving force, *that from invisibility and unconsciousness leads through free association, to consciousness and discovery. Between these two extreme forms there is a third one,* physiological automatism. *It was first developed in sculpture by Hans Arp. In physiological automatism the automatic factor is in the free movement of the agent, the arm and hand. When Arp or Tanguy create their forms one has the impression that the objects have been produced by a rhythmic movement of the arm and hand. The early scribblings of a child are also the result of automatic movement of the pencil and the hand on the paper but they are spasmodic instead of being harmonious; they are interrupted by such obstacles as weakness of the hand and lack of attention. The shapes in Miro's and Tanguy's pictures or in Arp's sculpture are the product of*

an attention that is used to protect the free development of physiological movement from interruptions and that is why the forms and images thus created look, although they are purely imaginary, as if they were alive. They are biomorphic *as opposed to the geometric forms Brancusi excels in using. There is no automatism in Brancusi because he illustrates ideas the way Klee often does in painting.*[23]

It is of interest to note that also in 1942 Matta, Motherwell, and Baziotes were proselytizing the merits of psychic automatism. They contacted and then discussed this method with Jackson Pollock, Hans Hofmann, Willem de Kooning, Arshile Gorky, Peter Busa, and Gerome Kamrowaki with the specific aim of holding an exhibition at Peggy Guggenheim's Art of This Century to show up the Surrealists as deviating from the original premises laid down by Breton in his 1924 manifesto and consequently to present a more valid, less literary form of Surrealism.[24] Although the exhibition never took place because Matta did not want to give up his position with the Surrealists, and also because the Americans were such individualists, the dissemination of surrealist ideas, which had been around for over a decade, and the emphasis they received as a method for reaching deeper levels of the self were important elements in the formative phase of Abstract Expressionism.

Cubist ideas likewise had been around and for a longer period of time than surrealist ones. American avant-garde artists even in the teens of this century had become deft adherents of Cubism. Perhaps the reason why a cubist syntax was used by so many Abstract Expressionists during the forties is that they simply could not get away from it and, furthermore, probably did not want to. The cubist grid provided a basic modernist vocabulary while Surrealism supplied a working method; the two combined to form basic tools that were determinant without being constraining. Cubism provided a means for structuring even the most inchoate doodles occurring from psychic automatist procedures; and, more importantly, it was fluctuant enough to provide a needed indeterminacy.

When Clement Greenberg remarked that Abstract Expressionism continued Analytical Cubism into the realm of nonobjectivity—the avenue Picasso and Braque refrained from taking—his statement contained the gratuity of a missing piece in a jigsaw puzzle that had been so firmly locked in place that no one questioned its validity.[25] But his description is simply morphological and did not take into consideration the significance of their imagery. Differing from Cubists, Abstract Expressionists were not interested in the visual world. Their main concerns—as they have explicated them in interviews, lectures, and random notes—were to penetrate the world within themselves and to paint new objects, their feelings about the world rather than the world itself.[26] Their perception of the outside world was useful only as a metaphor directing the viewer to the concept of an interior landscape. To them Cubism represented only one style among many and was especially useful because it was synonymous with modernity. Their use of the cubist syntax was usually for structural articulation, not as an investigatory tool in itself. De Kooning consistently remained close to Cubism, but even in his most cubist works he avoids precise grids, choosing instead curvilinear whiplashes or implicit structures resulting from superimposition of numerous cut and torn sketches. In his abstract works the cubist grid holds in place and provides a rationale for abrupt transitions caused by his overlapping sketches of anatomical parts. The cessation of one form and its abrupt transition into another in paintings as *Mailbox* (fig. 8) would become incoherent without the background of Cubism. But the cubist infrastructure was not used as a way of analyzing reality, which had already been torn apart and recombined by him; it stood rather as a graph or blueprint under which various shapes were subsumed. So schooled was Pousette-Dart in the language of Cubism that each time he began a new work in the forties, he started with a cubist armature, which he in turn proceeded to destroy with heavy coruscations of paint. His finished works resembled not so much Cubism as something distinctly different from it. Hovering, vibrating presences in his

completed works appear as something slightly out of focus, something existing on the periphery of vision.

Differing from Cubists, Abstract Expressionists forsook the analysis of the world outside them to emphasize subjects suggestive of interior states. And differing also from some Surrealists, they chose not to picture unconscious terrains with the clarity of a nineteenth-century academic painting.

Even when Abstract Expressionists painted landscapes, they turned them into "inscapes," to use Gerard Manley Hopkins's term that was often used in the forties by Matta. They painted interiors, usually subterranean realms or else,

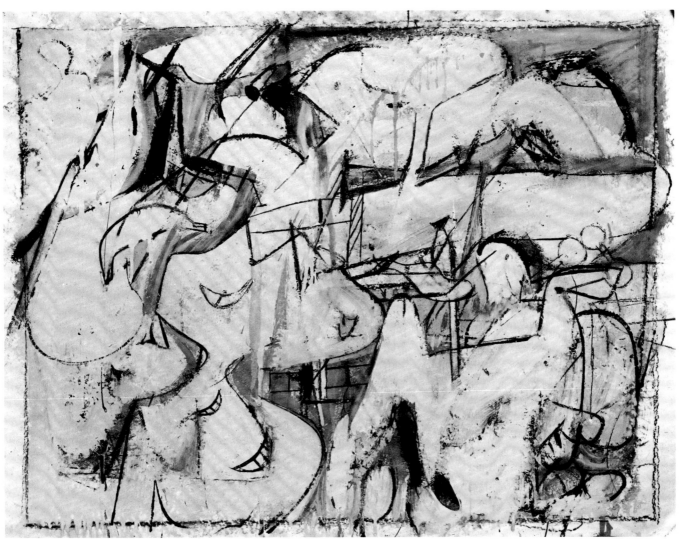

8 Willem de Kooning
Mailbox, 1948
Oil, enamel, and charcoal on paper pasted on cardboard, 23¼ x 30 inches
Private collection

in the case of Gorky, used the landscape as a metaphor for the "anatomical blackboard" within. In his Journals Hopkins employed "inscape" at times to indicate an interior but more often to designate an indefinable poetic quality of a landscape or work of art. "Inscape" of something for Hopkins means the self of something. "Inscape" labels great art's uniqueness, its capacity to turn in on itself—consequently its inwardness—and to present a viewer with its essential identity. The inscape of a poem directs one toward language's sonority, which encourages one to dwell on sounds and rhythms rather than turning to interpretations of the text. Thus the inscape of a real landscape would be presented in a poem via sounds and rhythms rather than direct visual description. And in the case of painting "inscape" defines a viewer's distinct awareness and enjoyment of subtle colors and harmonious shapes in great compositions so that his delight in the visual panoply before him discourages him from relinquishing the sensuous surface to look for ulterior meanings. With the Abstract Expressionists, the primary emphasis was also on the qualitative unity

19

of the work. Although the painters were concerned with meaning, they wished to present subject matter in terms that would not obviate a painting's importance, turning it into mere illustration.

For example, Adolph Gottlieb consistently reminded viewers that the symbols employed in his pictographs did not have a referent external to the painting. He was not creating, he would emphasize, hieroglyphs whose meaning could be discerned by checking motifs in a dictionary of symbols.[27] He wished—and this is important for all of the Abstract Expressionists—to give the semblance of meaning but not specific symbols which could be deciphered and

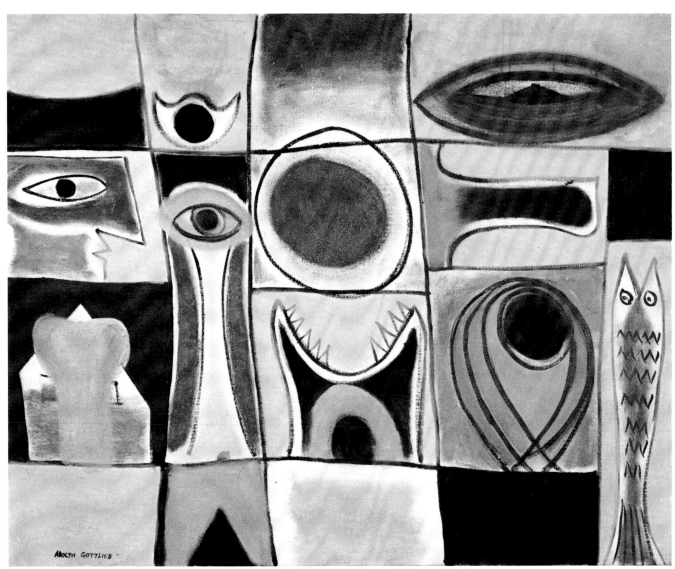

9 Adolph Gottlieb
Forgotten Dream, 1946
Oil on canvas, 24 x 30 inches
Herbert F. Johnson Museum of Art,
Ithaca, New York; Gift of Albert A. List

rationally explained in verbal terms. His main concern was with those meanings communicable through painting, that is, through visual perception. Since the composition is usually an all-over one, the viewer's attempts to find a point of focus is thwarted. One can focus on only two grids at any one time: in looking for a length of time, one sees first one pair of grids, then another pair comes into focus, and later still others. Psychologically, when one gazes at a pictograph, one has the distinct feeling the painting mirrors what the looking glass reflects in Picasso's *Girl Before a Mirror* (fig. 108): an interior state as opposed to an external countenance. In other words, in looking at a pictograph—and again this experience is true for almost all early Abstract Expressionist works—one is somehow gazing into a magical mirror that permits one to look deeply within oneself. The work of art is a palimpsest—Freud's magic writing tablet—a mirror of the self in the act of becoming aware of itself. The activity is analogous to

20

meditation when one looks within in a relaxed state so that images seem to come to one of their own volition, without one's willing them. In Gottlieb's pictographs the asymmetrical grid creates the effect of an overall unity, a simple gestalt, but the individual forms within compete with the grid for attention. Consequently, the grid's rationality is denied by the symbols it contains, and its "good" gestalt is superseded by fluctuant images. Also figures in individual compartments are accented in such a manner that no one segment nor any one shape stamps itself out on the mind of the viewer. It is important to reiterate that in a successful Gottlieb pictograph one's eyes do not naturally move to any one focus. Focus is broken up into numerous foci, thereby forcing the viewer to shift focus and thus peripherally scan the painting.

Peripheral vision usually refers to unfocused vision, but it also, as in the case of looking at Gottlieb's pictographs, can designate the indirect vision predominating with constantly shifting foci. Between the viewer's shifting from focal point to focal point, there are subliminal instants when his vision is out of focus and thereby peripheral. This is one type of peripheral vision. The other occurs when one stands before a large canvas and the total view is out of focus.

This characteristic of shifting foci alternating with peripheral vision, with the resultant effect being an emphasis on the peripheral image, is a major designating element of Abstract Expressionism during its formative years and continues as a crucial factor in the later painting. For the most part the Abstract Expressionists were consciously unaware of the emphasis they placed on peripheral vision. Their proclaimed concerns with the unconscious as the most relevant territory for investigation, their knowledge that it is by definition inaccessible, and their efforts to trap aspects of the preconscious through improvisatory procedures, particularly psychic automatism, led them to look at the world in a different way. Instead of attempting to study nature with the rational stare of academic realism or with the sweeping but studied glance of Impressionism, they tended to emphasize the world which they found out of the corner of their eyes, the blurred, conflated image of peripheral vision. Intuitively they arrived at this type of vision as an analogy to those contents of the mind that shrink from the gaze of consciousness. In other words their emphasis on shapes approximate to peripheral vision served as a visual analogue to the preconscious or perhaps even to the unconscious mind.

Anton Ehrenzweig, in his essay "Cézanne and Peripheral Vision" contained in his book *The Psycho-analysis of Artistic Vision and Hearing: An Introduction to a Theory of Unconscious Perception*, 1953, hypothesizes that the stratification of the mind into conscious and unconscious may well have its origin in the physiological structure of vision. While closely packed central cone cells permit focused vision, surrounding and less populous rod cells allow for a blurred grasp of the periphery; the former serves as an analogue for the narrow lens of consciousness and the latter for the diffuse and unfocused preconscious or unconscious. Ehrenzweig allies peripheral vision with unconscious perception by pointing out that rod cells are vastly superior to cones in only one situation, twilight. He then buttresses this fact with the observation that one often experiences split-second hallucinations with vision occurring in dark places (scotopic vision) when focusing cone cells are ineffectual. The frightening projections under these crepuscular conditions, according to Ehrenzweig, demonstrate the close relations between peripheral vision and the subconscious, or between radiating rods and dream images. Because with peripheral vision one sees only a somewhat undifferentiated space, one senses he or she has intuited or simply felt the presence of an object rather than seen it. Ehrenzweig's in-depth psychological research into the way man perceives indicates a possible physiological basis for what to the Abstract Expressionists must have been an instinctive and generally unacknowledged metaphor. Attitudes of some Abstract Expressionists having a direct bearing on this subject concern their insistence that their paintings be exhibited under dim lighting.[28] They probabaly intuited the peripheral nature of their imagery and recognized that the apparitional

character of some of their art was more convincing in darkened galleries.

William Baziotes was one of the few Abstract Expressionists to indicate his concerns with peripheral vision. While his statement was made in the fifties, it is worth quoting because it does relate to his work of the forties:

Suppose I deliberately look at the Hudson River at night—that is, the boats, the moving water, the buildings across the river, and the lights flickering, I go home with these impressions in my mind and start painting. Later on, however, during the painting, I might realize that what was just to the side of me, say a street lamp, a tree, a bench, and a man sitting there, attracted me more than anything else. I don't make any deliberate attempt to find subject matter. Certain things that go on around me make very strong impressions on me; impressions I might not be completely aware of at first.[29]

Ehrenzweig's ideas provide a key to the unity characterizing early Abstract Expressionist endeavors. At this point one might cavil, "the work of painters as different as Pollock and Baziotes cannot be subsumed under a common stylistic category." But if one considers that these artists were concerned with the unconscious, had read Freud and Jung, aspired, as Rothko indicated, to be the most modern and the most ancient at the same time, consistently refrained from literary anecdotal works, and persistently maintained the significance of their designately abstract endeavors, then one can begin to formulate the underpinnings of the movement. Their atavistic subject matter points in the direction of the primitive whom they supposed resided somewhere within modern man, perhaps in his unconscious mind. Their use of an imagery approximate to peripheral vision indicates, in perceptual terms, their conce with that which lies on the edge of consciousness. And their incipient iconography of improvisatory gestures coupled with pentimenti stylistically reinforces their interests in the unconscious, which is assumed to disgorge some of its content in dreams where images—similar to those in their paintings—collide, conflate, and fade in a most indeterminate space. Together atavistic subject matter, peripheral imagery, and improvisatory gestures as well as pentimenti unify the aims of the Abstract Expressionists, providing on various levels reinforcement of their psychological interests. The artists eschewed the articulating tendency of the mind, the backbone of gestalt psychology, for a more free-flowing, instinctual attitude. They avoided precise, compact shapes, choosing instead vague and often inarticulate forms reflective of true retinal images as opposed to the selected images of which the perceiver is conscious.

Abstract Expressionism deals with peripheral vision, with the "fringe," the word William James used to designate psychic overtones—a "suffusion" of "relations and objects but dimly perceived." Objects lose their specificity and become part of a field of conflated and/or suffused forms. Most of the paintings evidence ragged or bleeding edges. The vision, which is early Abstract Expressionism, conjures up the twilight of reason, the dimly-lit threshold between consciousness and unconsciousness known as the preconscious, so that peripheral vision is expressive of preconscious terrain.

The dispersed all-over quality of some early Abstract Expressionist paintings works perceptually in a fluctuant manner. The works encourage a constant shifting of focus, a visual play between alternating segments, and create a sensation of unrest, of perpetual activity. There is also another type of dynamism in these works, a directional movement imparting a continuous sense of Becoming. And the sense of Becoming is reinforced in literal terms by pentimenti in the paintings.

Peripheral vision renders something one knows without seeing it directly, something one knows only by looking out the corners of one's eyes. All one sees is a massing of forms, vaguely suggestive of known elements. The more one stares at Pollock's *Water Figure* (fig. 12), for example, the less one knows about the figure. Looking at an early Abstract Expressionist painting is unlike studying a blurred photograph in which one can vaguely comprehend some forms and guess at others. In an Abstract Expressionist work, the forms—even when

22

10 Mark Rothko
Vessels of Magic, 1946
Watercolor on paper, 38¾ x 25¾ inches
The Brooklyn Museum, New York

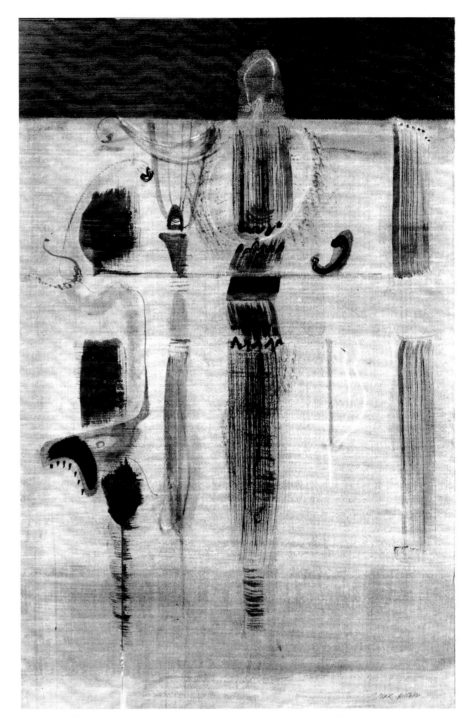

looked at directly—are almost always on the periphery. In them there is a certain built-in ambiguity. Try as one might with *Water Figure*, one simply cannot get closer to understand the full articulation of the figure. The same situation appears in many other Abstract Expressionist paintings in which vagueness, lack of definition, and merging of figure and background are the rule rather than the exception. In Rothko's *Vessels of Magic* (fig. 10), forms are veiled; they do not exist on a one-to-one basis with any known object. In early Abstract Expressionism indeterminants remain indeterminate; obscurities continue to be obscure.

As with Impressionism in which the painters' distinctly new element is in the realm of visual perception, light broken up into its prismatic colors and line conceived optically, so with Abstract Expressionism, innovations are to be found in designatedly visual terms, only the discovery is scotopic. No Impressionist, except possibly Monet, consistently used broken color to suggest light in the majority of his work: in reality only a few exemplify the rigors of the movement.

Similarly with Abstract Expressionism, many works are unconcerned with images reflective of scotopia. Some, however, are. And even more importantly the overall impetus of Abstract Expressionism points in this direction. These artists in the late thirties and forties often paint a twilight world in terms of a scanning vision. The focus is diffused in favor of an all-over or sequential composition. In his book Ehrenzweig points to a few of these characteristics as distinguishing traits of modern art. He remarks that modern painting, starting with Cézanne and Picasso, has relinquished good gestalts for fluid, fluctuant, and unfocused compositions, with an emphasis on superimposition of shapes rather than juxtaposition of forms. It would seem to follow that these characteristics, which are also among the distinguishing qualities of early Abstract Expressionism as I have posited it here, would tend to deny the innovations I am describing. But with the early Abstract Expressionists it is important to stress that peripheral vision is reinforced by subject matter and stylistic concerns: an iconography of the unconscious that includes primitivistic forms as well as pentimenti and the look of spontaneity. Also some early Abstract Expressionists, as Rothko, Newman, Stamos, and Still, generally encourage a scotopic reading of their works by employing subdued tones. Others, particularly Krasner, Pollock, and Reinhardt, paint in terms of highly saturated hues mainly of the same value which contend with one another for the viewer's attention, thus canceling out the power of any one hue and consequently stressing a peripheral reading. To focus on these highly saturated pigments for any length of time is troubling to the eyes: for relief one views the picture sequentially in terms of scanning and refocusing, an act which discourages focused concentration and encourages free association. The importance of early Abstract Expressionism rests primarily on the extent to which artists subsumed all their elements under the aegis of a generative idea, the discovery of the unknown within themselves, to give a different weight and focus to the general modernist vocabulary at hand.

Speaking metaphorically, early Abstract Expressionism represents a descent from the golden light of pure reason, from the abode of Apollo, to Dionysian realms—it is a Nietzschean acquiescence to the darkness of the unsurveyed terrain of the unconscious, which the painter hopes to penetrate to the lowest depths to enter Hades and drink from the river Lethe. When he wrote "A Tour of the Sublime," Motherwell reflected on this descent:

When living Ulysses meets in Hades the shade of Ajax, from whom he had won the armor and set on the course that led to Ajax's death, Ulysses expressed his regret; but Ajax "did not answer, but went his way on into Erebus with the other wraiths of those dead and gone." One has not the right from one's anguish to bring to the surface another's anguish. This must be the meaning of the first century A.D. treatise on the Sublime when it says: "The silence of Ajax in The Wraiths is inexpressibly great."

Perhaps—I say perhaps because I do not know how to reflect, except by opening my mind like a glass-bottomed boat so that I can watch what is swimming below—painting becomes Sublime when the artist transcends his personal anguish, when he projects in the midst of a shrieking world an expression of living and its end that is silent and ordered.[30]

Earlier the traditional artist's muse had been internalized, but now more definitely located she was not only stationed in, but she was also equated with, the artist's own unconscious.

Communicating the feeling of the Sublime—so often stated as the intentions of these artists in their later Abstract Expressionist paintings and so often expressed as the viewer's reaction to the paintings—is actually achieved through peripheral viewing. The sense of being enveloped and surrounded by the painting (as opposed to the act of scrutinizing an object) is realized when the subliminal peripheral viewing that we do continuously is suddenly intensified.

In this essay I have attempted to outline important aspects of Abstract Expressionism during its formative years. The artists used a general vocabulary

of shapes derived from twentieth-century art. In their quest for a significant art of congruent with Freud's and Jung's discoveries in psychology, they bypassed what must have seemed the most innovative art, geometric abstraction, for an organic Cubist-Surrealist format that appeared more human and less technological. Gorky was a member of the Surrealist group, and both Rothko and Newman later referred to their early paintings as surrealist. But the art of these painters, as well as that of the other Abstract Expressionists, differs from Surrealism in practice and turns to a truer form of Surrealism more in line with the original tenets of Breton's manifesto of 1924. Innovations in early Abstract Expressionism are to be found in peripheral imagery coupled with a primitivistic subject matter reflective of myths used by psychologists. Also the painters' open-ended attitudes toward the process of painting in which self-definition occurred as an uncalculated result, not an intended outcome, is a crucial element of this art even in the formative years. The differences between its formative period and Abstract Expressionism as we commonly think of it in the late forties and fifties occur in the increased scale and abstraction of the later paintings. By the fifties the majority of these artists dropped mythic overtones in favor of abstract titles, probably because they intuited that the large size of their works, which were intended to be seen from a distance of only a few feet, would encourage peripheral vision and consequent preconscious or unconscious reactions. To look at a Pollock drip painting, a Rothko hovering field, a Newman zip, a Reinhardt black painting, or a Motherwell Elegy, for example, from a close vantage point is to be confronted with surfaces that deny focused scrutiny and compel the viewer to scan peripherally. In this manner Abstract Expressionists in later works distill their art of the subject matter that was so important in helping them to achieve formal innovations and allow their emphasis on a new way of seeing to stand alone. For them subject matter served as a lever to pry loose the modernist vocabulary at hand from its original associations. Their subject matter became a personal mythos at times associated in formal terms with cave paintings, Roman frescoes, and squiggling biomorphic shapes reflective of microscopic realms. Always their subject matter existed on the fringe, the fringes of civilization (its beginnings) and the fringes of the mind, which led them to peripheral imagery, the fringes of vision. Once they made their concerns concrete in designately visual terms, they relinquished the lever, subject matter, to emphasize their discovery. And this change differentiates early Abstract Expressionism from its more abstract descendant.

1 Adolph Gottlieb, Mark Rothko, and Barnett Newman, Letter to the Editor, *New York Times*, 13 June 1943, sec. 2, p. 9. Lawrence Alloway reported that, according to Gottlieb, Rothko wrote this section ("Melpomene and Graffiti: Adolph Gottlieb's Early Work," *Art International* 12 [20 April 1968]: 21-24; reprinted in idem, *Topics in American Art Since 1945* [New York: W. W. Norton & Co., 1975], p. 27).
2 Mark Rothko, Introduction to *Clyfford Still: First Exhibition of Paintings* (exhibition catalogue, Art of This Century, New York, 12 February-2 March 1946).
3 To my knowledge, *Black Hand*, 1943 (fig. 68), is the first handprint by a New York artist. Later handprints occur in Pollock's *Number 1*, 1946, Hofmann's *Third Hand*, 1947, and in many works by Jasper Johns. In the late forties and the fifties the atavistic and also aesthetic qualities of handprints figure largely in the art of Tony Stubbins, an English member of the little known School of Altamira.
 It is interesting to note that a handprint occurs on the cover to a catalogue for Miró's 1936 exhibition at Pierre Matisse Gallery, New York.
4 Lee Krasner, conversation with Robert Carleton Hobbs and Gail Levin, The Springs, East Hampton, New York, 31 August 1977. Krasner recalled that Pollock changed the title to the painting on a stormy day when both James Johnson Sweeney and Peggy Guggenheim came to visit. When I queried her as to the significance of the storm and whether it suggested the myth, i.e., the rumbling bull, Krasner

refused to say. She simply repeated, "It was a stormy day and if you want to make a connection that is up to you." She did say she would not discount the importance of the storm as Pollock frequently was affected by such circumstances.

5 Stamos, on a questionnaire from the Whitney Museum of American Art, [1955], Artist's File, Library of the Whitney Museum of American Art, New York. Stamos wrote, "To free the mystery of the stone's inner life my object." I wish to express my thanks to Barbara Cavaliere for furnishing me with this statement.
Barnett Newman, Foreword to *Stamos* (exhibition catalogue, Betty Parsons Gallery, New York, 10 February-1 March 1947) Newman wrote:
The work of Theodoros Stamos, subtle and sensual as it is, reveals an attitude towards nature that is closer to true communion. . . . One might say that instead of going to the rock, he comes out of it. In this Stamos is on the same fundamental ground as the primitive artist who never portrayed the phenomenon as an object of romance and sentiment, but always as an expression of the original noumenistic mystery in which rock and man are equal.
6 Martica Sawin, "Transcending Shape: Richard Pousette-Dart," *Arts Magazine* 49 (November 1974): 58.
7 In light of Gorky's interest in a worm's eye view of the world, it is interesting to note a quotation by Amédée Ozenfant in *Foundations of Modern Art* (trans. by John Rodker [New York: Dover Publications, 1952; first published in English, 1931], p. 289):
We must lie flat and stretch out on the earth: everything changes when we take up the position of the newly born or dead. Seeing things from a height of five feet six inches when we are erect, shows them at our service: the world is at our feet. But stretched out, the blades of grass about us become forests, and God's creatures beneath our eyes equal to us: our blind egocentricity corrects itself, because we see where we stand in the ensemble of things.
This attitude is also akin to Paul Klee's.
8 Lee Krasner, conversation with Hobbs, New York, April 1977.
9 *John Graham's System and Dialectics of Art*, annotations and introduction by Marcia Epstein Allentuck, ed. (Baltimore: Johns Hopkins Press, 1971), p. 95, Question 4, "What is the purpose of art?"
10 John Graham, "Primitive Art and Picasso," *Magazine of Art* 30 (April 1937): 237-38.
11 Robert J. Goldwater, *Primitivism in Modern Art* (1938; rev. ed., New York: Vintage Books, 1967), pp. 178-224. The term "primitivism of the subconscious" is Goldwater's.
12 Tony Smith, telephone conversation with Hobbs, October 1975.
13 The last two characteristics listed are especially representative of Rothko's style.
14 Robert Motherwell, conversation with Hobbs, Greenwich, Conn., 14 November 1975.
15 Richard Pousette-Dart, conversation with Hobbs, Suffern, N.Y., November 1975. Pousette-Dart does not remember this piece. He did frequent the Museum of Natural History in the thirties and created

in the early forties forms of amazing similarity to those appearing in Northwest Coast American Indian art.
16 Esther Gottlieb, conversation with Hobbs, New York, December 1975.
17 Ibid. Mrs. Gottlieb related that he saw these works at the Metropolitan Museum. Also, Gottlieb said to Martin Friedman, "The way I arrived at the pictograph stemmed from my great fondness for early Italian paintings of the 13th and 14th centuries" (quoted by Mary R. Davis in "The Pictographs of Adolph Gottlieb: A Synthesis of the Subjective and the Rational," *Arts Magazine* 52 [November 1977]: 147, n. 22).
18 Thomas B. Hess, *Barnett Newman* (New York: The Museum of Modern Art, 1971), refers to Newman's interest in Indian Mounds. Also Newman wrote poetically about terror felt by primitives in "Las formas artisticas del Pacifico," *Ambos Mundos* 1 (June 1946): 51-55; reprinted in English in "Art of the South Seas," *Studio International* 179 (February 1970): 70-71; and in *The Ideographic Picture* (exhibition catalogue, Betty Parsons Gallery, New York, 20 January-8 February 1947).
19 Gorky's art of the thirties would not correlate with this observation since at that time he was a close follower of Picasso.
20 James Johnson Sweeney, *Joan Miro* (New York: The Museum of Modern Art, 1941; reprinted, New York: Arno Press, 1969), p. 13.
21 Dore Ashton, *The New York School: A Cultural Reckoning* (New York: Viking Press, 1973), p. 98.
22 Jeffrey Wechsler, *Surrealism and American Art 1931-1947* (exhibition catalogue, Rutgers University Art Gallery, New Brunswick, N.J., 5 March-24 April 1977), p. 21.
23 Nicolas Calas, *Confound the Wise* (New York: Arrow Editions, 1942), p. 244.
24 Sidney Simon, "Concerning the Beginnings of the New York School: 1939-1943: An Interview with Robert Motherwell conducted by Sidney Simon in New York in January 1967," *Art International* 11 (Summer 1967): 20-23.
25 Clement Greenberg, "'American-Type' Painting," contained in *Art and Culture: Critical Essays* (Boston: Beacon Press, 1961) pp. 212, 218.
26 Robert Motherwell, "Painters' Objects," *Partisan Review* 2 (Winter 1944): 93-97.
This idea receives further elaboration in Motherwell's unpublished lecture, "French Art vs. U.S. Art Today," Lecture to "Forum 49," Provincetown, Mass., 11 August 1949, typescript in the collection of the artist, Greenwich, Conn.
27 In "Melpomene and Graffiti" (*Topics*, p. 26), Alloway reported, "Gottlieb told me that when he happened to learn of preexisting meanings attached to any of his pictographs, they became unusable. The signs needed to be evocative, but unassigned."
28 Rothko's concern with dim lighting has been clearly noted. See Brian O'Doherty, "The Rothko Chapel," *Art in America* 61 (January 1973): 15:
His sense of the environment was theatrical rather than architectural, and his chosen

lighting for his art was more dramatic than gallery lighting; he favored a shadowy indeterminacy that would allow his canvases to gather exactly the right amount of light to declare their presence and monitor its every change.
Also Thomas B. Hess ("Editorial: Mark Rothko, 1903-1970," *Art News* 69, no. 4 [April 1970]: 29) relates the following anecdote about Mark Rothko:
Philip Guston remembers the time when he and Rothko went to see the installation of one of Rothko's shows at Janis. They strolled into the gallery and Mark, without a word, switched off half the lights. When Janis emerged from his office, the three of them chatted a bit and, in a pause in the conversation, Janis slid off and turned all the lights back on. Rothko didn't say anything. They finished their visit; Janis went back to work, Guston and Rothko waited for the elevator, and just before they entered it, Rothko turned half the lights back off again. "I'm positive," Guston says, "that Mark sneaked up there every day and turned the lights down—without ever complaining or explaining."
Stamos remembers at the Betty Parsons Gallery all the artists helped to hang their own shows and often aided fellow artists. He said that Newman, Reinhardt, Rothko, and he all insisted on dim lighting because they felt strong lighting would make their paintings look washed out. Once Rothko came to visit Stamos and mentioned enjoying a certain painting hanging in a dark area. He told Stamos to keep the painting in this spot because he liked the way it looked without illumination. Stamos said that the room at Peggy Guggenheim's Art of This Century where the Americans exhibited contained windows so there was no way for exhibiting artists to control the lighting. He also mentioned that the Kootz Gallery was known for its overpowering lights. Janis was also usually brightly lit. Theodoros Stamos, telephone conversation with Barbara Cavaliere, 19 November 1977. I wish to thank Cavaliere for relaying to Stamos the question which I had about gallery lighting.
Betty Parsons, in a letter to Hobbs, 17 January 1978, mentions, "As I remember, the lighting for the large paintings of Jackson Pollock, Barnett Newman, Mark Rothko, etc., were moderately lit with flood light not spot light."
Motherwell has said that he prefers dim lighting in galleries whenever possible (Motherwell, conversation with Hobbs, Greenwich, Conn., 23 January 1976). But in the forties he did not make a practice of exhibiting his art in dim lighting.
29 Paula Franks and Marion White, eds., "An Interview with William Baziotes," *Perspective No. 2* (New York: Hunter College, [1956-57]), pp. 27, 29-30.
30 Robert Motherwell, "The Ides of Art —a tour of the sublime," *Tiger's Eye* 1 (December 1948): 48.

Miró, Kandinsky, and the Genesis of Abstract Expressionism

by Gail Levin

During the late 1930s and early 1940s, European art developments began to interest many American artists. A number of younger artists in New York had begun to turn away from Regionalism and Socialist Realism in art, and their interest in politics. Several factors influenced these shifts: Many leftist artists were disillusioned by the Nazi-Soviet Nonaggression Pact of 1939. The Museum of Modern Art, founded in 1929, had begun, under the direction of Alfred Barr, to offer important shows of European modern art, including "Cubism and Abstract Art" in 1936 and "Fantastic Art, Dada, Surrealism" in 1936-37. This essay will discuss the relationship between Abstract Expressionism in its formative years and European art by focusing on the seminal influences of Miró and Kandinsky,[1] although other artists such as Ernst, Masson, Matta, Mondrian, and Picasso were also crucial to the development of the movement.

Solomon Guggenheim began to collect abstract art extensively under the direction of the Baroness Hilla Rebay; with the official opening in 1939 of the Museum of Non-Objective Painting (later the Solomon R. Guggenheim Museum), his collection was easily accessible to the public. Along with the work of Wassily Kandinsky, Rebay collected the art of those she called "historical builders," including especially Rudolf Bauer, a German artist whose work resembles Kandinsky's, as well as Fernand Léger, Paul Klee, Ladislaus Moholy-Nagy, Albert Gleizes, and Juan Gris. Beginning in 1936, Guggenheim's collection was exhibited in various places from Charleston, South Carolina, to his own apartment in the Plaza Hotel, New York. Lee Krasner recalls seeing Kandinsky's work there.[2] The first official exhibition at the new Museum of Non-Objective Painting, which opened on 1 June 1939 in a town house on 54th Street, was called "Art of Tomorrow." In an environment of silver decor with a gray carpet and classical music playing in the background, European abstract art could be seen regularly in New York City.[3] Hilla Rebay also assured that Kandinsky's ideas would become better known in America by translating his writings into English.[4]

One individual who was particularly important for the developing young artists in New York was the sophisticated and worldly John Graham. This enigmatic character was born Ivan Dabrowsky in Kiev, Russia, and fled to Paris in 1920 at the age of thirty-nine after supporting Crimean counterrevolutionaries.[5] Graham had come to know the art of the Russian avant-garde, including Mikhail Larionov, Vladimir Tatlin, David Burliuk, Kasimir Malevich, and Wassily Kandinsky.[6] In Paris, Graham met Paul Eluard, André Breton, and Picasso, among other artists and writers, with whom he kept in touch during his frequent visits to Paris after he emigrated to America in the early twenties. In New York, Graham enrolled at the Art Students League. He soon became friends with Stuart Davis, Jackson Pollock, Willem de Kooning, Lee Krasner, David Smith, Arshile Gorky, Barnett Newman, and others on whom he was to have considerable influence through his book *System and Dialectics of Art*, published in Paris and New York in 1937, and through an article entitled "Primitive Art and Picasso," published in *Magazine of Art* in April 1937. In 1960 David Smith would write, "John Graham means much to me, as he did to de Kooning and Gorky."[7] In *System and Dialectics of Art*, John Graham referred to Smith and de Kooning as "young outstanding American painters," and to Gorky as an example of an artist with "highly developed taste." Smith would also later recall topics of discussion among his

artist friends Graham, Davis, de Kooning, Gorky, and others:

In these early days it was Cubist talk. Theirs I suppose was the Cubist canvas, and my reference image was the Cubist construction. The lines then had not been drawn by the pedants—in Cubist talk, Mondrian and Kandinsky were included.[8]

Graham exerted a strong intellectual influence on all of the artists who would come to be known as the Abstract Expressionists, for they greatly respected his vast knowledge of European avant-garde and of primitive art. Smith recalled Gorky's concern with Graham's aesthetic theories:

I remember watching a painter, Gorky, work over an area edge probably a hundred times to reach an infinite without changing the rest of the picture, based on Graham's account of the import in Paris of the "edge of Paint."[9]

The war in Europe and especially the capture of Paris by the Nazis resulted in the emigration of many leading contemporary artists to New York. Most significant among these artists for the evolution of Abstract Expressionism were the Surrealists including André Breton, Salvador Dali, Max Ernst, André Masson, Yves Tanguy, Matta, and Kurt Seligmann. Others whose presence exerted considerable influence were Piet Mondrian and Fernand Léger. The significance for younger American artists of the sudden dramatic shift of the international art world center from Paris to New York must not be underestimated. In March 1942, the exhibition "Artists in Exile," shown at the Pierre Matisse Gallery, New York, included fourteen artists who had come to live in America: Eugene Berman, Breton, Chagall, Ernst, Léger, Lipchitz, Masson, Mondrian, Ozenfant, Seligmann, Tanguy, Tchelitchew, and Zadkine. Magazines such as *View* and *VVV* also helped to familiarize American artists with Surrealism.

In October 1942 Peggy Guggenheim, Solomon's niece, opened her gallery, Art of This Century, on 57th Street. There she showed her extensive collection of modern European art (which included many of the Surrealists then living in New York, including her husband at the time, Max Ernst), as well as the art of younger American painters such as Jackson Pollock, Robert Motherwell, Clyfford Still, Adolph Gottlieb, William Baziotes, Richard Pousette-Dart, and Mark Rothko. Peggy Guggenheim also gave Hans Hofmann his first one-artist exhibition in New York.

There had been exhibitions of Surrealism in New York since the early thirties.[10] Just two months after the first important group exhibition of Surrealism was held in December 1931 at the Wadsworth Atheneum in Hartford, Connecticut, the Julien Levy Gallery in New York featured a slightly modified version of the same show. This gallery presented one-artist exhibitions of the work of such Surrealists as Salvador Dali in 1934, and Matta in 1940; the Americans Joseph Cornell and Arshile Gorky also showed there. The Pierre Matisse Gallery showed André Masson in 1935 and Joan Miró almost annually from 1932.

On 14 October 1942, "First Papers of Surrealism," an exhibition sponsored by the Coordinating Council of French Relief Societies, opened in the Whitelaw Reid Mansion on Madison Avenue. The installation, highlighted by an intricate twine webbing created by Marcel Duchamp, included work by artists such as Arp, Ernst, Klee, Matta, Magritte, Miró, Masson, Moore, Picasso, and Seligmann. The work of young American artists such as Motherwell, Baziotes, David Hare, Alexander Calder, and Jimmy Ernst was also in the exhibition.

Perhaps more than the emigré artists actually living in New York, the work of three artists, Joan Miró, Wassily Kandinsky, and Pablo Picasso, exerted considerable influence on the emerging Abstract Expressionists. Their work became well known to American artists through magazines like *Cahiers d'Art*, people like John Graham and André Breton, and various exhibitions in museums and galleries. Various writers have discussed the significant influence European art and artists have had on the developing Abstract Expressionists.

While the importance of Picasso's art has been given considerable attention by Dore Ashton, Thomas Hess, William Rubin, Irving Sandler, and others, the

impact of Kandinsky's art has been relatively neglected and that of Miró's art has not yet received sufficient attention. Thus this essay attempts to reevaluate the influences that the art of Miró and Kandinsky had on artists in New York in the late thirties and early forties. In the work of certain of the Abstract Expressionists, namely Reinhardt, Stamos, and Still, the influence of neither Miró nor Kandinsky is apparent. Other Abstract Expressionists may only briefly have noted these European artists. Krasner's interest in Miró's biomorphism was limited to the mid-thirties, preceding her own purely abstract Little Images of a decade later. The bright colors of her abstractions of 1938 owe more to Matisse's work than to Kandinsky's Improvisations, but these may have influenced her choice of color in the first Little Image abstractions of 1946. Picasso's influence is treated in several of the essays on individual artists in this volume: those on de Kooning, Gorky, Krasner, Motherwell, and Pollock.

The importance of European art has been acknowledged by the Abstract Expressionists themselves. In 1945 Hans Hofmann told an interviewer that "Picasso has been the outstanding influence throughout [modern art's] development."[11] He praised Mondrian for bringing "plastic art to ultimate purity, while Kandinsky sought new directions and might be called anti-plastic." Hofmann stressed that Kandinsky's "development reached heights in his late works," explaining that "in his attempt to be non-objective, [Kandinsky] escaped into the realm of geometric fantasy." Hofmann also singled out Arp's "emphasis on shape's life" which he felt Miró had, under the influence of Klee, pursued successfully to an even greater degree. The year before, Jackson Pollock spoke of his admiration for both Picasso and Miró and wrote:

The fact that good European moderns are now here is very important, for they bring with them an understanding of the problems of modern painting. I am particularly impressed with their concept of the source of art being the unconscious. This idea interests me more than these specific painters do.[12]

Robert Motherwell also saw Miró's automatism as an important influence on Pollock, and he learned much from Miró's art that proved valuable for his own work. In 1959 he would write that "Miró is not merely a great artist in his own right; he is a direct link and forerunner in his automatism with the most vital painting of today."[13] William Baziotes acknowledged his admiration for Miró and met him on Miró's visit to New York in 1947.[14] Interest in the art of Miró is evident in the early work of Rothko, Newman, and Gottlieb, and it is readily apparent in Gorky's work.

Although Gorky had seen Miró's work at the Valentine Gallery as early as 1928, he only became deeply interested in it during the late 1930s and early 1940s after he had worked through his earlier interests in Cézanne and Picasso. Gorky's untitled gouache, 1939 (fig. 11), indicates his debt to Miró. The crisp biomorphic shapes, the flat, solid background, and even tiny mannerisms such as the dot surrounded by a circle (which serves as an eyelike form for a biomorphic shape in the top right, corresponding to Miró's Hunter's eye) can be compared

11 Arshile Gorky
Untitled, 1939
Gouache on paper, 13¾ x 17¾ inches
Collection of Peter Socolof

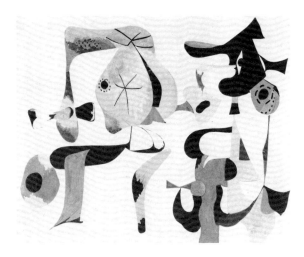

12 Jackson Pollock
Water Figure, 1945
Oil on canvas, 72 x 29 inches
Hirshhorn Museum and Sculpture Garden,
Smithsonian Institution, Washington, D.C.

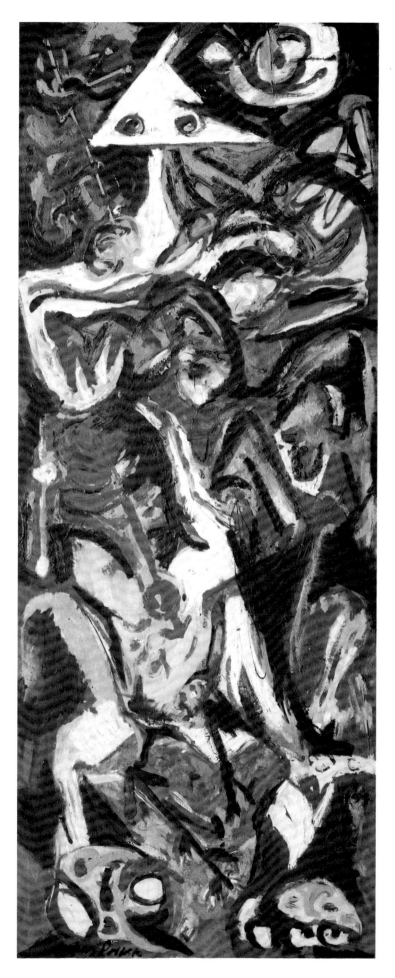

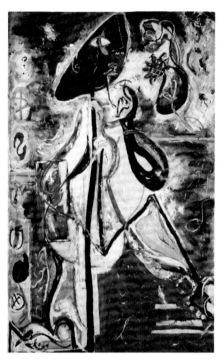

13 Jackson Pollock
Moon Woman, 1942
Oil on canvas, 69 x 43 inches
The Peggy Guggenheim Foundation

14 Jackson Pollock
Direction, 1945
Oil on canvas, 31½ x 22 inches
The Peggy Guggenheim Foundation

to a well-known Miró painting like *The Hunter (Catalan Landscape)*, 1923-24 (fig. 15). Gorky would certainly have seen this painting at the Museum of Modern Art which acquired it in 1936 and included it in the Miró exhibition of 1941.

Pollock's fascination with the art of Miró is particularly noteworthy in several of his works of the early 1940s, such as *Moon Woman*, 1942 (fig. 13), *Direction*, 1945 (fig. 14), or *Water Figure*, 1945 (fig. 12). The stick figures of *Moon Woman* and *Direction* are undoubtedly derived from those of Miró in a work like *Dancer*, 1935 (fig. 17), which was in the Miró exhibition at the Museum of Modern Art in 1941 and reproduced in the catalogue. That there are two copies of this exhibition catalogue in the Pollocks' library at The Springs would seem to indicate that both Lee and Jackson saw this important exhibition. Pollock, in *Direction*, added the same circles at the end of the stick figure's legs that decorated Miró's figures; the circle head of Pollock's figure is nearly divided in half and resembles the head of Miró's *Dancer*.

Pollock's *Water Figure* contains imagery related to Miró's, for instance in *The Hunter (Catalan Landscape)* (fig. 15). Pollock's central figure has a triangular head like Miró's Hunter (located on the upper right corner), complete with eyes and wavy arms. Pollock's use of linear, arrowlike forms piercing circles are also close to those of Miró. Yet Pollock's painting manifests an intentionally crude application of paint—an emphatic painterliness—that is absent from Miró's linear vocabulary. This is part of Pollock's immediacy and originality, and it sets him apart from the artists that inspired him.

Rothko's early abstractions are quite close to Miró's work in their vocabulary of biomorphic forms, in their linear quality, and as metaphors for landscape. Rothko's use of the horizon line in *Landscape*, 1945 (fig. 130), and in *The Entombment*, 1946 (fig. 16), is similar to the one used by Miró in *The Hunter (Catalan Landscape)* and other paintings. Rothko's *Landscape* contains wavy black lines that recall Miró's, although Rothko's are consistently rougher in their execution. The organic shapes in *The Entombment* are directly related to those in Miró's compositions of 1933, several of which were shown in the Miró exhibition at the Museum of Modern Art in 1941, which Rothko certainly would have had an opportunity to see. Rothko's *Baptismal Scene*, 1945 (fig. 38), also demonstrates devices found in Miró's work such as *The Hunter (Catalan Landscape)*: the linear overlay, biomorphic shapes, and even the black spiderlike shape with six appendages in the upper right corner. Rothko's

15 Joan Miró
The Hunter (Catalan Landscape), 1923-24
Oil on canvas, 25½ x 39½ inches
The Museum of Modern Art, New York

16 Mark Rothko
The Entombment, 1946
Oil on canvas, 40 x 60 inches
Collection of Mr. and Mrs. Herbert Ferber

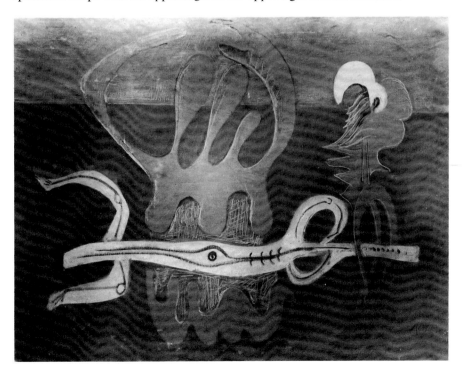

acquaintance with Miró's work offered him a new avenue of development that would ultimately lead to a new spatial freedom in his mature works.

Miró was also important briefly to the development of Bradley Walker Tomlin, who in 1947 made a dramatic shift from the Cubist still lifes he had been painting since the late thirties. An untitled painting, 1948 (fig. 18), indicates Tomlin's familiarity with Miró's *Dancer*, 1935 (fig. 17). Tomlin has repeated both the bi-lobed intersecting head with the two large circular eyes and the heavy black outlines of the figure itself. He has carried his line further to create a concealing web, perhaps inspired by Surrealist automatism, Pollock's

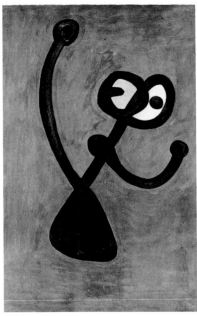

17 Joan Miró
Dancer, 1935
Oil on canvas, 41½ x 29¾ inches
Pierre Matisse Gallery, New York

18 Bradley Walker Tomlin
Untitled, 1948
Oil on canvas, 30 x 25 inches
Solomon & Co. Fine Art, New York

poured paintings, or even Duchamp's string installation at the "First Papers of Surrealism" exhibition in 1942.

Although Newman appears to have absorbed some of Miró's forms in works like *Pagan Void*, 1946 (fig. 3), he insisted that Surrealism was too limited in its intentions: "The present painter is concerned not with his own feelings or with the mystery of his own personality but with the penetration into the world mystery."[15] Around 1944-45, Newman's attention was more intimately tied to nature itself, rather than to other artists' imagery. This is clear in his vibrant crayon drawings of this formative period such as *The Song of Orpheus* (fig. 19).

Gottlieb also experimented with shapes derived from Surrealism in his early abstractions and pictographs. His *Alchemist (Red Portrait)*, 1945 (fig. 69), indicates his knowledge of Miró's art in its use of biomorphic shapes and linear overlay. In one of a series of untitled pastels of 1942 (fig. 20), Gottlieb depicted a fantastic head reminiscent, in its toothy jaws, of Miró's personages and heads of the thirties. Gottlieb's use of handprints in *Black Hand*, 1943 (fig. 68), may be linked to that on the cover of the catalogue for the Miró exhibition at the Pierre Matisse Gallery in 1936.

Perhaps of even greater significance than the Miró exhibition at the

Museum of Modern Art in 1941 was America's most extensive viewing to date of Kandinsky's work, the Museum of Non-Objective Painting's major memorial retrospective exhibition of 227 works, held from 15 March to 30 May 1945. This exhibition, which followed Kandinsky's death in Paris on 13 December 1944, aroused the New York art world to heightened interest in the work of this pioneering abstract artist. The tremendous impact of this exhibition on artists in New York makes it comparable to the historically important Cézanne memorial retrospective exhibition held in Paris at the Salon d'Automne of 1907. Art critic Emily Genauer was prophetic in her review of an earlier and smaller Kandinsky

19 Barnett Newman
The Song of Orpheus, 1945
Oil, oil crayon, and wax crayon on paper;
19 x 14 inches
Collection of Annalee Newman

20 Adolph Gottlieb
Untitled, 1942
Pastel on paper, 23¼ x 18½ inches
Collection of Betty Parsons

retrospective at the Nierendorf Galleries in New York (opened 26 December 1944):
The abstract movement in art appears to have found new strength this year, and Kandinsky made so important a contribution to it.[16]
 Among the frequent visitors to the Kandinsky exhibition at the Museum of Non-Objective Painting was Arshile Gorky. His interest in Kandinsky is apparent in his work of the early 1940s. One no longer finds the more direct derivation of his earlier "Cézanne" and "Picasso" periods, but instead a personal internalization of the essence of Kandinsky's color and fluid forms.
Actually, however, his interest in Kandinsky began much earlier. In his article "Stuart Davis," published in *Creative Art* in 1931, Gorky wrote that Davis "works upon the platform where are working the giant painters of the century—Picasso, Léger, Kandinsky, Juan Gris. . . ."[17] Gorky owned a copy of Will Grohmann's *Kandinsky*, published by Editions Cahiers d'Art in 1930.[18] Gorky had also evidently read Kandinsky's *Concerning the Spiritual in Art*, which surely must have supported ideas that he already held.[19] Mrs. Agnes Gorky Phillips, whom Gorky married in 1941, wrote of Kandinsky, "He was as important to Gorky as Picasso. It would be hard to overrate his influence."[20] In the catalogue of his exhibition at the Julien Levy Gallery in 1945, Gorky

33

falsely claimed that he had studied abroad with Kandinsky for three months in 1920.[21] In fact, Gorky arrived in New York from Soviet Armenia (via Tiflis in Soviet Georgia, Constantinople, and Athens) on 1 March 1920 and did not visit any place more exotic than Providence, Rhode Island (where his father was then living), and Watertown, Massachusetts (where he lived in the home of his older sister).[22] Yet Gorky's desire in 1945 to be associated with Kandinsky attests to his admiration for the Russian artist's work at this time. Gorky's exhibition at the Julien Levy Gallery opened in March, coinciding with the great Kandinsky memorial exhibition at the Museum of Non-Objective Painting which opened on 15 March. Gorky, it seems, sought some of the attention being paid to Kandinsky.

Perhaps Gorky's interest in Kandinsky's work resulted from John Graham's influence upon him. In *System and Dialectics of Art*, Graham listed Kandinsky, along with Marc, Burliuk, Larionov, and other artists, under the heading "Expressionism," which he defined as "a cult of self-expression regardless of rules and tradition. As a definite movement it grew out of the Blaue Reiter organization. It is akin to Fauvism."[23]

Another important friend of Gorky's was André Breton, whom he met in New York during the winter of 1944. Irving Sandler has pointed out that "Kandinsky's automatist pictures had been largely overlooked, even by the Surrealists," and that "Gorky was thus the first artist to recognize their viability."[24] Breton had written in 1938, however, that "Kandinsky in my view presents deeper philosophical undertones in his work than any other artist since Seurat" and that "Kandinsky's marvelous eye . . . belongs to one of the most exceptional, one of the greatest revolutionaries of vision."[25] He may well have communicated his enthusiasm to Gorky. Although the Surrealist emigrés did not often include Kandinsky in the exhibitions that they organized in the early 1940s, this may have been because his art was by this time constantly represented in the Museum of Non-Objective Painting.

Gorky may have been attracted to such ideas of Kandinsky's as the parallels between emotions and colors, set out in *Concerning the Spiritual in Art*. For Kandinsky, feelings like joy or grief were "only material expressions of the soul," and shades of color "awaken in the soul emotions too fine to be expressed in prose."[26] This thinking may have appealed to Gorky who, as an art instructor at the Grand Central Art School (1925-31), "stressed getting emotion into a drawing and underlined the point by bringing a Hungarian violinist to fiddle for the class."[27] Gorky seems to have agreed with Kandinsky's statement that:

Music is found to be the best teacher. For some centuries, with few exceptions, music has been the art which has devoted itself not to the reproduction of natural phenomena, but to the expression of the artist's soul and to the creation of an autonomous life of musical sound.[28]

It is interesting to note that the art critic Clement Greenberg, who himself studied painting with Hans Hofmann, did not at first share the enthusiasm for Kandinsky demonstrated by many of his contemporaries in the avant-garde. As Dore Ashton would write, Greenberg denounced

Kandinsky's paintings—in which the picture planes are "pocked with holes" and the "negative space" is not properly accounted for. Perhaps Pollock's obvious regard for Kandinsky and Gorky's outright homage galled Greenberg.[29]

In 1945 Greenberg described Gorky's most recent work as

. . . less serious and less powerful . . . for the problems involved in Kandinsky's earlier abstract paintings were solved by Kandinsky himself, while the problems of "biomorphism" were never really problems of modern painting. . . .[30]

Sandler has stressed Greenberg's adherence to Cubist aesthetic in the mid-1940s and his resulting "hostility" to Surrealism, with which he initially related Kandinsky's work.[31] By 1955, Greenberg revised his opinion and wrote of the importance of Kandinsky for Gorky's development:

To break away from an overpowering precedent, the young artist looks for an alternative one. The late Arshile Gorky submitted himself to Miró in order to

break free of Picasso, and in the process, did a number of pictures we now see
have independent virtues, although at the time—the late '30s—they seemed too
derivative. But the 1910-1918 Kandinsky was even more of a liberator and
during the first . . . years [of World War II] stimulated Gorky to a greater
originality.[32]

De Kooning, who had only arrived in New York from the Netherlands in
1926 at the age of twenty-two, met John Graham in an art gallery as early as
1927. Graham later introduced de Kooning to Gorky, and he taught both artists
much about primitive and avant-garde art. According to Dore Ashton,
"de Kooning remembers that Pollock, who probably met Graham in 1937, once
lent him an article by Graham and uncharacteristically insisted on getting it
back."[33] This article must have been "Primitive Art and Picasso," in which
Graham distinguished between the "Greco-African culture" and the
"Perso-Indo-Chinese culture":

The Perso-Indo-Chinese tradition has influenced the impressionists; its florid
design and its yellow and green color schemes are found in the paintings of
van Gogh, Renoir, Kandinsky, Soutine, Chagal [sic]; the Greco-African is
exemplified by Ingres, Picasso, Mondrian.[34]

According to Thomas Hess, de Kooning would have heard about
Kandinsky from John Graham although he may have known of his art in
Holland through the artists of de Stijl. In 1959, in a chronology of de Kooning's
work, Hess noted: "Some small pictures of around 1928 indicate that he was
experimenting with abstraction at this time, some of it symbolic, some influenced
by the flat colored geometrics of Kandinsky."[35]

In 1951, in a symposium held at the Museum of Modern Art, de Kooning
stated: "I admire some of Kandinsky's painting very much," but he also
explained what he considered the limitations inherent in Kandinsky:

[He] understood "Form" as a form, like an object in the real world; and an
object, he said, was a narrative—and so, of course, he disapproved of it. He
wanted his "music without words." He wanted to be "simple as a child." He
intended, with his "inner-self," to rid himself of "philosophical barricades" (he
sat down and wrote something about all this). But in turn his own writing has
become a barricade, even if it is a barricade full of holes. It offers a kind of
Middle-European idea of Buddhism or, anyhow, something too theosophic for
me.[36]

De Kooning indicated clearly that he was familiar with Kandinsky's *Concerning*
the Spiritual in Art and the Russian artist's ideas about music, "the principle of
internal necessity," and theosophy. De Kooning had probably read Kandinsky's
treatise some time after 1946 or 1947 when two new English translations were
published in New York. De Kooning told Harold Rosenberg in 1972 that "I am
an eclectic painter by chance. I can open almost any book of reproductions and
find a painting I could be influenced by. . . ."[37]

The influence that Kandinsky's work had on de Kooning, though, was a
much less direct process than Gorky's use of the Russian's art. De Kooning's
gestural style of painting relates in its spontaneity and fluidity of surface to
Kandinsky's early Improvisations, which he no doubt saw at the Museum of
Non-Objective Painting. He has, however, pushed beyond Kandinsky's
Improvisations, which still maintain a real illusionistic space and relate to
landscape, to create canvases that are composed of purely abstract shapes and
lines floating on the surface plane without a discernable figure-ground
relationship. In this achievement, de Kooning owes a debt to his friend Arshile
Gorky and probably also to Jackson Pollock's own break with Cubist space.
De Kooning is often quoted as having said "Jackson broke the ice."

One imagines that Pollock would have been sympathetic to Kandinsky's
spiritual concerns such as theosophy, which captivated John Graham, his friend
and mentor. De Kooning has recalled that it was Graham who first discovered
the unknown Jackson Pollock.[38] Marcia Epstein Allentuck suggests that
"Kandinsky's felicitous phrase 'the purposive vocation of the human soul,' by

which he meant its quest for formal embodiment and affective expression in a work of art, could serve as an epigraph for *System and Dialectics of Art*."[39] Pollock owned a copy of Graham's book, which was inscribed to him from the author, who was an important influence on Pollock in the late thirties. Graham included de Kooning, Pollock, and Krasner along with important European artists in "American and French Paintings" at the McMillen Gallery in 1942.[40]

Pollock may have picked up Kandinsky-like ideas from Graham, who also shared his admiration of Picasso, either in conversation or in his writings. Pollock, who executed a series of drawings for a Jungian analyst in 1941, was

21 Jackson Pollock
Untitled Drawing, 1946
Ink, pastel, gouache, wash on paper;
22½ x 30⅞ inches
Private collection

well aware of the relationship of his inner needs to his art, an idea expressed by Kandinsky: "That which is beautiful is produced by internal necessity, which springs from the soul."[41] Betty Parsons described this aspect of Pollock:
He was also extremely intrigued with the inner world—what is it all about? He had a sense of mystery. His religiousness was in those terms—a sense of rhythm of the universe, of the big order—like the Oriental philosophies.[42]
Pollock's one-man show at Peggy Guggenheim's Art of This Century from 19 March through 14 April 1945 coincided with the Kandinsky memorial retrospective. Reviews such as "Jackson Pollock . . . derives his style from that of Kandinsky though he lacks the airy freedom and imaginative color of the earlier master"[43] must have compelled Pollock to study carefully Kandinsky's work in the memorial retrospective. Pollock certainly saw many paintings by Kandinsky when he worked on frames and as a custodian at the Museum of Non-Objective Painting for several months in 1943. Pollock may also have picked up an interest in Kandinsky's ideas from Stanley William Hayter, who

published "The Language of Kandinsky" in *Magazine of Art* for May 1945. During the fall of 1944 and into the next year Pollock worked on experimental graphics at Hayter's Atelier 17.[44] In New York, during 1945, with all the attention being paid to Kandinsky's work, Pollock, like other young artists, could hardly escape its influence. Although Gorky and de Kooning had already been interested in Kandinsky they, unlike Pollock, were primarily concerned with his earliest abstract paintings, those before he was at the Bauhaus during the 1920s. This focus on Kandinsky's early abstractions was probably at least partially responsible for critics' failure to understand the impact of his work on Pollock for whom Kandinsky's geometric abstractions paintings at the Bauhaus as well as his Improvisations were important.

An untitled drawing of 1946 by Pollock (fig. 21) is related to Kandinsky's *Kleine Welten VIII*, 1922 (fig. 22). Pollock's drawing, with its clearly designated focal point at center, about which the rest of the composition revolves, is similar to Kandinsky's abstract woodcut. A fundamental difference is that Pollock's design approaches the edges in a way that predicts his all-over pattern of the drip paintings to come. The two compositions have many similar configurations, like the nearly triangular shape pierced by a line that appears on the lower left edge of Kandinsky's work and in Pollock's drawing appears reversed on the upper left edge. Heavy black lines forming an X shape appear at the top center of both compositions. Pollock probably adopted the furry or spikey black lines in this drawing from other works by Kandinsky, such as *Black Lines* (fig. 23) or *Light Picture* (fig. 24), both of 1913. In the upper left of the Pollock drawing is a horizontal V-shaped configuration made up of red color over black lines similar to the green and purple horizontal V shapes in *Black Lines*. In both of these works, Kandinsky experimented at using line in a nonfigurative way, with only a very few shapes. In his abstractions, Pollock also dealt with nonfigurative line, through which he would eventually produce even more radical innovations. The titles he chose for some of his paintings in 1946, such as *Yellow Triangle*, *Magic Light*, and *Shimmering Substance*, recall titles of some of Kandinsky's works from the 1920s such as *Yellow Circle*, *Green Wedge*, and *Lighter* (*Sich aufhellend,* also known as *Self-Illuminating*).

Two artists who seem to have paid only brief attention to Kandinsky's art are Richard Pousette-Dart and Barnett Newman. Pousette-Dart's *Pegeen*, 1942-43 (fig. 36), is impressive in its vivid color and dynamic rhythms. The shapes themselves and the linear emphasis recall such of Kandinsky's paintings as *Deep Brown* (fig. 110) or *Lighter* (fig. 25), both of 1924. The red and blue wavy vertical lines along the right side recall those often seen in Kandinsky's works such as *Open Green*, 1923 (fig. 26). Newman was preoccupied with ornithology and other aspects of nature in the early 1940s, and about 1945 he produced a series of lyrical crayon drawings based on natural forms (fig. 99). Their freedom of execution and brightness of color indicate that they may have been influenced by Kandinisky's Improvisations.

Another of the Abstract Expressionists who was interested in Kandinsky's work was Hans Hofmann. When he left for Paris in 1904, Hofmann evidently had not met Kandinsky and, as Kandinsky departed from Munich in 1914, the year Hofmann returned, the two artists probably never did meet, although Miz Wolfegg, whom Hofmann later married, knew Kandinsky's mistress, Gabriele Münter, from Munich. Hofmann remained in Munich during World War I, and he stored many of Kandinsky's important early works in his studio.[45] At one time Hofmann also owned both an oil and a watercolor by Kandinsky.

Hofmann recorded many of the ideas he had developed in his years of teaching in an essay titled "The Search for the Real in the Visual Arts."[46] Dore Ashton has pointed out that Hofmann derived a "subjective metaphysics" from Kandinsky and that "he uses Kandinsky's musical diction: 'Color is a plastic means of creating intervals. Intervals are color harmonies produced by special relationships, or tensions. . . .' "[47] In his essay, Hofmann also wrote, "The spiritual quality dominates the material," a matter Kandinsky had thoroughly

22 Wassily Kandinsky
Kleine Welten VIII, 1922
Woodcut, 10¾ x 9⅛ inches
The Solomon R. Guggenheim Museum, New York

discussed in *Concerning the Spiritual in Art*.[48] According to Hofmann:
Color stimulates certain moods in us. It awakens joy or fear in accordance with its configuration. In fact, the whole world, as we experience it visually, comes to us through the mystic realm of color. Our entire being is nourished by it. This mystic quality of color should likewise find expression in a work of art.[49]
Kandinsky had discussed this at length and elaborated on the various moods or feelings that different colors could convey, for example: "Light warm red has a certain similarity to medium yellow, alike in texture and appeal, and gives a feeling of strength, vigor, determination, triumph."[50]

24 Wassily Kandinsky
Light Picture, 1913
Oil on canvas, 30⅝ x 39½ inches
The Solomon R. Guggenheim Museum,
New York

23 Wassily Kandinsky
Black Lines, 1913
Oil on canvas, 51¼ x 51¼ inches
The Solomon R. Guggenheim Museum,
New York

 Hofmann's theories seem to owe much to his knowledge of Kandinsky's treatise. He learned from Kandinsky as he learned from Matisse's color and from Cubism, but he went on to produce significant works and develop an original theory of painting worthy of his great reputation as a teacher and the lasting influence that he has had through his students.

American artists learned a great deal from European art and artists during the early 1940s. The interaction between American and French artists in New York is comparable to the situation in Paris just before World War I. In a sense, Peggy Guggenheim was like Gertrude Stein, introducing the American and foreign contingents. Yet the tables were turned, for Americans were now operating in the midst of the avant-garde on their own turf. Just as the French writers Guillaume Apollinaire and Louis Vauxcelles were the critics that counted for the generation of struggling young American artists in early twentieth-century Paris, so now the Abstract Expressionists had Clement Greenberg, Harold Rosenberg, and others of their own milieu to respond to their work. The Abstract Expressionists had the advantage of being able to work within their own familiar environment, with the additional benefit of the stimuli of European art and artists accessible to

them in New York. In this unique situation, the young Americans found inspiration and gradual acceptance, enabling them to create a new art, distinct from their European sources.

What made the Abstract Expressionists' art different from the European work that helped give rise to it, was perhaps, more than any other salient quality, its sense of immediacy and of crude intensity. The work was usually more forceful and less elegant than their European antecedents. Led by Pollock's break with the Cubist space in his "poured" paintings of 1947, Americans denied spacial illusion and pushed their forms forward to the limit of the picture plane.

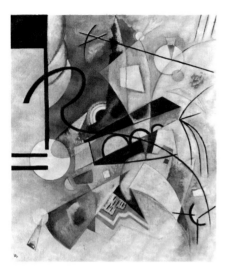

25 Wassily Kandinsky
Lighter (Sich aufhellend, also known as
Self-Illuminating), 1924
Oil on canvas, 32¼ x 28¾ inches
Collection of David Lloyd Kreeger

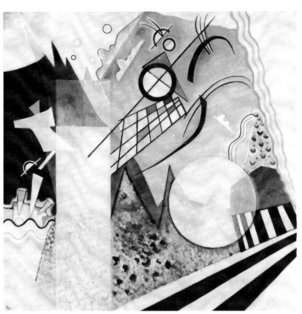

26 Wassily Kandinsky
Open Green, 1923
Oil and ripolin enamel on cardboard,
38¼ x 38¼ inches
Collection of Norton Simon

The emphasis here on the influence of Kandinsky and Miró and other European sources is not intended to deny the presence of nativist ideas and their importance for the artists who were to emerge as the Abstract Expressionists. One cannot discount the importance of working on the large-scale mural projects for the WPA, the vastness of the American landscape and the tradition of nineteenth-century painting inspired by it, or the fascination with American Indian art. This last interest was pursued by the Surrealists themselves in their search of the primitivist myth.

Yet surely the presence of so many important European artists in exile during the years of World War II provided many Americans with the impetus necessary to push beyond Regionalist subject matter toward new frontiers of endeavor. The Surrealists were a major catalyst, both through their art and through their presence which prompted young Americans to consider the great modern masters still in Europe: Kandinsky, Miró, and Picasso. Out of these considerations came much that was of use in forging the style that emerged in New York during these years, one that would hold the art world's attention long after many of the Europeans who inspired it had returned to Europe. This was Abstract Expressionism.

1 Portions of this essay are adapted from Sandra Gail Levin, "Wassily Kandinsky and the American Avant-garde, 1912-1950" (Ph.D. dissertation, Rutgers University, New Brunswick, N.J., May 1976).
2 Lee Krasner, interview with Levin, 6 February 1971.
3 Dore Ashton, *The Life and Times of the New York School: American Painting in the Twentieth Century* (London: Adams & Dart, 1972), p. 113 (republished as *The New York School: A Cultural Reckoning* [New York: Viking Press, 1973]).
4 Hilla Rebay, ed., *Kandinsky* (New York: Solomon R. Guggenheim Foundation, 1945). Idem, ed., *In Memory of Wassily Kandinsky: A survey of the Artist's Paintings and Writings* (includes *Ruckblicke*, Kandinsky's brief autobiography), (New York: Solomon R. Guggenheim Foundation, 1945). Wassily Kandinsky, *Uber das Geistige in der Kunst: Insbesondere in der Malerei* (Munich, 1912); trans. and ed., Hilla Rebay as *On the Spiritual in Art* (New York: The Solomon R. Guggenheim Museum of Non-Objective Painting, 1946); retrans., based on trans. by M.T.H. Sadler as *The Art of Spiritual Harmony* (London and Boston, 1914), as *Concerning the Spiritual in Art* (New York: Wittenborn, Schultz, 1947). Wassily Kandinsky, *Point and Line to Plane*, trans. Howard Dearstyne and Hilla Rebay (New York; The Solomon R. Guggenheim Museum of Non-Objective Painting, 1947).
5 Marcia Epstein Allentuck, ed., Introduction to *John Graham's System and Dialectics of Art* (1937), (Baltimore: Johns Hopkins Press, 1971), p. 11.
6 Ibid., p. 5.
7 David Smith, "Notes on My Work," *Arts* 34 (February 1960): 44.
8 Ibid.
9 Quoted in Allentuck, ed., *Graham's System*, p. 17.
10 For further information on Surrealism in New York, see Jeffrey Wechsler, *Surrealism and American Art 1931-1947* (exhibition catalogue, Rutgers University Art Gallery, New Brunswick, N.J., 5 March-24 April, 1977).
11 Ben Wolf, "The Digest Interviews Hans Hofman," *Art Digest* 19 (April 1945): 52.
12 Jackson Pollock, "Answers to a Questionnaire," *Arts & Architecture* 61 (February 1944): 14; reprinted in Francis V. O'Connor, *Jackson Pollock* (New York: The Museum of Modern Art, 1967), pp. 32-33.
13 Robert Motherwell, "The Significance of Miró," *Art News* 58 (May 1959): 66; reprinted in Barbaralee Diamonstein, ed., *75 Years of Art News*, (New York: Artnews Books, 1977), p. 300.
14 William Baziotes, "Symposium: The Creative Process," *Art Digest* 28 (15 January 1954): 16, 33; reprinted in *William Baziotes: A Memorial Exhibition* (New York: The Solomon R. Guggenheim Museum, 1965), p. 41.
15 Barnett Newman, "The Plasmic Image, Part I" (c. 1943-45), in Thomas B. Hess, *Barnett Newman* (New York: The Museum of Modern Art, 1971), p. 38.

16 Emily Genauer, "Capsule Reviews," *Art News* 44 (15 January, 1945): 29; quotation cited here is from a longer review of the Nierendorf Galleries' Kandinsky retrospective which was originally published in the *World Telegram,* New York.
17 Arshile Gorky, "Stuart Davis," *Creative Art* 9 (September 1931): 213-17; reprinted in Harold Rosenberg, Arshile Gorky: *The Man, the Time, the Idea* (New York: Horizon Press, 1962), p. 128.
18 Robert Frank Reiff, *A Stylistic Analysis of Arshile Gorky's Art from 1943-1948* (Ph.D. dissertation, Columbia University, New York, 1961; reprinted, New York: Garland Publishing, 1977), p. 226. Mr. Weyhe showed Reiff the statement of purchase by Gorky of the book from his bookstore.
19 Reiff, *Gorky's Art*, p. 181. Reiff interviewed Jeanne Raynal, the mosaicist and an intimate friend of Gorky's, who stated that Gorky knew this book and that his wife had probably read it to him. It may, however, have been the first English translation by M.T.H. Sadler, *The Art of Spiritual Harmony* (see n. 4).
20 Agnes Gorky Phillips to Robert Reiff, letter of 1 December 1958, quoted in Reiff, *Gorky's Art*, p. 228, n. 2.
21 *Arshile Gorky* (exhibition catalogue, Julien Levy Gallery, New York, March 1945).
22 Ethel K. Schwabacher, *Arshile Gorky* (New York: Macmillan, 1957), p. 27.
23 Allentuck, ed., *Graham's System*, p. 116. Allentuck has pointed out that "Kandinsky may be said to have influenced not only Graham as artist but as critic and disciple of the occult. . . . When Graham actually did read Kandinsky—whether in Russia or in France—cannot be established. Nevertheless, the key concepts and spiritual accommodations of Kandinsky's highly significant treatise . . . recur in all Graham's writings. Even if they did not lead him to the occult, they certainly could have reinforced his interest and provided it with a theoretical justification" (pp. 6-8).
24 Irving Sandler, *The Triumph of American Painting: A History of Abstract Expressionism* (New York: Praeger, 1970), p. 52.
25 André Breton, *Surrealism and Painting* (New York: Harper & Row, 1972), p. 286.
26 Kandinsky, *Concerning*, p. 63.
27 Rosenberg, *Gorky*, p. 45.
28 Kandinsky, *Concerning*, p. 40.
29 Ashton, *New York School* (1972), p. 159.
30 Clement Greenberg, "Art," *The Nation* 160 (24 March 1945): 343.
31 Sandler, *Abstract Expressionism*, p. 84.
32 Clement Greenberg, "American-Type Painting," *Partisan Review* 22 (Spring 1955): 182.
33 Ashton, *New York School* (1972), p. 68.
34 Graham, "Primitive Art and Picasso," pp. 236-37.
35 Hess, *De Kooning*, 1959, p. 114.
36 Willem de Kooning, "What Abstract Art Means to Me," written for a symposium held at the Museum of Modern Art, 5 February 1951; published in *The Museum of Modern Art Bulletin* 18

(Spring 1951); reprinted in Thomas B. Hess, *Willem de Kooning* (New York: The Museum of Modern Art, 1968), p. 145.
37 Interview reprinted in Harold Rosenberg, *Willem de Kooning* (New York: Abrams, 1974), p. 38.
38 Willem de Kooning, "De Kooning on Pollock: An Interview with James T. Valliere," *Partisan Review* 34 (Fall 1967): 603.
39 Allentuck, ed., *Graham's System*, p. 8.
40 Some of the other Americans included were Stuart Davis and Walt Kuhn. The "French" painters included Braque, Bonnard, Matisse, Modigliani, Picasso, and Segonzac.
41 Kandinsky, *Concerning*, p. 75.
42 Francine du Plessix and Cleve Gray, "Who Was Jackson Pollock?" (Interviews with Lee Krasner, Anthony Smith, Betty Parsons, and Alfonso Ossorio), *Art in America* 55 (May-June 1967): 55. Lee Krasner (p. 50) mentioned that Pollock had listened to Krishnamurti's lectures as a teenager. Smith (p. 54) said that "[Pollock] mused aloud about esoteric religious ideas, Oriental philosophy, things I knew nothing about."
43 "The Passing Shows," *Art News* 44 (1-14 April 1945): 6.
44 O'Connor, *Pollock*, pp. 33-34.
45 William C. Seitz, *Hans Hofmann* (New York: The Museum of Modern Art, 1963), p. 7.
46 Hans Hofmann, *Search for the Real and Other Essays*, ed. Sara T. Weeks and Bartlett H. Hayes, Jr. (1948; reprinted, Cambridge, Mass.: M.I.T. Press, 1967).
47 Ashton, *New York School* (1972), pp. 82-83.
48 Hofmann, *Search*, p. 41. Kandinsky, *Concerning*, pp. 36, 77, etc.
49 Hofmann, *Search*, p. 45.
50 Kandinsky, *Concerning*, p. 61.

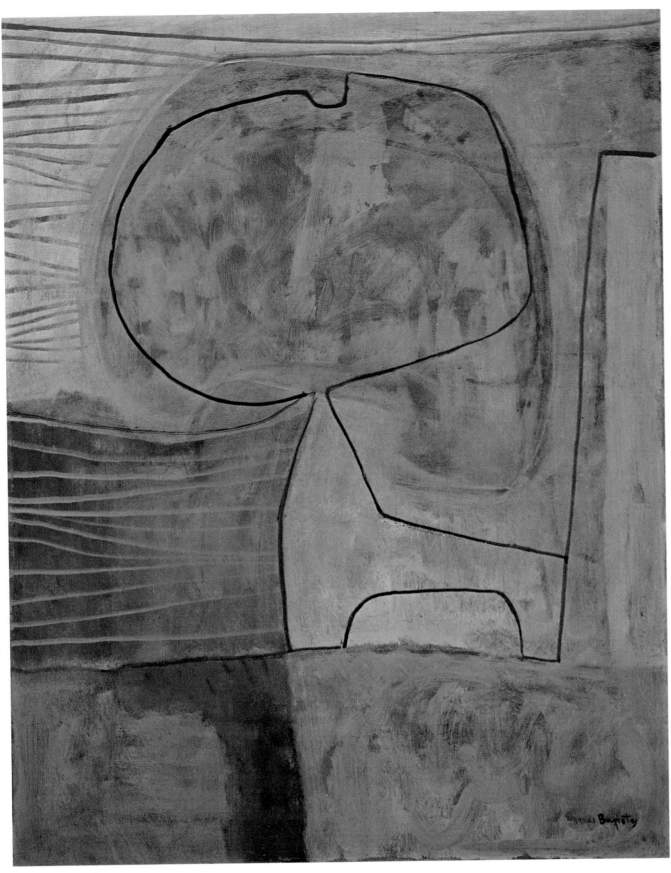

27 William Baziotes
The Web, 1946
Oil on canvas, 30 x 23 inches
Herbert F. Johnson Museum of Art,
Cornell University, Ithaca, New York

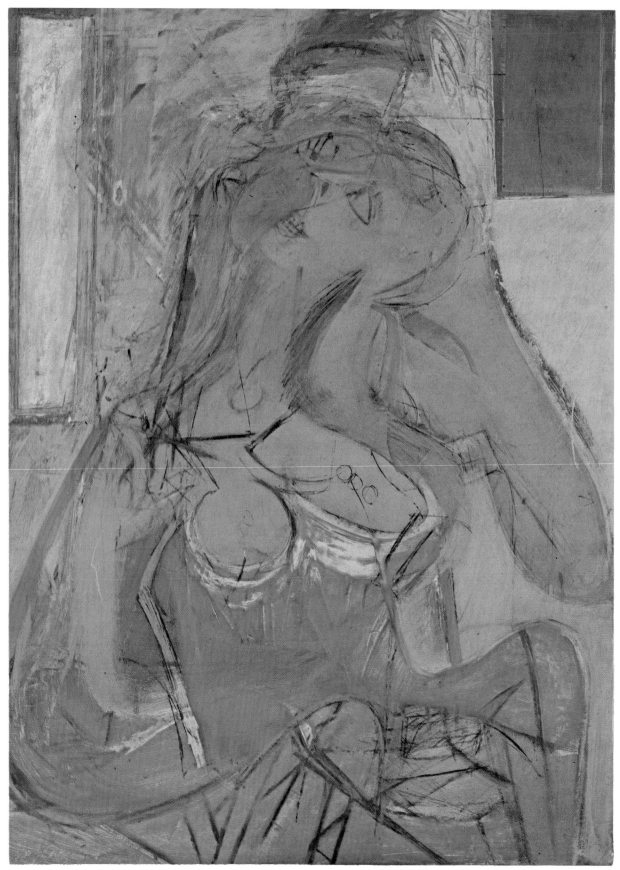

28 Willem de Kooning
Pink Lady, c. 1944
Oil and charcoal on composition board,
48¼ x 35¼ inches
Collection of Mr. and Mrs. Stanley K.
Sheinbaum

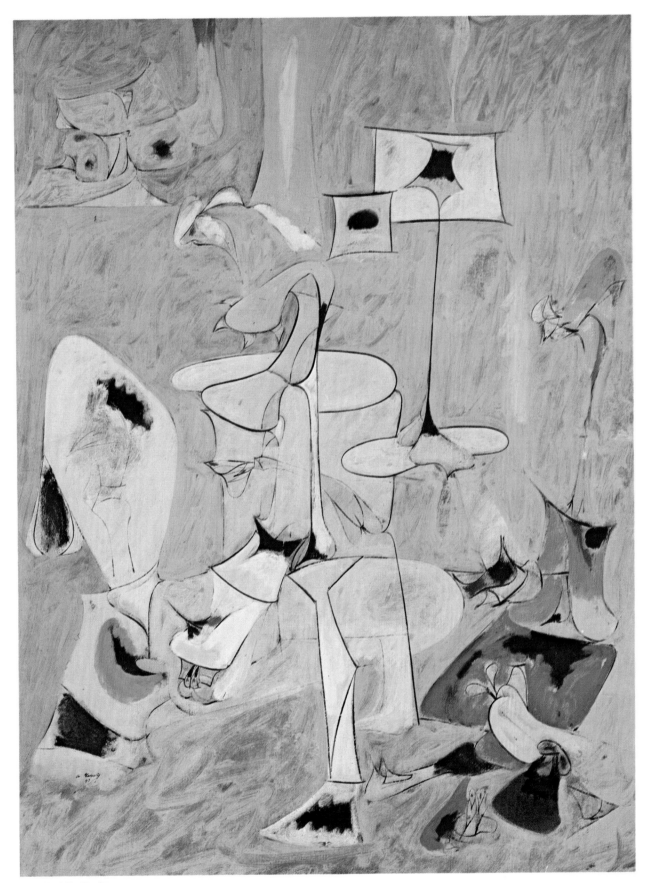

29 Arshile Gorky
The Betrothal, II, 1947
Oil on canvas, 50¾ x 38 inches
Whitney Museum of American Art,
New York. 50.3

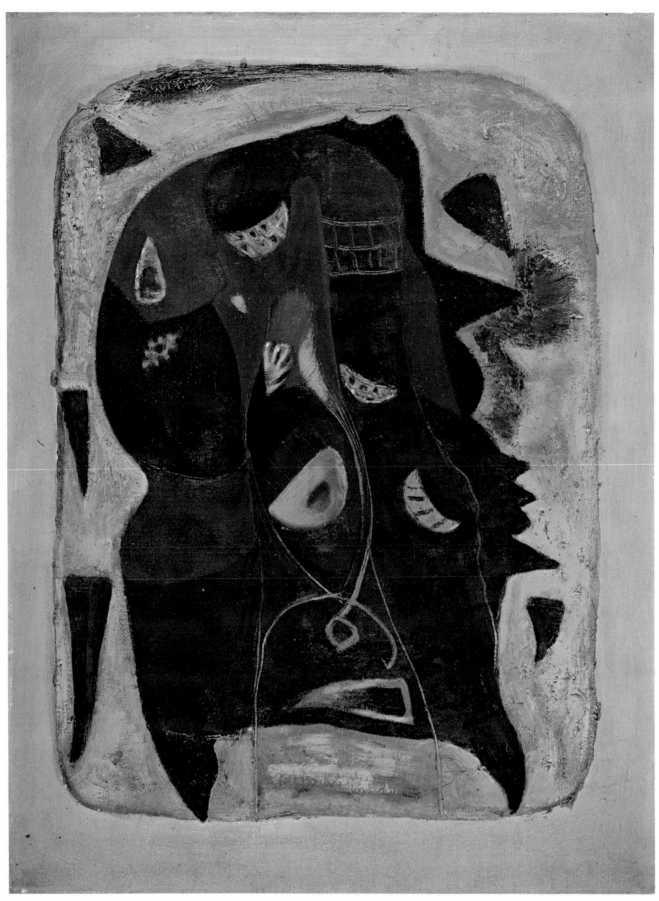

30 Adolph Gottlieb
Persephone, 1942
Oil on canvas, 34 x 26 inches
Private collection

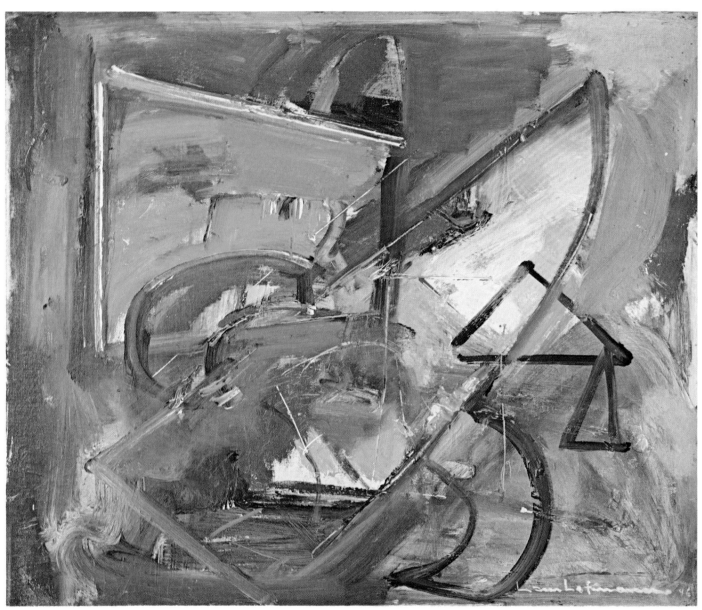

31 Hans Hofmann
Mirage, 1946
Oil on canvas, 25¼ x 30 inches
Herbert F. Johnson Museum of Art,
Cornell University, Ithaca, New York;
Gift of David M. Solinger

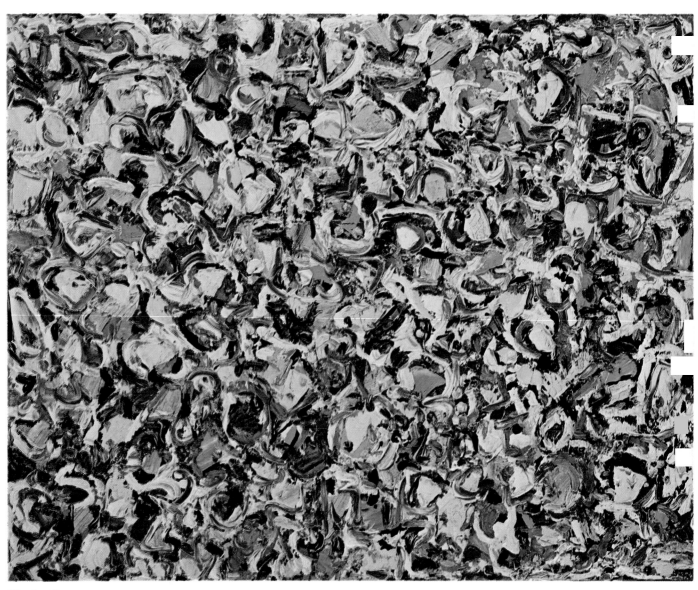

32 Lee Krasner
Noon, 1947
Oil on canvas, 24 x 30 inches
Collection of the artist

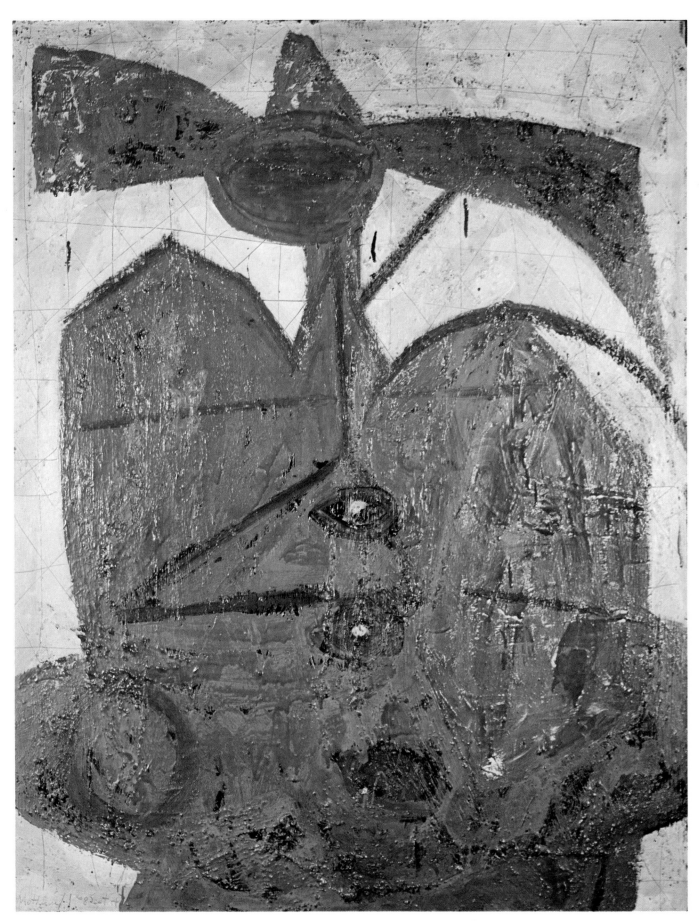

33 Robert Motherwell
Emperor of China, 1947
Oil on canvas, 48 x 36 inches
Collection of Mr. and Mrs. Maxwell Jospey

47

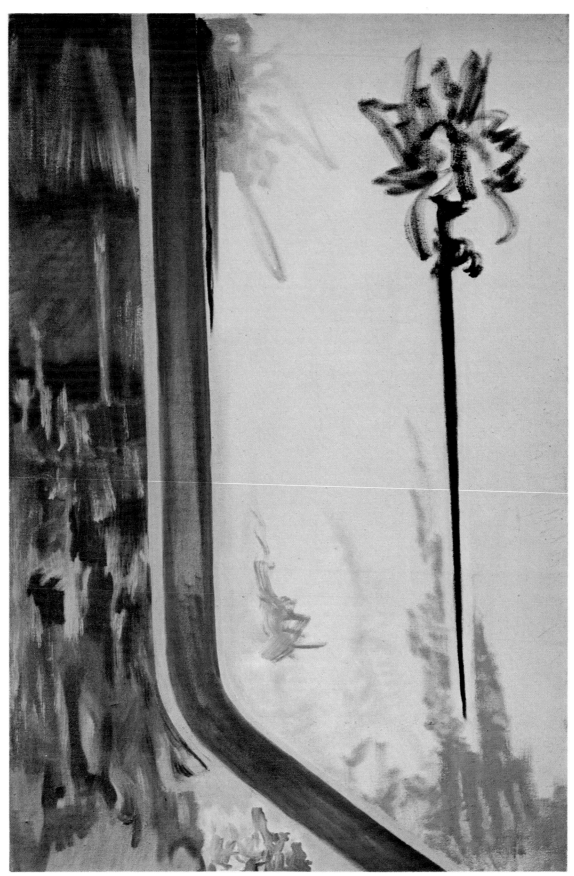

34 Barnett Newman
Untitled, 1945
Oil on canvas, 36 x 24¼ inches
Collection of Annalee Newman

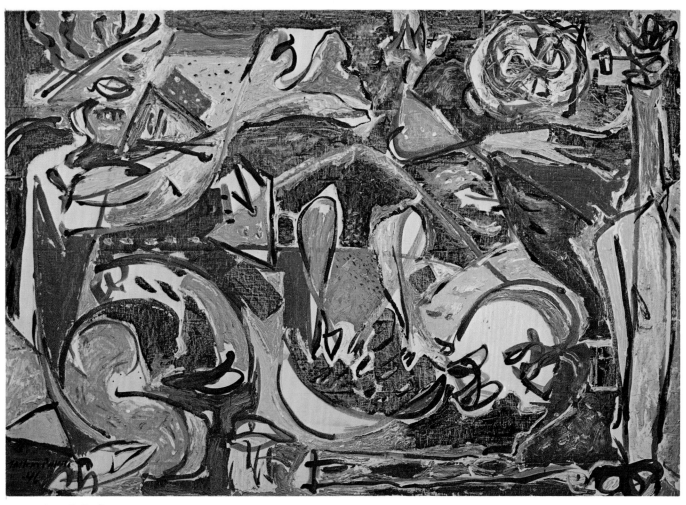

35 Jackson Pollock
The Key, 1946
Oil on canvas, 59 x 83⅞ inches
Collection of Lee Krasner

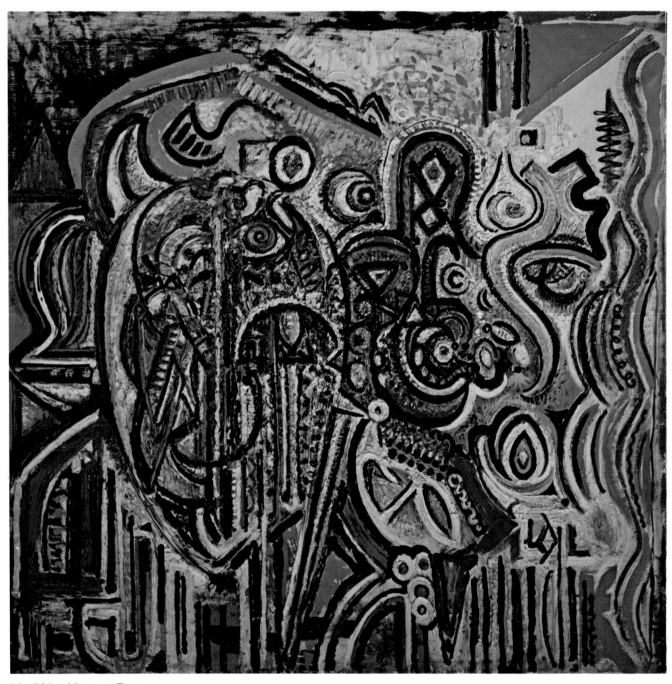

36 Richard Pousette-Dart
Pegeen, c. 1943
Oil on canvas, 50 x 52 inches
Collection of the artist

37 Ad Reinhardt
Number 18—1948-49
Oil on canvas, 40 x 60 inches
Whitney Museum of American Art,
New York. 53.13

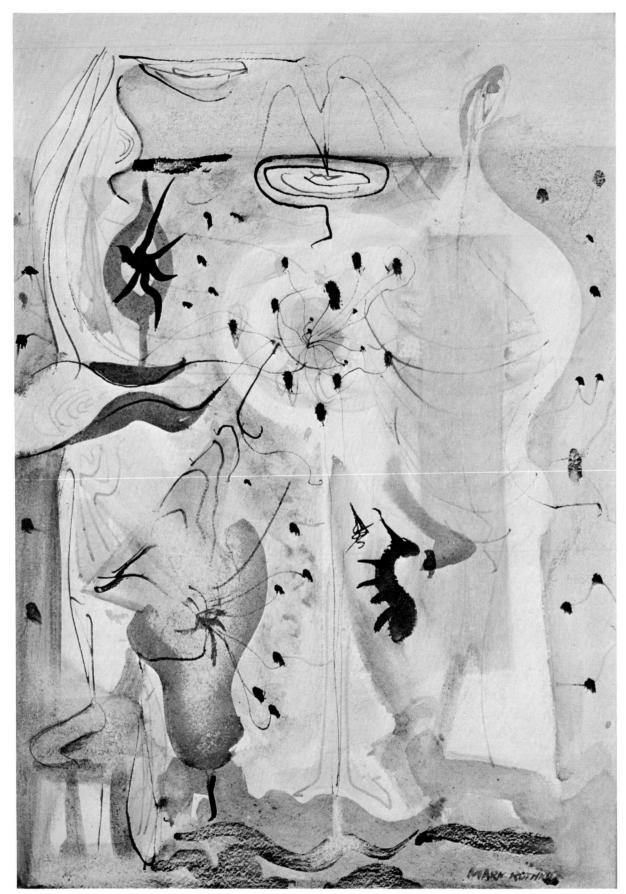

38 Mark Rothko
Baptismal Scene, 1945
Watercolor on paper, 19⅞ x 14 inches
Whitney Museum of American Art,
New York. 46.12

39 Theodoros Stamos
Movement of Plants, 1945
Oil on masonite, 16 x 20 inches
Munson-Williams-Proctor Institute,
Utica, New York; Edward W. Root Bequest

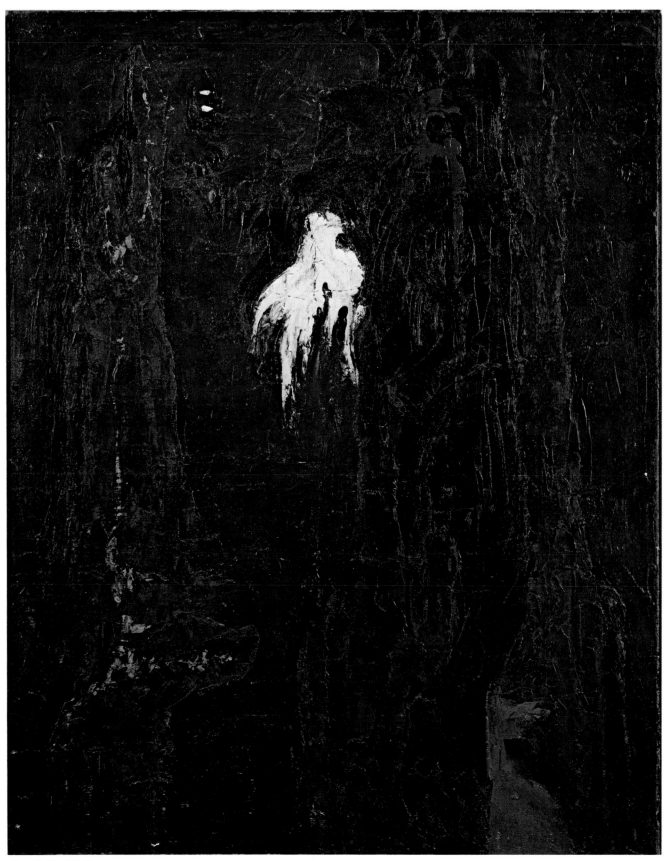

40 Clyfford Still
Untitled, 1945
Oil on canvas, 42½ x 33¾ inches
Whitney Museum of American Art,
New York; Gift of Mr. and Mrs.
B. H. Friedman. 69.3

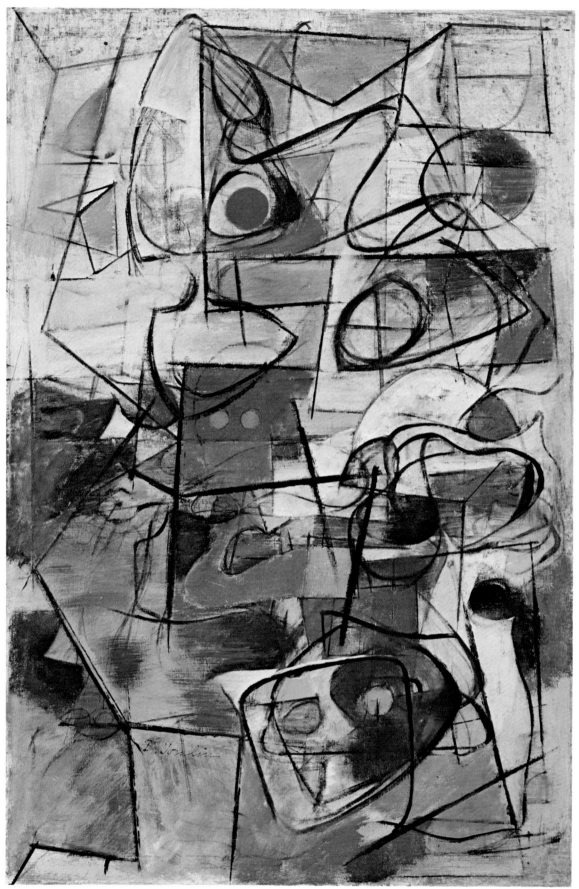

41 Bradley Walker Tomlin
Number 10-A, c. 1947
Oil on canvas, 46 x 31 inches
Collection of Daniel Mari

William Baziotes (1912-1963)

Even the most profound thought is limited by the invincible circumstances which make all thought superficial. One only enters a forest of transpositions, or, rather, a palace walled with mirrors which multiply to infinity the light of a solitary lamp.[1]

This passage from Paul Valéry's *Introduction to the Method of Leonardo da Vinci* personifies the central spirit of Baziotes's art. It is an art of elusive apparitions, "shadows of shadows" in Poe's words,[2] capturing the soul of "psychal impressions" which arise in those Proustian states that occur in the moment between wakefulness and sleep.

Baziotes was among the first American artists of his generation to become acquainted with the Surrealists in New York toward the end of the thirties. Around 1939, he began experimenting with automatic techniques, his work moving deeper into abstract realms.[3] In 1942 he painted *The Butterflies of Leonardo da Vinci* (fig. 43), exemplifying this period of closest contact with artists such as Matta and André Masson.[4] Yet Baziotes's vision is more closely allied with Valéry's writings on Leonardo, writings often paraphrased by Matta,[5] than with the Surrealists' proliferation of a more earthly dream. The butterflies in Baziotes's painting are his remembrance of images such as those in Poe's "Fairy-land," where these symbols of frail and strange beauty and flight have returned

56

to earth, "have brought a specimen upon their quivering wings,"[6] as the painter who has returned to the world from his canvas. Above all, Baziotes's gossamer threads of phosphoric color are the butterflies in Leonardo's fable who, "marvelling greatly at such radiant beauty," are drawn to the flaming light of "carnal delights," only to find slow and tortuous death in its fires, having learned the "rapacious and destructive nature" of the "accursed light" only at the moment of doom.[7]

During the next few years, Baziotes moved in a direction quite separate from Surrealism. Although he used the Surrealist idea of psychic automatism,

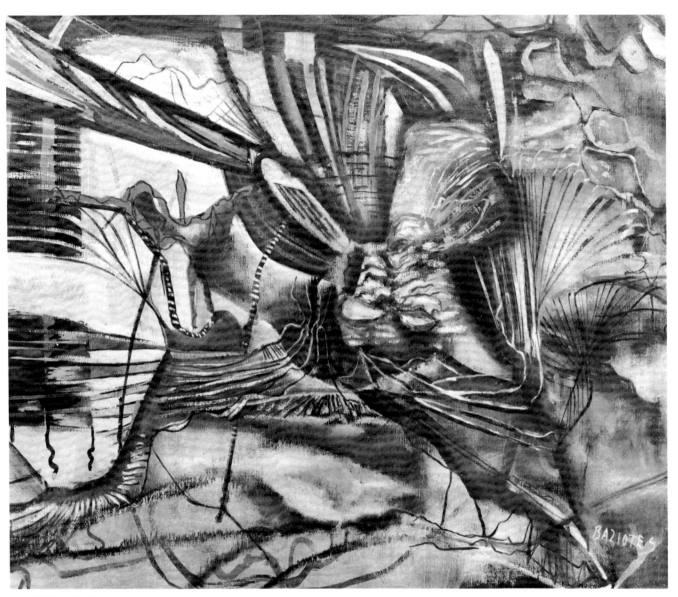

43 William Baziotes
The Butterflies of Leonardo da Vinci, 1942
Duco enamel on canvas, 19 x 23 inches
Marlborough Gallery, New York

his artistic goal more closely parallels that of Poe who, in his "Poetic Principles," stressed the need for the poet to express his ardent outpourings with "profound and enduring effect," in a form "as closely woven as the mesh of chain mail . . . in an impeccable, gripping and terrible manner."[8] Baziotes was developing an art of demonic subtlety; the slow, gnawing fear which he felt in facing the unknown within was no less risky for all its seeming lack of outer frenzy. Every approach to the canvas was a gamble, a chance that the significant content which he sensed as his goal would be revealed out of the experience of the painting process.[9] It was intuitive painting with full knowledge of the possibilities inherent in paint, knowledge so fully assimilated that it could free him from consciousness of formal concerns so that painter and painting could act as one.

Baziotes's subject matter arose from the process of painting in a way very

57

like the way he saw the world.

As for the subject-matter in my painting, when I am observing something that may be the theme for a painting, it is very often an incidental thing in the background, elusive and unclear, that really stirred me, rather than the thing before me.[10]

Baziotes located his images on the edges of vision. He was drawn to the mirror which reveals the self hidden within, not Narcissus' mirror but the mirror which also emits shadowy forms of the world around us, off to the sides, around a corner, like the hazy reflections of passersby one gets while gazing into a store

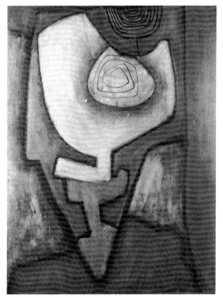

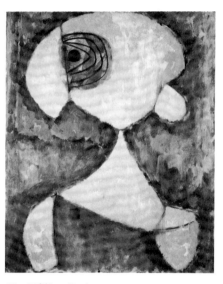

45 William Baziotes
Mirror Figure, 1948
Oil on canvas, 30 x 24 inches
Collection of Frances and Frederick B. Washburn

44 William Baziotes
Circus Abstraction, 1946
Oil on canvas, 32½ x 24 inches
Collection of Suzanne Vanderwoude

window. He stepped through the looking glass to find the part of self which exists in the bizarre wonderment of the Cheshire cat, in the offbeat characters on the edges of reality, of sanity.

In *The Web*, 1946 (fig. 27), a scumbled environment of mossy yellow-greens and midnight blues is inhabited by a wandering, crayon-like line which turns into a bloody, faceless silhouette of some sort of night creature perched on the edge of a cliff, straining its neck and baying at the moon. Behind it run rows of nervous horizontal line, the piercing melancholia of monotone wails reverberating in the night skies, the ensnaring web now behind self, lamentations to the moon from the psyche of the painter bound to earth. *Mirror Figure*, 1948 (fig. 45), is one of a group of paintings of the period (most well known among them, *Dwarf* and *Cyclops*, both 1947), which fuse the sinister and the sensuous in a single figure of multiple associations. *Mirror Figure* recalls Baziotes's fascination with deformity, his attraction to Goya and to Olmec figures, his obsessive drawings of a World War I "basket case" from a photo in a book. Baziotes was enthralled with the image of the clown, intrigued by jesters and dwarfs, those tiny, satanically clever creatures, charmed "possessions" of kings who placed great faith in their wisdom and magical powers. The birdlike head and ringed eye suggest the deadly cunning of the vulture, the prehistoric reptiles which Baziotes loved at the American Museum of Natural History and in their modern counterpart at the Bronx Zoo.[11] The fleshy pink form also evokes the female nude emerging from a background of

58

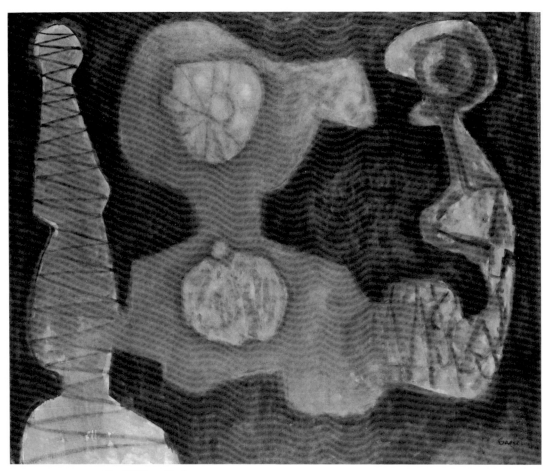

46 William Baziotes
Night Mirror, 1947
Oil on canvas, 50 x 60 inches
Vassar College Art Gallery,
Poughkeepsie, New York;
Gift of Mrs. John D. Rockefeller

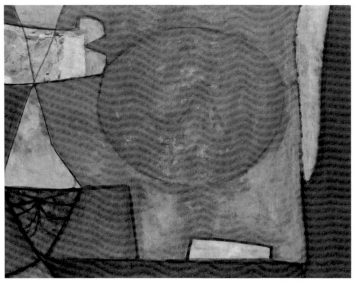

47 William Baziotes
Pink Wall, 1946
Oil on canvas, 30 x 38 inches
The Solomon R. Guggenheim Museum,
New York; Gift of Mr. and Mrs.
Herman Ackman

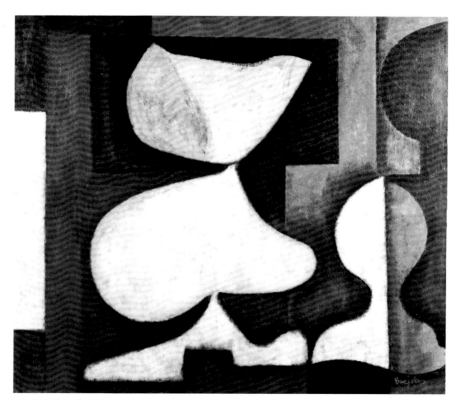

48 William Baziotes
The Mannequins, 1946
Oil on canvas, 40 x 48 inches
Whitney Museum of American Art,
New York; Gift of David M. Solinger
in honor of John I.H. Baur. 74.106

sickly greens, emanating with the pungent odor of sweet decay. The female nude,
bewitching elixir of beauty and fear, appears within many of Baziotes's images,
"painted as though they were the flesh of a woman."[12] In *Pink Wall*, 1946 (fig.
47), dark blue pentimenti shows through areas of in-between hues, the tesselated
pinks of Italian marble evoking a wall of flesh, a wall to be broken down in the
effort to reach the realms of spirit, also a reference to the ancient Roman walls
which Baziotes loved at the Metropolitan Museum;[13] in the lower left corner is
a fluted, hourglass shape. In *The Mannequins*, 1946 (fig. 48), Baziotes focuses
in on such tantalizing distortions, blending vessel with voluptuous nude; they are
the headless bodies which serve as dressmakers' dummies, artists' models, and
the "clothes horses" that display costumes on stages for the customers of famous
designers such as Balenciaga, whose fluid, Velázquez-like drapery interested
Baziotes.[14] Some primitive tribes held that man had a number of souls in
animal/human shapes, the principle one in the form of a "mannikin," the others
being shadows of it.[15]

Baziotes's paintings are an enigmatic fusion of inner and outer vision,
evolving out of the fabric of his canvas and out of the fabric of his psyche,
expressing what Valéry called "the nervous and psychic part of man."[16]

BC

1 Paul Valéry, *Introduction to the Method of Leonardo da Vinci*, trans. Thomas McGreevy (London: John Rodker, 1929), p. 14.

2 Edgar Allan Poe, from *Marginalia*, as quoted in *Possibilities 1*, eds. Robert Motherwell, Harold Rosenberg, Pierre Chareau, John Cage (New York: Wittenborn, Schultz, 1947), p. 40.

3 Baziotes was reading Symbolist poetry with his poet friend Byron Vazakas in Reading, Pennsylvania, from around 1931. For more information about this period and the activities of Baziotes, see Barbara Cavaliere, "An Introduction to the Method of William Baziotes," *Arts Magazine* 51 (April 1977): 124-30. See also Barbara Cavaliere and Robert C. Hobbs, "Against a Newer Laocoon," ibid., pp. 110-17.

4 In 1942, Masson painted *Leonardo da Vinci and Isabella d'Este*, which is illustrated in William Rubin and Carolyn Lanchner, *André Masson* (New York: The Museum of Modern Art, 1976), p. 66. Baziotes's painting *The Butterflies of Leonardo da Vinci* was included in the exhibition "First Papers of Surrealism," held at the Whitelaw Reid Mansion, New York, 1942, and organized by André Breton and Marcel Duchamp.

5 When I read the passage which opens this essay to Mrs. Ethel Baziotes, she remembered that it was similar to an expression which Matta used to repeat often during their friendship in the early forties.

6 Edgar Allan Poe, "Fairy-land," in *The Complete Poetical Works of Edgar Allan Poe*, with memoir by J. H. Ingram (London: Mershon Co., n. d.), p. 270. This book is from Baziotes's library.

7 Leonardo da Vinci, "Fables," in *The Notebooks of Leonardo da Vinci*, trans. with intro. by Edward McCurdy (New York: Reynal & Hitchcock, 1939), p. 1070. Baziotes revered Leonardo and read this version of his notebooks. It should also be noted that Baziotes was a collector of mounted specimens of butterflies, examples of which still hang in his home.

8 *Baudelaire on Poe: Critical Papers*, trans. and ed. Lois and Francis Hyslop (State College, Pa.: Bald Eagle Press, 1952), p. 115. Robert Motherwell pointed this book out to Cavaliere as important to both Baziotes and himself during the early forties.

9 From a statement by William Baziotes in *Possibilities 1*, p. 2. See also *Modern Artists in America*, eds. Robert Motherwell and Ad Reinhardt (New York: Wittenborn Schultz, [1951]), p. 15.

10 Ibid. This idea relates Baziotes to the ideas on peripheral vision developed by Robert C. Hobbs, in his essay "Early Abstract Expressionism: A Concern with the Unknown Within" in this catalogue.

11 See William Baziotes, letter to Alfred Barr, 26 April 1949, response to questionnaire from the Department of Painting and Sculpture, The Museum of Modern Art, on their acquisition of *Dwarf*, Archives of American Art, Washington, D. C.

12 Ibid.

13 Baziotes often visited the Metropolitan Museum of Art, New York, where he was drawn to the Roman wall paintings and mosaics, particularly to the bedroom from Boscoreale, and to the marble sculptures of Greece and Rome.

14 Information from Mrs. Ethel Baziotes in discussion with Cavaliere.

15 See Sir James George Frazer, *The Golden Bough: Study in Magic and Religion* (New York: Macmillan Publishing Co., 1922; Macmillan Paperback, 1963), pp. 208, 220-22, for more information on the idea of the soul as "mannikin" and the primitive belief in the mirror reflections and shadows as personifications of the soul.

16 Paul Valéry, "Concerning Corot," in *Variety: Second Series*, trans. W. A. Bradley (New York, Harcourt, Brace & Co., 1938), p. 38. An excerpt from this essay by Valéry chosen by William Baziotes appeared under the title "The Silence of Painters," in *Possibilities 1*, p. 5. This essay makes many points parallel to Poe's ideas in the *Marginalia*.

Willem de Kooning (b. 1904)

The important formative years for Willem de Kooning's mature style were those spent in New York City after he immigrated in 1926, even though he studied art in night classes at the Rotterdam Academy of Fine Arts and Techniques during the years 1916-24. Nonetheless, one should not overlook his familiarity with the Dutch modernist movement, de Stijl, that was centered around the abstract sensibility of Piet Mondrian. He was also cognizant of Dutch Art Nouveau and had gained practical experience working with commercial artists, decorators, and the art director of a major department store in Rotterdam.

In New York, de Kooning became friends with John Graham and Arshile Gorky, both of whom were to exert a significant influence on him. He met Gorky in 1929 through another painter, Mischa Resnikoff,[1] and he has always stressed the importance of his friendship with Gorky for his own development.

In 1935, de Kooning worked for a year on the Federal Arts Project, only to be asked to resign because he was not yet an American citizen. Working with the FAP gave him the opportunity to concentrate on his art which encouraged him so much that he came to consider his art of primary importance.[2] One of his assignments was to work on plans for a mural for the Williamsburg Federal Housing Project. When de Kooning left the project, Lee Krasner was initially assigned the task of painting a mural based on one of his designs; this mural has since disappeared.[3] De Kooning's surviving studies indicate that his designs were close to Gorky's paintings of the mid-thirties, such as *Organization* (fig. 59). One such study by de Kooning, a tiny untitled gouache (fig. 49), is directly related to Gorky's composition in its rectilinear and ovoid shapes and its linear grid. Both artists ultimately borrowed from such works by Picasso as *Painter and Model* or *The Studio*, both of 1928 and in the Museum of Modern Art, New York, and both shown there in "Cubism and Abstract Art" in 1936.

During the twenties and thirties, Gorky was producing important portraits, in part influenced by Ingres's classicism. An especially strong one, *Portrait of Master Bill*, about 1937, represents de Kooning, who was also interested in portraiture. Although the forms of the human figure only partially disintegrate in Gorky's portraits, de Kooning has impressively pursued this to organic abstraction, yielding the most unexpected results.[4] Nonetheless, in the early forties, de Kooning's portraits were not much more radical than those by Gorky a few years earlier. Yet by the time he painted *Pink Lady*, about 1944 (fig. 28), his treatment of a portrait had begun to result in a new style. The classicism of his earlier portraits was being eroded by a kind of shattering of the central image. The repeated facial features reverberated across the surface; the limbs

49 Willem de Kooning
Untitled, c. 1937
Gouache on paper, 7 x 14 inches
Whitney Museum of American Art,
New York; Frances and Sydney Lewis
Collection. 77.34

50 Willem de Kooning, 1938, in his studio
on West 22nd Street, New York

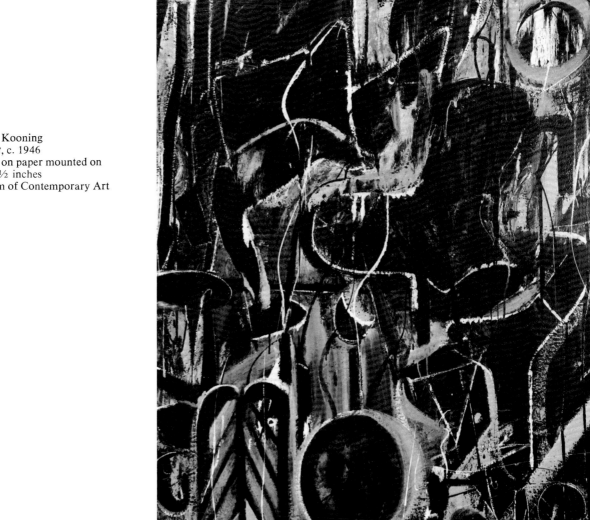

51 Willem de Kooning
Light in August, c. 1946
Oil and enamel on paper mounted on
canvas, 55 x 41½ inches
Tehran Museum of Contemporary Art

52 Willem de Kooning
Grey and Black Composition, 1948
Oil on paper mounted on masonite,
24 x 36 inches
Collection of Mr. and Mrs. Stephen D.
Paine

53 Willem de Kooning
Abstract Still Life, c. 1938
Oil on canvas, 30 x 36 inches
Private collection, courtesy of
Xavier Fourcade, Inc., New York

became attenuated or elongated. Willful distortion reminiscent of the Cubist dislocation in Picasso's work was combined with gestural brushstrokes. One pictorial device in *Pink Lady* links it to de Kooning's earlier abstractions: the use of rectangular windowlike shapes to organize the background. These add structure and linear definition and recall de Kooning's early mural design and its relationship to work by Gorky and Picasso.

The need for an ordered geometric background structure did not begin to disappear from de Kooning's work until, probably under Pollock's influence, he increased his gestural activity by loosening shapes and allowing paint to run in pictures like *Light in August*, about 1946 (fig. 51), or *Grey and Black Composition*, 1948 (fig. 52). Looking at his *Abstract Still Life*, about 1938 (fig. 53), one can contrast the ordered, solid structure on the right side of the composition with the freedom implicit in his work after 1946. In *Untitled,* about 1944 (fig. 54), de Kooning maintained the windowlike rectangles, yet combined them with some loose dripping brushwork. There is still a very clear sense of foreground and a more distant field which would give way to surface animation in the mature work.

54 Willem de Kooning
Untitled, c. 1944
Oil and charcoal on paper mounted on
composition board, 13½ x 21¼ inches
Collection of Mr. and Mrs. Lee V. Eastman

De Kooning did not have his first one-artist exhibition until 1948 at the Egan Gallery. That year his *Mailbox* (fig. 8) was in the Annual Exhibition at the Whitney Museum of American Art. By this time, however, he was already known among artists and had participated in various group exhibitions. In 1942 he, along with Krasner and Pollock, showed in the exhibition "American and French Painting" organized by John Graham at the McMillen Gallery. He was represented by *Standing Man*, one of his portraits of 1939; in contrast, Krasner showed a painting stylistically related to Picasso, and Pollock showed his innovative *Birth*.

55 Willem de Kooning
Untitled, 1945
Pastel, pencil on paper, 12 x 13⅞ inches
Allan Stone Galleries, New York

Before 1946, a key year in de Kooning's development, his paintings had not yet proceeded to the point where they lacked every obvious trace of a recognizable form. To reach this stage, he adapted a biomorphic vocabulary learned from Miró and Picasso, but absorbed through Gorky. He combined this with a loose painterly application of pigment, probably influenced by his knowledge of Surrealist automatism and his regard for Pollock's invention of drip painting. The result was what we think of when we hear Harold Rosenberg's term "action painting."[5]

GL

1 For a complete chronology, see that compiled by Richard S. Lanier in Harold Rosenberg, *De Kooning* (New York: Harry N. Abrams, 1973), pp. 283-86.
2 Thomas B. Hess, *Willem de Kooning* (New York: The Museum of Modern Art, 1968), p. 17.
3 Lee Krasner, interview with Gail Levin and Robert Carleton Hobbs, The Springs, East Hampton, New York, 31 August 1977.
4 This was pointed out by William C. Seitz in *Arshile Gorky, Paintings Drawings Studies* (New York: The Museum of Modern Art, 1962), p. 16.
5 Harold Rosenberg, "The American Action Painters," *Art News* 51 (December 1952): 22-23, 48-50.

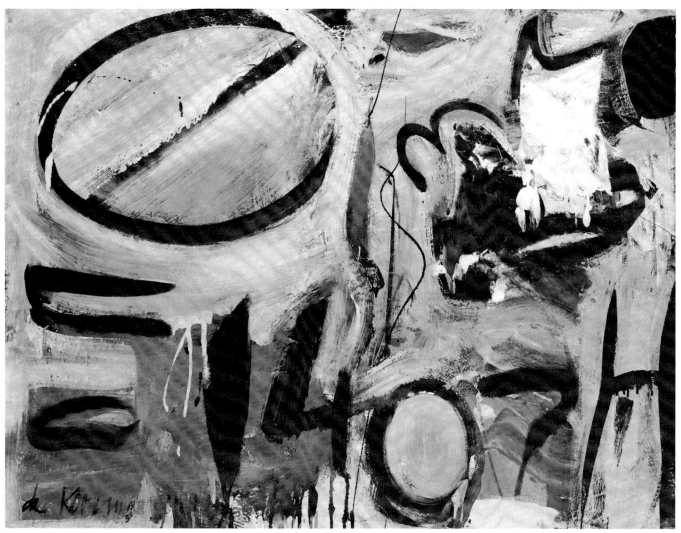

56 Willem de Kooning
Open Road, 1948
Oil on paper, 30 x 40 inches
Philadelphia Museum of Art; The Albert
M. Greenfield and Elizabeth M. Greenfield
Collection

Arshile Gorky (1904-1948)

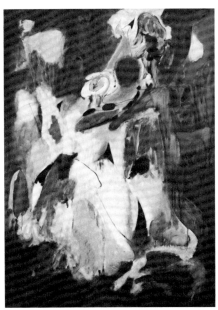

57 Arshile Gorky
Waterfall, c. 1943
Oil on canvas, 60½ x 44½ inches
Tate Gallery, London

Arshile Gorky emigrated to America in 1920, at the age of fifteen, from Turkish Armenia where he was born. He chose the pseudonym Arshile Gorky (his given name was Vosdonig Manoog Adoian) and told a newspaper interviewer that he was a cousin of the Russian writer Maxim Gorky, whom he claimed to hear from occasionally.[1] Gorky also falsely claimed that he had attended Brown University and that he had studied in Paris.[2] Meyer Schapiro, who knew Gorky, wrote that he "was a fervent scrutinizer of paintings" and that he frequently went to museums.[3] Gorky was largely self-taught, and he learned by carefully studying the works of those artists he considered great. Schapiro wrote of this aspect of Gorky's development:

His career was remarkable as a development from what seemed a servile imitation of other painters to a high originality. For almost twenty years he produced obviously derived pictures, versions of Cézanne, Picasso, Léger, Miró, Kandinsky and others; and suddenly he flowered as an imaginative artist whom certain admirers class with the very great.[4]

Julien Levy, the art dealer, also commented on Gorky's self-imposed apprenticeship: "I had never before met a painter with the empathy to enter so completely into the style of another."[5]

In the twenties and thirties, Gorky's consuming interest was the art of Cézanne and then Picasso. In 1932 he told Julien Levy: "I was *with* Cézanne for a long time, and now naturally I am *with* Picasso."[6] Around 1933 Gorky met Willem de Kooning, who became a close friend; they shared a studio for a number of years during the late 1930s.[7]

Gorky's work in the early 1940s reveals a deepening interest in Miró, a continuation of the interest already apparent in the Image in Xhorkom series of the late 1930s. At this time Gorky's art was much less derivative than that of his Cézanne and Picasso periods, but in the early 1940s he continued to develop from his specific interest in the work of other artists, particularly Matta and Kandinsky.

Like Kandinsky's Improvisations, Gorky's works in the early 1940s relate to nature. In the summer of 1943, Gorky and his wife, Agnes, went to live at her parents' new home, Crooked Run Farm, in Hamilton, Virginia. Here, Gorky evidently felt right at home and responded to nature with new inspiration.[8] Around this time he painted a number of canvases relating to waterfalls with appropriately wet-looking fluid shapes. One of these canvases, *Waterfall*, about 1943 (fig. 57), has been repeatedly linked to Gorky's interest in Kandinsky's art.[9] While Kandinsky also painted a waterfall (*Cascade de Lana*, 1907), Gorky's *Waterfall* is probably not related to any one painting by Kandinsky.[10] Gorky's forms in *Waterfall,* particularly the concentric circle motif in the top center, as well as the loose blots of color and the black linear drawing amid the thinly applied color, are definitely reminiscent of many of Kandinsky's Improvisations and other works, for example *Light Picture* (fig. 24) or *First Abstract Watercolor*, with which Gorky was probably familiar through reproductions.[11]

In the next year, 1944, his paintings continued to demonstrate a relationship to Kandinsky's Improvisations both in form and color, as well as Gorky's growing interest in Surrealist automatism. One may compare, for example, Gorky's *Water of the Flowery Mill*, 1944 (fig. 61), to Kandinsky's

58 Arshile Gorky, c. 1946, with daughter Maro in Connecticut

59 Arshile Gorky and Willem de Kooning, c. 1935, in front of Gorky's *Organization* in an early state

60 Arshile Gorky
Carnival, 1943
Crayon on paper, 22 x 28⅜ inches
Collection of Mr. and Mrs. Edwin A.
Bergman

61 Arshile Gorky
Water of the Flowery Mill, 1944
Oil on canvas, 42 x 48¾ inches
The Metropolitan Museum of Art,
New York; George A. Hearn Fund, 1956

Impressions III, 1911 (Städtische Galerie, Munich). Gorky has captured both
Kandinsky's flowing, momentary shapes and his brilliant, warm colors. Gorky,
managing to use black and white in the midst of a dynamic color scheme in the
same way that Kandinsky had before him, created an equally dramatic effect.
Gorky actually achieved the overall unity at which Kandinsky merely hinted
through the use of dripping paint. Gorky's major canvases usually were not, in
fact, very spontaneously painted, for he often worked out specific studies on
paper. Such is the case with *The Liver is the Cock's Comb*, 1944 (fig. 62), for
which a study of 1943 exists in pencil, ink, and wax crayon. While his *Water of*

the Flowery Mill of the same year is quite close in feeling to landscape, *The Liver is the Cock's Comb* departs from this natural gentle aura, to include fantastic creatures with toothlike claws and skeletal forms. In this aspect, Gorky's work seems close to that of some of the Surrealist painters then living in New York, such as Tanguy and Matta with whom Gorky became friendly around 1944. His lively use of color, however, and his floating forms with fluid edges would seem to indicate that in *The Liver is the Cock's Comb* he was still involved with the example set by Kandinsky.[12] In his canvases in the 1940s, Gorky had come to understand Kandinsky's art and had progressed beyond these

62 Arshile Gorky
The Liver is the Cock's Comb, 1944
Oil on canvas, 72 x 98 inches
Albright-Knox Art Gallery, Buffalo,
New York; Gift of Seymour H. Knox

ideas to create an art both powerful and totally personal.

Even in his most individual mature works, Gorky referred to the art that inspired him. *The Betrothal, II*, 1947 (fig. 29), uses the image of a horse and rider which he had originally sketched from Paolo Uccello's *Battle of San Romano*. Large photographs of Uccello's painting decorated Gorky's studio wall. According to Schwabacher, the images of horse and spear indicated love and death for Gorky.[13] Another sketch, a study for *The Betrothal, II*, gives us the clues necessary for understanding Gorky's symbols, but this kind of interpretation is not necessary. Rather one can read these shapes as pure poetic

71

abstractions, although references to representation, often to human anatomy, abound.

Among the burgeoning Abstract Expressionists, Gorky's art is transitional. It is most closely related to European painting, partly because of Gorky's friendships with Breton and Matta. Yet he was never a Surrealist, although he certainly felt the influence of the Surrealists' biomorphic shapes and automatism. Gorky's sources were more diverse, from Kandinsky's lyrical abstract improvisations to the classicism of Ingres, Uccello, and Picasso. Unlike the work of the other Abstract Expressionist painters, we must consider Gorky's work of his last years as formative in the sense of forging a new style. Ironically, this was a period of great personal despair for Gorky, who was suffering from the effects of a fire in his studio, throat cancer, and injuries from an automobile accident, and he took his own life in 1948 at the age of forty-four.

GL

63 Arshile Gorky
One Year the Milkweed, 1944
Oil on canvas, 37 x 47 inches
Estate of A. Gorky, courtesy of Xavier
Fourcade, Inc., New York

64 Arshile Gorky
The Limit, 1947
Oil on paper over burlap, 50 x 60½ inches
Xavier Fourcade, Inc., New York

1 "Fetish of Antique Stifles Art Here," *New York Evening Post*, 15 September 1926; reprinted in Harold Rosenberg, *Arshile Gorky: The Man, the Time, the Idea* (New York: Horizon Press, 1962), pp. 123-26.
2 Robert Frank Reiff, *A Stylistic Analysis of Arshile Gorky's Art from 1943-1948* (Ph.D. dissertation, Columbia University, New York, 1961; reprinted, New York: Garland Publishing, 1977), pp. 120-21.
3 Meyer Schapiro, Introduction to Ethel K. Schwabacher, *Arshile Gorky* (New York: Macmillan and Whitney Museum of American Art, 1957), p. 11.
4 Ibid.
5 Julien Levy, Foreword to William C. Seitz, *Arshile Gorky: Paintings, Drawings, Studies* (New York: The Museum of Modern Art, 1962), p. 7.
6 Ibid.
7 Thomas B. Hess, *Willem de Kooning* (New York: The Museum of Modern Art, 1969), p. 114.
8 Schwabacher, *Gorky*, p. 96.
9 Other Waterfalls painted by Gorky are listed in Julien Levy, *Arshile Gorky* (New York: Harry N. Abrams, 1966), for instance, pl. 84, *Waterfall*, 1942, and pl. 87, *Housatonic Falls*, begun 1942-43. Reiff compares Gorky's *Waterfall* to Kandinsky (*Gorky's Art*, pp. 226-29). Rosenberg has written, "The relation to Kandinsky is very clear in paintings of '43-'44 such as *The Waterfall* and *The Liver is the Cock's Comb*, with the flowing edges of its forms . . ." (*Gorky*, pp. 113-14). This comparison of *Waterfall* to Kandinsky's work has also been made in an excellent study of Gorky's sources by William Rubin ("Arshile Gorky, Surrealism, and the New American Painting," *Art International* 7 [February 1963]; reprinted in Henry Geldzahler, *New York Painting and Sculpture, 1940-1970* [New York: E. P. Dutton and The Metropolitan Museum of Art, 1969], pp. 372-402).
10 Reiff (*Gorky's Art,* p. 226) indicates, and I concur, that it is not likely that Gorky knew this work by Kandinsky.
11 Rubin ("Gorky," p. 391) has made a convincing visual comparison in his juxtaposition of Gorky's *Waterfall* to Kandinsky's *Sunday*, 1911; yet Gorky could not have known this work which was then hidden away in the basement storeroom of Gabriele Münter (and was not exhibited until after her gift of several hundred paintings by Kandinsky to the Städtische Galerie in Munich during the fall of 1956). What Rubin referred to as "the painterly language inspired by Kandinsky" must then be attributed to Gorky's admiration of many of Kandinsky's early works, which he saw both in exhibitions in New York and in reproductions in the books he studied.
12 Rubin ("Gorky," p. 391) has suggested, "The great plumes of color, probably inspired by Kandinsky's on the order of *Black Lines* (1913), are potently seductive even though as a group their registration does not finally cohere." Indeed, Gorky could easily have seen Kandinsky's *Black Lines* (fig. 23) on exhibit at the Museum of Non-Objective Painting. The painting was in the museum's collection from its founding in 1939 and was later included in the memorial retrospective exhibition in 1945, and reproduced as the frontispiece in the accompanying catalogue.
13 Schwabacher, *Gorky*, p. 131.

Adolph Gottlieb (1903-1974)

65 Adolph Gottlieb
The Sea Chest, 1942
Oil on canvas, 26 x 34 inches
The Solomon R. Guggenheim Museum,
New York

66 Adolph Gottlieb
Eyes of Oedipus, 1941
Oil on canvas, 32 x 25 inches
Private collection

Adolph Gottlieb's late magic realist paintings prefigure his pictographs. In 1937-38 he began a series of still lifes, composed of detritus found in the Arizona deserts, and continued to paint natural found objects when he went to Gloucester. In these later works, he composed beach still lifes which he placed in boxes of his own construction. The effect is startlingly metaphysical: fragments from the ocean floor suggest elements dragged up from the waters of one's own unconscious, and the compartmentalized spaces of the boxes are metaphors for the bracketing faculty of the conscious mind. That Gottlieb returned to an illusionistic crate with a random grid in *The Sea Chest,* 1942 (fig. 65), after he had begun in 1941 to create pictographs with abstract horizontal and vertical divisions suggests that realism and abstraction were different approaches to essentially the same concern.

In terms of myth these magic realist paintings may be more distinctly related to Gottlieb's early Abstract Expressionist works. The sea boxes suggest an acquaintance with sacred rites of the Eleusian mysteries, particularly the activities occurring after initiates finished a ritualistic cleansing in the sea and drank potions: the time when they placed symbolic objects in a chest. The problem with the sea boxes is that, in spite of their mystery, they remain essentially illustrations of the myth. What Gottlieb appears to have been seeking was an art that involved the viewer on a deeper level with the ambiance of myth. In his pictographs, he found what he was hunting. While the sea boxes are suggestive of an earlier phase of the Eleusian ritual, Gottlieb's paintings *Persephone*, 1942 (fig. 30), and *The Rape of Persephone*, 1943, elusively call to mind a later stage described by Plutarch. In this part of the ritual, initiates, reenacting Persephone's abduction by Pluto, descend into subterranean cavities and pass through seemingly endless corridors where they are subjected to terrors, causing them to shudder and sweat profusely. Finally they reach the end, a light place, where the symbolic rebirth is completed. Even though the myth serves as a text for these two pictographs, the paintings are in no way simple illustrations of the text. Paralleling the Eleusian mysteries, which according to Aristotle had to be experienced, not learned, the paintings must be experienced directly: a recounting of their elements cannot encompass their meaning.

Even though Gottlieb has long been considered a primary exponent of subject matter inhering in an abstract format, his use of subject matter—like that of so many Abstract Expressionists—is allusive and often intentionally ambiguous. His primitivistic signs, each occupying a cubical in his pictographs, are definitely more important as vectors pointing to the symbolic nature of the work as a whole than as precisely decodable ciphers. In other words, the value of a sign is precisely as a sign, much more than as a notation with a referent external to itself. As Lawrence Alloway has related, Gottlieb would delete a sign from his repertoire if he discovered it was being interpreted in a particular fashion:[1] he deliberately intended his images to be vague. Agreeing with his friend John Graham that primitive art is closely allied with the unconscious,[2] Gottlieb used his generally primitivistic images as clues, directing the viewer to the unconscious communication he hoped his pictographs would convey. The stenographic signs in *Alchemist (Red Portrait)* (fig. 69), for instance, are far less important as calligraphs whose enumeration might add up to a transcribable poem than they are signs suggesting generally the key of alchemy which

67 Adolph Gottlieb

unlocked for Jung, Gottlieb's mentor, the significance of dreams.

Gottlieb's first pictograph, *Eyes of Oedipus* (fig. 66), seems to refute
the theory that his signs are uninterpretable, but even in this painting signs are
general rather than specific and ultimately refer more to the function of the
painting than to a literary idea. In this painting the possibility of a literary
interpretation is present, referring, of course, to the king of Thebes who blinds
himself after he discovers he has killed his father and married his mother. Eyes
in this situation ironically point to the limitations of eyesight to internal vision
and indicate Gottlieb's art at this time is moving from a recording of the external
world to an evocation of an internal one. It should be emphasized that Gottlieb
is not veering away from vision in his pictographs. In them he is concerned not
with recording what he sees but with creating paintings to act on vision in such a
way as to provide access to deeper levels of the self. If only the depiction of
archetypes were of interest to Gottlieb, his art would merely be illustrations of

Jungian ideas. His intent rather was to create an atmosphere conducive to a special sort of meditation in which the viewer could begin to catch a glimpse of the unknown within himself. In Gottlieb's pictographs the more obvious subject matter, manifested in the primitivistic signs, is a conscious clue directing the viewer to a largely unconscious experience that is catalyzed by the abstract elements in the painting (see essay "Abstract Expressionism: A Concern with the Unknown Within"). In *Pictograph #4* (fig. 70), for example, the subject matter tautologically reinforces the abstract qualities of the painting and even establishes a scanning pattern. Eyes in this picture function more as vectors than

68 Adolph Gottlieb
Black Hand, 1943
Oil on linen, 30 x 24 inches
Private collection

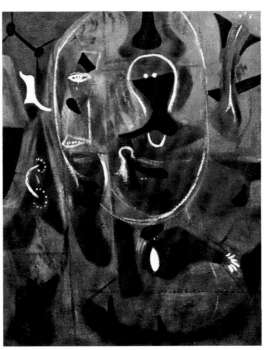

69 Adolph Gottlieb
Alchemist (Red Portrait), 1945
Oil on canvas, 34 x 26 inches
Private collection

metaphors: they denote numerous focal points in the painting, thus necessitating peripheral scanning. Augmented by hands pointing in different directions and the Janus head, the eyes cue the viewer to the primary importance of the painting, its concern with sight. Eyes, moreover, in this picture as in *Eyes of Oedipus* are analogous to eyes in those mystical heads by John Graham: they represent the bridge between inner and outer reality, and consequently point in the direction of the art's content, the unconscious.

In Gottlieb's art subject matter both parallels and underscores the abstract qualities of the painting. His subject matter referring to myths and magic is the vocabulary used by psychologists to interpret dreams. Its use implies his interest in the unconscious with the benefit of never stating it directly. By mainly employing earth colors, indicative of ancient and tribal arts and conceiving his forms in terms of broad masses, Gottlieb can allude to a primitive origin for his forms while avoiding the pejorative "archaistic." Important as his subject matter is, however, its relationship with the abstract qualities of the painting is the area of crucial importance to Gottlieb, for it is there, where primitivistic forms reinforce the essential peripheral vision occasioned by the work, that his real innovations lie.

RCH

WHITNEY MUSEUM OF AMERICAN ART

945 Madison Avenue at Seventy-Fifth Street New York, New York 10021 (212) 794-0600

ABSTRACT EXPRESSIONISM: THE FORMATIVE YEARS

October 3-December 3, 1978

CHECKLIST OF THE EXHIBITION

Abstract Expressionism: The Formative Years is the first major survey exhibition of the beginning of the most important development in American art in the 20th century. There is no single definition of Abstract Expressionism. It lies somewhere between an assimilation of European modernist styles and a dramatic break with Cubist space into an abstraction dealing with myth, the subconscious, and gestural techniques. Abstract Expressionism was never an organized movement comparable to Futurism, Surrealism, or other avant-garde groups in the 20th century. It had no central organization, no manifesto.

The artists included in the exhibition developed as Abstract Expressionists at different times. Art historians have traditionally thought of Abstract Expressionism as beginning in 1945, with the resulting implication that this art is a postwar phenomenon. However, the works gathered here are evidence that it had begun at least by the early 1940s.

In order to give full representation to the artists' formative years, the works chosen for the exhibition are the first by each that can be called Abstract Expressionist. Paintings and drawings by William Baziotes, Willem de Kooning, Arshile Gorky, Adolph Gottlieb, Hans Hofmann, Lee Krasner, Robert Motherwell, Barnett Newman, Jackson Pollock, Richard Pousette-Dart, Ad Reinhardt, Mark Rothko, Theodoros Stamos, Clyfford Still, and Bradley Walker Tomlin range in date from about 1935 through 1949.

These works from the important early years of Abstract Expressionism enable a reassessment of the individual artists, their development, and the very meaning of the term Abstract Expressionism.

WILLIAM BAZIOTES (1912-1963)

The Butterflies of Leonardo da Vinci, 1942.
Duco enamel on canvas, 19 x 23 inches.
Marlborough Gallery, New York

Circus Abstraction, 1946. Oil on canvas,
32 1/2 x 24 inches. Collection of Suzanne
Vanderwoude

The Mannequins, 1946. Oil on canvas, 40 x 48
inches. Whitney Museum of American Art; Gift
of David M. Solinger in honor of John I. H. Baur
74.106

Pink Wall, 1946. Oil on canvas, 30 x 38 inches.
The Solomon R. Guggenheim Museum, New York; Gift
of Mr. and Mrs. Herman Ackman

The Web, 1946. Oil on canvas, 30 x 24 inches.
Herbert F. Johnson Museum of Art, Cornell
University, Ithaca, New York; Membership
Purchase Fund and David M. Solinger Fund

Figures in the Night, 1947. Oil on canvas,
24 1/2 x 23 1/2 inches. Solomon and Company
Fine Art, New York

Night Mirror, 1947. Oil on canvas, 50 x 60
inches. Vassar College Art Gallery, Poughkeepsie,
New York; Gift of Mrs. John D. Rockefeller

Mirror Figure, 1948. Oil on canvas, 30 x 24
inches. Collection of Frances and Frederick B.
Washburn

WILLEM DE KOONING (b. 1904)

Abstract Still Life, c. 1938. Oil on canvas,
30 x 36 inches. Private collection, courtesy
of Xavier Fourcade, Inc., New York

Untitled, c. 1944. Oil and charcoal on paper
mounted on composition board, 13 1/2 x 21 1/4
inches. Collection of Mr. and Mrs. Lee V.
Eastman

Pink Lady, c. 1944. Oil and charcoal on compo-
sition board, 48 3/8 x 35 5/8 inches. Collection
of Mr. and Mrs. Stanley K. Sheinbaum

Untitled, 1945. Pastel, pencil on paper, 12 x
13 7/8 inches. Allan Stone Gallery, New York

Untitled, 1945-46. Oil on paper mounted on
board, 28 1/4 x 22 1/4 inches. Allan Stone
Gallery, New York

Light in August, c. 1946. Oil and enamel on paper
mounted on canvas, 55 x 41 1/2 inches. Tehran
Museum of Contemporary Art, Iran

Grey and Black Composition, 1948. Oil on paper
mounted on masonite, 24 x 36 inches. Collection
of Mr. and Mrs. Stephen D. Paine

Mailbox, 1948. Oil, enamel, and charcoal on
paper pasted on cardboard, 23 1/4 x 30 inches.
Private collection

Open Road, 1948. Oil on paper, 30 x 40 inches.
Philadelphia Museum of Art, Pennsylvania; Albert M.
Greenfield and Elizabeth M. Greenfield Collection

Untitled, 1946. Oil on paper on masonite, 27 1/2 x
34 1/2 inches. Collection of Mr. and Mrs. Lee V.
Eastman

ARSHILE GORKY (1904-1948)

Painting, 1936-37. Oil on canvas, 38 x 48
inches. Whitney Museum of American Art;
Purchase 37.39

Untitled, 1939. Gouache on paper, 13 3/4 x
17 3/4 inches. Collection of Peter Socolof

Anatomical Blackboard, 1943. Crayon and pencil,
20 1/4 x 27 3/8 inches. Collection of Mr. and
Mrs. Walter Bareiss

Carnival, 1943. Crayon, 22 x 28 3/8 inches.
Collection of Mr. and Mrs. E. A. Bergman

Drawing, 1943. Pencil and wax crayon on paper,
22 x 27 3/4 inches. Allan Stone Gallery, New York

Water of the Flowery Mill, 1944. Oil on canvas,
42 x 48 3/4 inches. Metropolitan Museum of Art;
New York; George Hearn Fund 1956

Good Afternoon, Mrs. Lincoln, 1944. Oil on
canvas, 30 x 38 inches. Allan Stone Gallery,
New York

The Liver Is the Cock's Comb, 1944. Oil on
canvas, 72 x 98 inches. Albright-Knox Art Gallery,
Buffalo, New York; Gift of Seymour H. Knox

One Year the Milkweed, 1944. Oil on canvas,
37 x 47 inches. Estate of Arshile Gorky; courtesy
of Xavier Fourcade, Inc., New York

The Betrothal II, 1947. Oil on canvas, 50 3/4
x 38 inches. Whitney Museum of American Art 50.3

The Limit, 1947. Oil on canvas over burlap,
50 x 60 1/2 inches. Estate of Arshile Gorky; courtesy
of Xavier Fourcade, Inc., New York

ADOLPH GOTTLIEB (1903-1974)

Pictograph--Symbol, 1942. Oil on canvas, 54 x
40 inches. Private collection

Pictograph (Yellow and Violet), 1942. Oil on
linen, 48 x 36 inches. Private collection

Persephone, 1942. Oil on canvas, 34 x 36
inches. Private collection

Untitled, 1942. Pastel on paper, 23 1/4 x
18 1/2 inches. Private collection.

Black Hand, 1943. Oil on linen, 30 x 24
inches. Private collection

Pictograph #4, 1943. Oil on canvas, 36 x 23
inches. The Adolph and Esther Gottlieb
Foundation, New York

Alchemist (Red Portrait), 1945. Oil on canvas,
34 x 26 inches. Private collection

Follow Red Line, 1946. Oil on canvas, 34 x 26
inches. Collection of Mr. and Mrs. S. Schwartz

Forgotten Dream, 1946. Oil on canvas, 24 x 30
inches. Herbert F. Johnson Museum of Art,
Cornell University, Ithaca, New York; Gift of
Albert A. List

HANS HOFMANN (1880-1966)

Spring, 1940. Oil on wood, 11 1/4 x 14 1/8
inches. Museum of Modern Art, New York; Gift
of Mr. and Mrs. Peter A. Rübel, 1968

Landscape, 1941. Oil on board, 30 x 35 inches.
Andre Emmerich Gallery, New York

Cataclysm (Homage to Howard Putzel), 1945.
Watercolor on gesso on cardboard panel, 51 3/4
x 48 inches. Andre Emmerich Gallery, New York,
and the Estate of Hans Hofmann

Untitled, 1945. Crayon and gouache on paper,
17 1/2 x 23 1/2 inches. Andre Emmerich Gallery,
New York

Bacchanale, 1946. Oil on board, 64 x 48 inches.
Andre Emmerich Gallery, New York, and the
Estate of Hans Hofmann

Mirage, 1946. Oil on canvas, 25 1/4 x 30
inches. Herbert F. Johnson Museum of Art,
Cornell University, Ithaca, New York; Gift of
David M. Solinger

Palimpsest, 1946. Oil on board, 39 1/2 x 59 1/2 inches. Andre Emmerich Gallery, New York, and the Estate of Hans Hofmann

Ecstasy, 1947. Oil on canvas, 68 x 60 inches. University Art Museum, University of California, Berkeley; Gift of the artist

LEE KRASNER (b. 1908)

Untitled (1701-c), 1938. Oil on paper, 19 x 24 3/4 inches. Private collection

Untitled, 1938. Oil on paper, 19 x 24 3/4 inches. The Pace Gallery, New York

Untitled, 1946. Oil on linen, 27 3/4 x 30 inches. Private collection

Abstract #2, 1946-48. Oil on canvas, 20 1/2 x 23 1/4 inches. The Pace Gallery, New York

Noon, 1947. Oil on canvas, 24 x 30 inches. Private collection

Composition, 1949. Oil on canvas, 38 x 28 inches. Philadelphia Museum of Art, Pennsylvania

Continuum, 1949. Oil and enamel on canvas, 54 1/8 x 43 7/8 inches. Collection of Alfonso A. Ossorio

ROBERT MOTHERWELL (b. 1915)

Recuerdo de Coyoacan (Memory of Coyoacan), 1941. Oil on canvas, 42 x 34 inches. Collection of the artist

The Joy of Living, 1943. Collage (ink, tempera, crayon, construction paper, mulberry paper, and map on cardboard), 43 1/2 x 33 5/8 inches. The Baltimore Museum of Art; Saidie A. May Collection

Personage, 1943. Oil on canvas, 48 x 38 inches. Norton Gallery and School of Art, West Palm Beach, Florida

Spanish Prison, 1943-44. Oil on canvas, 52 x 42 1/2 inches. Collection of Mrs. H. Gates Lloyd

Blue Air, 1946. Oil on paperboard mounted on paperboard, 41 1/2 x 28 3/8 inches. Hirshhorn Museum and Sculpture Garden, Smithsonian Institution, Washington, D. C.

Emperor of China, 1947. Oil on canvas, 48 x 36 inches. Collection of Mr. and Mrs. Maxwell Jospey

In Grey with Parasol, 1947. Collage and oil on board, 47 1/2 x 36 1/2 inches. Art Gallery of Ontario; Gift from the Women's Committee Fund, 1962

The Homely Protestant (Bust), 1947-48. Oil on canvas, 30 x 24 inches. Collection of the artist

BARNETT NEWMAN (1905-1970)

Untitled, 1945. Oil on canvas, 36 x 24 1/4 inches. Collection of Annalee Newman

Untitled, c. 1945. Watercolor, 11 1/2 x 16 3/4 inches. Collection of Betty Parsons

The Song of Orpheus, 1945. Oil, oil crayon, and wax crayon on paper, 19 x 14 inches. Collection of Annalee Newman

Untitled, c. 1944-45. Crayon on paper, 15 x 20 inches. Collection of Annalee Newman

Pagan Void, 1946. Oil on canvas, 33 x 38 inches. Collection of Annalee Newman

The Command, 1946. Oil on canvas, 48 x 36 inches. Collection of Annalee Newman

Euclidian Abyss, 1946-47. Oil and gouache on canvas board, 28 x 22 inches. Collection of Mr. and Mrs. Burton Tremaine

JACKSON POLLOCK (1912-1956)

Birth, c. 1938-41. Oil on canvas mounted on plywood, 46 x 21 3/4 inches. Collection of Lee Krasner

Moon Woman Cuts the Circle, 1943. Oil on canvas, 43 x 41 inches. Marlborough Gallery, New York

Night Mist, c. 1944. Oil on canvas, 36 x 74 inches. Norton Gallery and School of Art, West Palm Beach, Florida

Water Figure, 1945. Oil on canvas, 72 x 29 inches. Hirshhorn Museum and Sculpture Garden, Smithsonian Institution, Washington, D. C.

Untitled Drawing, 1946. Ink, pastel, gouache, wash on paper, 22 1/2 x 30 7/8 inches. Private collection

The Key, 1946. Oil on canvas, 59 x 83 7/8 inches. Collection of Lee Krasner

Something of the Past, 1946. Oil on canvas, 56 x 38 inches. Private collection

Tea Cup, 1946. Oil on canvas, 40 x 28 inches. Robert Elkon Gallery, New York

Shimmering Image, 1946. Oil on canvas, 24 1/2 x 20 1/4 inches. Collection of Mr. and Mrs. Stephen D. Paine

Male and Female, 1942. Oil on canvas, 73 1/4 x 49 inches. Collection of Mrs. H. Gates Lloyd

RICHARD POUSETTE-DART (b. 1916)

Symphony Number 1, The Transcendental, c. 1940-45. Oil on canvas, 90 x 120 inches. Andrew Crispo Gallery, New York

Within the Room, 1942. Oil on canvas, 26 x 60 inches. Collection of the artist

Pegeen, c. 1943. Oil on canvas, 50 x 52 inches. Collection of the artist

Figure, 1945. Oil on canvas, 80 x 50 inches. Andrew Crispo Gallery, New York

Fugue Number 4, 1947. Oil on canvas, 92 x 62 inches. Andrew Crispo Gallery, New York

AD REINHARDT (1913-1967)

Dark Symbol, 1941. Oil on masonite, 16 x 20 inches. Private collection

Abstract Painting, 1943. Oil on canvas, 40 x 32 inches. Marlborough Gallery, New York

Painting, 1946. Oil on masonite, 24 x 11 3/4 inches. Marlborough Gallery, New York

Untitled, 1946. Oil on canvas, 50 x 20 inches. Marlborough Gallery, New York

Number 18, 1948-49. Oil on canvas, 40 x 60 inches. Whitney Museum of American Art 53.13

Untitled, 1949. Oil on canvas, 43 x 63 inches. Private collection

MARK ROTHKO (1903-1970)

Baptismal Scene, 1945. Watercolor on paper, 19 7/8 x 14 inches. Whitney Museum of American Art 46.12

Landscape, 1945. Oil on canvas, 19 3/4 x 27 3/4 inches. Collection of Mrs. Herbert Ferber

Two-Sided Drawing, c. 1945. Ink on paper, 15 1/8 x 20 5/8 inches. Betty Parsons Gallery, New York

Implements of Magic, c. 1945. Watercolor on paper, 22 x 29 inches. Collection of Stephen Lapidus

The Entombment, 1946. Oil on canvas, 40 x 60 inches. Collection of Mrs. Herbert Ferber

Entombment I, 1946. Gouache on paper, 20 3/8 x 25 3/4 inches. Whitney Museum of American Art 47.10

Personage, c. 1947. Watercolor on paper, 20 1/2 x 14 1/4 inches. Truman Gallery, New York

Nocturnal Drama, c. 1945. Gouache on paper, 21 1/2 x 15 1/2 inches. Private collection

THEODOROS STAMOS (b. 1922)

Ancestral Flow, 1945. Oil on canvas, 14 x 22 inches. Pinacotheque Nationale Musee, Athens, Greece

Movement of Plants, 1945. Oil on masonite, 16 x 20 inches. Munson-Williams-Proctor Institute, Utica, New York; Edward W. Root bequest

Moon Flower and Surf, 1946. Gouache on board, 18 x 14 inches. Private collection

The Sacrifice, 1946. Oil on masonite, 30 x 39 1/2 inches. Collection of Dr. and Mrs. Louis Savas

Archaic Sentinel, 1947. Oil on masonite, 36 x 30 inches. Collection of Dr. and Mrs. Louis Savas

What the Wind Does, 1947-49. Oil on masonite, 58 x 45 1/2 inches. Collection of Mr. and Mrs. Nicholas Gaylord

Altar, 1948. Oil on masonite, 48 x 36 inches. Private collection

Altar #1, 1948. Oil on masonite, 36 x 48 inches. Private collection

CLYFFORD STILL (b. 1904)

Brown Study, c. 1935. Oil on canvas, 29 15/16 x 20 1/4 inches. Munson-Williams-Proctor Institute, Utica, New York

Untitled Drawing, 1943. Oil on paper, 18 x 12 inches. Collection of Dr. and Mrs. Irwin H. Makovsky

Untitled, c. 1943-44. Oil on paper, 27 1/2 x 21 1/2 inches. Collection of Earle Blew

Untitled (Fear), 1945. Oil on canvas, 24 1/2 x 18 1/2 inches. Collection of Betty Parsons

Untitled, 1945. Oil on canvas, 42 1/2 x 33 3/4 inches. Whitney Museum of American Art: Gift of Mr. and Mrs. B. H. Friedman 69.3

Untitled, 1946. Oil on canvas, 61 3/4 x 44 1/2 inches. Metropolitan Museum of Art, New York; Arthur and George Hearn Fund; Purchase 1977.174

Untitled 1946, No. 1, 1946. Oil on canvas, 70 x 40 1/2 inches. Collection of Mr. and Mrs. Richard Levitt

Untitled, 1946. Gouache and ink on paper, 24 x 16 inches. Collection of Betty Parsons

Untitled, 1946. Oil on brown denim, 51 x 32 7/8 inches. Menil Foundation Collection, Houston, Texas; Jermayne MacAgy bequest

1947 K. Oil on canvas, 63 x 40 inches. Collection of Dr. and Mrs. K. L. Levitan

BRADLEY WALKER TOMLIN (1899-1953)

Number 10-A, c. 1947. Oil on canvas, 46 x 31 inches. Private collection

Tension by Moonlight, 1948. Oil on canvas, 32 x 44 inches. Betty Parsons Gallery, New York

Untitled, 1948. Oil on canvas, 30 x 25 inches. Solomon and Company Fine Art, New York

Small Wind Disturbing a Bonfire, 1949. Oil on canvas, 23 x 44 inches. Collection of Mrs. Herbert Ferber

Maneuver for Position, 1948. Oil on canvas, 31 x 46 inches. Collection of Robert and Jane Meyerhoff

Number 12, 1949. Oil on canvas, 32 x 31 inches. Whitney Museum of American Art; Promised gift of Mr. and Mrs. B. H. Friedman in honor of John I. H. Baur 3.74

This exhibition was organized by the Whitney Museum of American Art and the Herbert F. Johnson Museum of Art, Cornell University, Ithaca, New York, supported by a grant from the National Endowment for the Arts.

70 Adolph Gottlieb
Pictograph #4, 1943
Oil on canvas, 36 x 23 inches
The Adolph and Esther Gottlieb
Foundation, New York

71 Adolph Gottlieb
Pictograph (Yellow and Violet), 1942
Oil on linen, 48 x 36 inches
Private collection

1 Lawrence Alloway, "Melpomene and
Graffiti: Adolph Gottlieb's Early Work,"
Art International 12 (20 April 1968):
21-24; reprinted in idem, *Topics in
American Art Since 1945* (New York:
W. W. Norton & Co., 1975), p. 26.
2 John D. Graham, "Primitive Art and
Picasso," *Magazine of Art* 30 (April
1937): 237-38.

Hans Hofmann (1880-1966)

Born in Weissenberg, Germany, Hofmann did not settle permanently in the United States until 1932.[1] He first traveled to America in 1930 at the invitation of Worth Rider, one of his former students in Germany. Rider was then professor of art at the University of California at Berkeley, where Hofmann taught that first summer. Hofmann's family had moved to Munich in 1886, and he was in Paris from 1904 to 1914. In the winter of 1914, he returned to Munich where he remained (except for summer vacations elsewhere in Europe) until his 1930 trip to America.

Both Hofmann's age and experience and his firsthand knowledge of the French and German vanguard set him apart from the younger American painters. Hofmann studied art at the Ecole de la Grande Chaumière in Paris in 1904, when Matisse was also studying at this school. He became a close friend of Robert Delaunay and met Picasso and Braque. During World War I, he opened his own art school in Munich. In the United States he would continue to run an art school; his first school in New York opened in 1933 on Madison Avenue. Thus from 1915 until 1937, when he finally began to spend more time painting, Hofmann's energies were largely directed toward his teaching. In this sense, he was late to reach artistic maturity and he did not deal conclusively with certain early influences until the 1940s. Fortunately he lived until the age of eighty-six, and he had time to take in his early influences and to synthesize his own unique style.

Hofmann's years in Munich devoted to teaching were also spent, as he described it, trying to "sweat Cubism out."[2] As Hofmann began to concentrate on developing his own style of painting in the late 1930s, he must have considered other modes of early modern painting outside the Parisian styles. This meant a reconsideration of German Expressionism and Russian avant-garde art.

Hofmann was never deeply interested in the Dada or Surrealist movements which became important after 1915, when he had moved from Paris to Munich

72 Hans Hofmann
Spring, 1940
Oil on wood, 11¼ x 14⅛ inches
The Museum of Modern Art, New York;
Gift of Mr. and Mrs. Peter A. Rübel, 1968

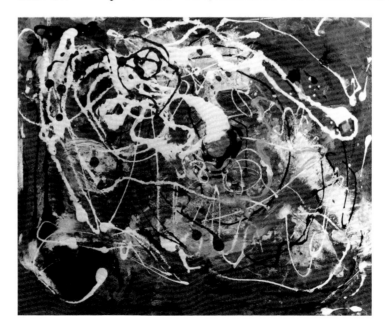

78

73 Hans Hofmann in his studio, probably early 1940s

and opened his art school. In New York, however, in the early 1940s, Hofmann was surely aware of the Surrealists' idea of automatism. As he had his first one-artist exhibition in New York at Peggy Guggenheim's Art of This Century in 1944, he certainly had opportunities to become familiar with the art of the Surrealist emigrés.[3] Nevertheless, it was in Kandinsky, whom he once called an "anti-plastic" painter, that Hofmann found a basis for his own freedom of execution and flowing color. Hofmann always maintained that his art was based on nature, which he called the stimulus to create "in the sense of enlivenment and profound visual experience."[4] In this sense Hofmann's abstractions are like Kandinsky's abstract Improvisations—based on nature.

By the early 1940s, Hofmann's still lifes, landscapes, and figure paintings had become increasingly abstract. In 1940 Hofmann painted *Spring* (fig. 72), which reveals a striking degree of freedom both of conception and of execution. Here Hofmann looked back to Kandinsky's early Improvisations. One may compare, for instance, Hofmann's *Spring* to Kandinsky's *Improvisation No. 35*, 1914 (Kunstmuseum, Basel). In both works one finds fluid areas of color with swirling lines clearly superimposed upon those areas. Hofmann's technique was to let the paint drip and run, however, while Kandinsky intentionally exercised more control. Hofmann also eliminated much of the depth one senses in Kandinsky in favor of paint floating in layers on the surface plane. In this sense,

Hofmann achieved what Pollock would soon accomplish in a much larger format. In the early 1940s, Hofmann's pictures were easel paintings on wood, but Pollock's works of the later 1940s were executed on unstretched canvas rolled across the floor. Hofmann was closer in his concept to what Kandinsky was painting, while Pollock actually became the center of his own gestural activity in his "action painting." Hofmann continued to loosen up with works such as *Fantasia*, 1943, *Effervescence*, 1944, and *Cataclysm*, 1945 (fig. 74).

Hofmann's interest in the biomorphic shapes of both Miró and Arp is manifested in paintings such as *Bacchanale*, 1946 (fig. 75), and *Ecstasy*, 1947

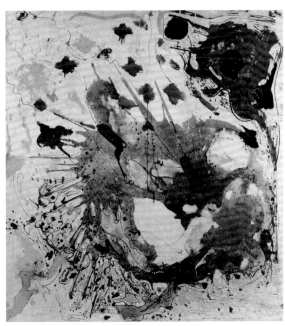

74 Hans Hofmann
Cataclysm (Homage to Howard Putzel),
1945
Watercolor on gesso, cardboard panel,
51¾ x 48 inches
Andre Emmerich Gallery, New York, and
the Estate of Hans Hofmann

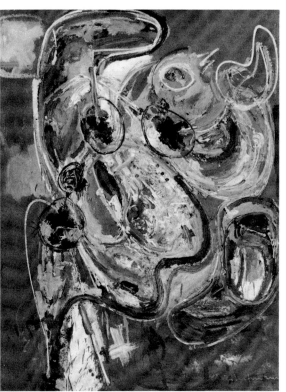

75 Hans Hofmann
Bacchanale, 1946
Oil on board, 64 x 48 inches
Andre Emmerich Gallery, New York, and
the Estate of Hans Hofmann

(fig. 76). Hofmann's tastes are indicated by his collection which included a Miró painting, an Arp bronze sculpture, and an oil and a watercolor by Kandinsky.[5] In 1942, Hofmann titled one of his pictures *The Painter with Miro Painting*; in his records he noted the importance of this work, reflecting his admiration for that artist.

The forties were years of experimentation for Hofmann. He produced uncharacteristic but important works such as *Palimpsest*, 1946 (fig. 4), which has linear drawing superimposed on a splattered canvas. The title *Palimpsest* was logically chosen, for according to *Webster's Third New International Dictionary* the word means "a parchment, tablet, . . . that has been used twice or three times after the earlier writing has been erased." This painting projects a sense of mystery, of concealed thoughts and images, and is reminiscent of Surrealist fantasies. In its automatism and doodling, it shows Hofmann's interest in Miró. As in Miró's *The Hunter (Catalan Landscape)* (fig. 15), Hofmann's forms are biomorphic and linear, with emphasis on eye shapes.

Hofmann's *Mirage*, 1946 (fig. 31), is an experiment in another direction. It reflects the geometry of Kandinsky's Bauhaus paintings of the twenties, which Hofmann had no doubt seen in the Kandinsky memorial retrospective at the Museum of Non-Objective Painting the previous year. The intersecting of transparent rectangles and triangles in *Mirage* is similar to that seen in works by

80

Kandinsky such as *Lighter*, 1926 (fig. 25).

Hofmann's roots, both personal and aesthetic, were in Europe, but the flowering of his art was on American soil. His greatest achievements as an artist were in the context of American painting, though as a teacher he represented the link to European modernism for many of his students. His mature painting was nourished by the same sources and events that prompted his younger American contemporaries to produce such radically new work as to deserve the new appellation Abstract Expressionism.

GL

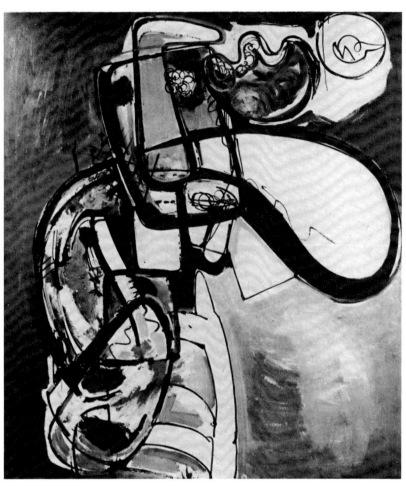

76 Hans Hofmann
Ecstasy, 1947
Oil on canvas, 68 x 60 inches
University Art Museum, University of
California, Berkeley; Gift of the artist

1 For a detailed chronology of Hofmann's life, see that compiled by Cynthia Goodman in Walter Darby Bannard, *Hans Hofmann: A Retrospective Exhibition* (Houston: The Museum of Fine Arts, 1976), pp. 105-108.
2 Clement Greenberg, *Hofmann* (Paris: Editions Georges Fall, 1961), p. 12.
3 Lee Krasner, who studied with Hofmann during 1937-40, introduced him to Jackson Pollock in 1942. They later encouraged him to show his work and thus his first exhibition in New York was at Art of This Century where Pollock showed. Contrary to published information, Pollock never studied with Hofmann.
4 William C. Seitz, *Hans Hofmann* (New York: The Museum of Modern Art, 1963), p. 14.
5 Cynthia Goodman, who is writing a catalogue raisonné of Hofmann's work, generously provided this information on his collection based on her conversations with Fritz Bultman.

Lee Krasner (b. 1908)

77 Lee Krasner
14th Street, c. 1934
Oil on canvas, 25¾ x 21¾ inches
Collection of the artist

Lee Krasner's independent development as one of the Abstract Expressionists has been obscured by her close association and her marriage to Jackson Pollock. She has described her reaction on her first visit to his studio in late 1941, as "the same sort of thing that I responded to in Matisse, in Picasso, in Mondrian."[1] Yet by this time her own art had passed through several distinctive styles which, in retrospect, demonstrate her individuality and artistic integrity apart from any later influence Pollock may have had on the evolution of her work.

Krasner's beginnings were quite traditional: the Women's Art School of Cooper Union where from 1926 to 1929 she drew from antique casts and from life, and the National Academy of Design from 1929 to 1932 where she studied with traditionalists like Leon Kroll and continued her life classes. In 1929, she, like so many others, was profoundly moved by her first visits to the newly opened Museum of Modern Art where she first experienced the work of Matisse and Picasso.

The evolution of her work in the 1930s was dramatic. Her *14th Street*, about 1934 (fig. 77), realistically depicts a rooftop view—a theme reminiscent of Edward Hopper's work of this time. She paid careful attention here to both detail and texture as well as to the overall design. Her somewhat simplified *Gansevoort 1*, about 1934 (fig. 78), a scene of the waterfront, indicates her initial attempts at the selective omission of the unnecessary. The next change of direction was more radical—the shift was to the Surrealists' world of fantasy. *Gansevoort 2*, about 1935 (fig. 79), reveals her familiarity with the work of Giorgio de Chirico. The dramatically illuminated sky, the deserted enigmatic space, the massive architecture, and even the angular forms of the masts recall his work, while the shadowy biomorphic form in the right foreground is reminiscent of Arp's or Miró's work. Although both Krasner and Pollock were later interested in Surrealist automatism and experimented with writing automatic poetry with Baziotes, Motherwell, and their wives in 1942,[2]

78 Lee Krasner
Gansevoort 1, c. 1934
Oil on canvas, 19¾ x 24¾ inches
Collection of the artist

79 Lee Krasner
Gansevoort II, c. 1935
Oil on canvas, 25 x 27 inches
Collection of the artist

80 Lee Krasner, c. 1940

81 Collage executed for a window display project for the War Services Division of the WPA. Photo, collection of Lee Krasner

Krasner pursued Surrealist imagery in a direct way as early as 1935.

Krasner's important involvement with the New Deal art projects began in 1934 when she worked from January through March as an artist on the Public Works of Art Project. By 1942, she was in charge of the window display project for the War Services Division of the WPA. That summer through the following October, Pollock was one of the eight artists assigned to her project.[3] Under her direction, the project produced some remarkable collages which were photographed and enlarged for window displays to advertise war effort courses being given at municipal New York City colleges (fig. 81). The surprising inclusion of abstract panels in several of these displays is consistent with Krasner's own work of the late thirties and also her signing of a petition to President Roosevelt during May of 1942 in which she protested the deterioration of creative activity on the WPA Easel Project in New York.[4] This project, more than most of the mural assignments, had provided abstract artists with a greater degree of freedom for creative expression.

The friendship between Krasner and Pollock began in late 1941. They had both been selected by John Graham to participate in the exhibition "American and French Paintings" held at the McMillen Gallery, 20 January-6 February 1942.[5] Krasner's entry, an untitled painting of 1941 (fig. 82), indicated her

deep interest in Picasso which undoubtedly appealed to Graham. Her adaptation of Picasso's style is similar to that by Willem de Kooning or Arshile Gorky of several years earlier; she had been acquainted with both artists since the mid-thirties.[6]

The abstractions she produced in 1938 as a result of her interest in Matisse's use of color are outstanding (figs. 5, 85). She had become deeply involved with the art of both Matisse and Picasso during her study with Hans Hofmann from 1937 to 1940. Recalling her early days at the Hofmann school, Krasner remarked that since she could not understand Hofmann's heavy German accent, what she really heard was the class monitor George McNeil's interpretation of what her teacher said.[7] Working from still lifes set up in the classroom, she painted vividly colored lyrical abstractions which manifest a remarkable vigor and belie their execution in a classroom. In several of these, all recognizable references to the object have disappeared, resulting in pure abstraction.

During 1943-45, as a result of her closeness to Pollock, Krasner sought a new way of painting that would express her own inner self. She struggled at "trying to lose cubism," and in her search she produced only thick gray slabs.[8] Just after their marriage in October of 1945, Krasner and Pollock moved to The Springs, East Hampton, where she evolved her series known as the Little Images. One of the first of the Little Images, *Noon*, 1946 (fig. 32), is vibrant with its bright color and rich thick surface. With this manifestation of an all-over impasto surface applied in such an energetic manner, Krasner comes closest to Pollock's painting, specifically in his work of 1946 such as *Shimmering Image* (fig. 112). She continued, however, to make the Little Images her own idiom. *Untitled*, 1946 (fig. 84), indicates her delicate lyrical sensibility by its sensuous pastel color and linear pattern. Although she had had a great deal of experience working on large scale WPA murals, Krasner intentionally kept her paintings small during the mid-1940s. An exception is her dramatic

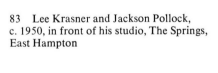

82 Lee Krasner
Untitled, 1941
Oil on canvas
Work lost; photo, collection of the artist

83 Lee Krasner and Jackson Pollock,
c. 1950, in front of his studio, The Springs,
East Hampton

84 Lee Krasner
Untitled, 1946
Oil on linen, 27¾ x 30 inches
Collection of the artist

85 Lee Krasner
Untitled, 1938
Oil on paper, 19 x 24¾ inches
Collection of the artist

Continuum, 1949 (figs. 86, 87), but this painting requires the same close viewing as the small works in order to convey its full calligraphic complexity. The elegant intimacy of Krasner's paintings of the mid-1940s is perhaps linked to her fascination with Irish and Persian illuminated manuscripts. Additionally, her childhood study of Hebrew introduced her to the interesting forms of those curvilinear letters. As the Little Image series progressed, Krasner's colors darkened and her focus then shifted to a kind of hieroglyphic form.

While these later paintings appear more controlled, their impact is projected through a persistent repetition of form. Krasner's work of the mid-forties, characterized by pure abstraction with a painterly intensity, merits a place for her among the pioneers of Abstract Expressionism.

GL

86 Lee Krasner
Continuum (detail), 1949
Oil and enamel on canvas, 54⅛ x 43⅞
inches
Collection of Alfonso A. Ossorio

1 Cindy Nemser, "The Indomitable Lee Krasner," *The Feminist Journal* 4 (Spring 1975): 6.
2 Francis V. O'Connor, *Jackson Pollock* (New York: The Museum of Modern Art, 1967), p. 26.
3 Letter of 1 October 1942 from Pearl Bernstein, Administrator, Board of Higher Education, to Audrey McMahon, General Supervisor, City War Services Project, lists Lenore Krassner as having had "charge of the project" and the following artists on the project: "Miss Ray Klein, Mr. Xceron, Mr. Jackson Pollock, Mr. Frederick Hauck, Mr. Ben Benn, Mr. Agostino, Mr. Greco, Mr. Truback."
4 O'Connor, *Pollock*, p. 26.
5 They had actually met briefly in 1936 at a loft party but Lee Krasner did not recognize his name when she learned that he was also included in the exhibition at the McMillen Gallery. She still has a postcard from Graham postmarked 19 November 1941 inviting her to participate in this exhibition.
6 In August 1977, in an interview with Levin and Hobbs, Krasner recalled sitting around Gorky's table at the Jumble Shop, a bar on Macdougal Alley during the mid-1930s.
7 Krasner, interview with Levin, 6 February 1971.
8 Krasner, interview with Levin and Hobbs, August 1977. Krasner still has one of these "gray slab" paintings.

87 Lee Krasner
Continuum, 1949
Oil and enamel on canvas, 54⅛ x 43⅞
inches
Collection of Alfonso A. Ossorio

Robert Motherwell (b. 1915)

88 Pablo Picasso
Woman in an Armchair, 1938
Ink and crayon on paper,
25½ x 19¾ inches
Formerly collection of Mrs. Meric Callery

89 Robert Motherwell
Untitled, 1944
Ink and wash on paper, 24 x 18⅛ inches
Private collection

In Robert Motherwell's art there is a certain hermeticism that can be interpreted if one looks for the proper key. An important one for many of his works of the forties is a Picasso drawing of 1938, *Woman in an Armchair* (fig. 88), which served as a basis for an untitled drawing of 1944 (fig. 89).[1] Although Motherwell creates a more abstract variation on Picasso's work, he retains important elements: the figure remains female, her left arm holding a dagger has been reduced to a triangular shape that incorporates both arm and weapon, and the entangled web in the background still surrounds the figure.

Even before Motherwell made a variation of this particular Picasso drawing, he was attracted to similar stylistic elements. His early collage *Joy of Living* (fig. 93), which repeats a title important to Matisse, contains in the right-hand side a suggestion of weblike spaces similar to those in the Picasso. Also, the automatist blob in the center with a triangular shape piercing it parallels, in a more abstract form and with more violence, the woman holding a knife in Picasso's drawing. That this work is concerned ironically with violence rather than joy is indicated in the portion of a military map of First Infantry Woods and Savage Hill. Situated in the upper right, the map serves metaphorically as the locus of a campaign, a campaign that Motherwell has poetically described on many occasions as the Abstract Expressionists' assault

90 Robert Motherwell, c. 1943, in his studio

91 Max Ernst and Robert Motherwell,
1944, playing chess in Amagansett,
Long Island

on their own internal Troy in an effort to win back their Helens and return to their homeland.[2] In this metaphor he is referring, of course, to the Abstract Expressionists' attempt to move beyond their own rationality in order to come to terms with their internal muse.

When he described this attempt to exceed the constraints of consciousness, "plastic automatism" (which is usually termed psychic automatism), Motherwell stressed that this process did not involve losing control so that the artist is simply an automaton who acts on directives from within.[3] He emphasized that while this process helps one to get beyond the tight reins of the

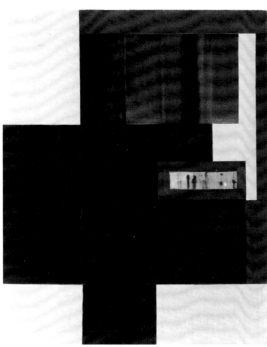

92 Robert Motherwell
Recuerdo de Coyoacan (Memory of Coyoacan), 1941
Oil on canvas, 42 x 34 inches
Collection of the artist

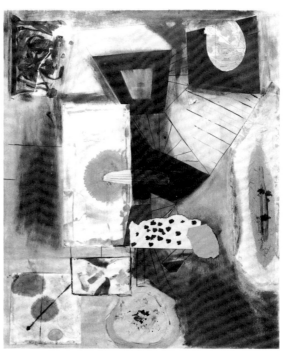

93 Robert Motherwell
Joy of Living, 1943
Collage (ink, tempera, crayon, construction paper, mulberry paper, and map on cardboard), 43½ x 33⅝ inches
The Baltimore Museum of Art;
Saidie A. May Collection

rational mind and set traps for apprehending elements from the preconscious, it is essentially a formal method for enlarging the small repertoire of shapes employed by many artists. In his paintings and collages, however, Motherwell's brand of psychic automatism was more fecund than he realized and led to a symbolization of suppressed ideas. Because these elements were immediately manifested in an abstract format, their symbolic ramifications have often eluded him. Perhaps he realized this, for he has often spoken of taking his work on the faith that it does have significance.[4]

A return to the Picasso drawing and its parallels with Motherwell's work of the forties illuminates some psychological aspects of his imagery. As we have seen, the web occurs in *Joy of Living*. It recurs in the form of bars in *Spanish Prison* (fig. 94) where a partially disembodied figure with a round orb for a head and a triangle for a torso approximates salient elements in Picasso's drawing. At this point, it should be emphasized, Motherwell made over in his own image aspects of the Picasso drawing to free himself of Picasso though not of the painful associations engendered by the subject matter of the drawing.

A painting integrally involved with the iconography of *Spanish Prison* is *Personage*, 1943 (fig. 95), which contains a coffin superimposed over a window. Defined with heavy dark lines, the coffin was inspired by Mexican

90

ones in Posada's prints[5] and reappears in many works, notably *Pancho Villa, Dead and Alive*, 1943. In the majority of his early works, Motherwell's internal sphere appears to have been a virtual chamber of horrors, which he appropriately titled in a drawing of the early forties *Kafka's Room*. When openings occur in the paintings, they are often covered with webs or bars. Or, in *Personage* for example, the window superimposed with a casket suggests that the opening from this rigidly two-dimensional realm is death. Life, then, in Motherwell's art is symbolized in brutal terms; any escape from it, any retreat from the affirmedly two-dimensional surface is construed as death or imprisonment.

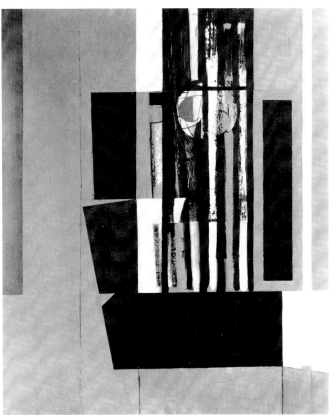

94 Robert Motherwell
Spanish Prison, 1943-44
Oil on canvas, 52 x 42½ inches
Collection of Mrs. H. Gates Lloyd

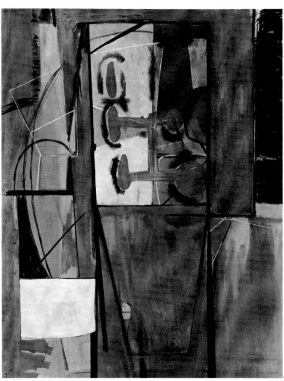

95 Robert Motherwell
Personage, 1943
Oil on canvas, 48 x 38 inches
Norton Gallery and School of Art,
West Palm Beach, Florida

In the later forties, Motherwell created several towering descendants of the figure in the Picasso drawing. *In Grey with Parasol* (fig. 96) is an abstract personage, most likely feminine, that continues the triangle of the skirt in Picasso's work as well as the hat, which is transformed into a parasol—indicated in the collage with a piece of artificial alligator skin. And the hat turned into an imposing headdress appears in *Emperor of China*, 1947 (fig. 33), and *The Homely Protestant (Bust)*, 1947-48 (fig. 98), as a symbol of authority.

In *The Homely Protestant (Bust)* the figure presides in a cave world. As with a great deal of Abstract Expressionist painting of the forties, this one is both evocative and foreboding. The figure, which is hieratical and at the same time almost chimerical so closely does it blend into the background, resembles one of Edgar Allan Poe's fancies, his intuitive meanderings that are largely unarticulated because they would lose their poetic evocativeness. They, like the material gleaned from the fringes of the unconscious, can only be approached indirectly. The situation is akin to the fairy tale about the emperor of China who was never to be looked at directly. One made a deep obeisance in his presence, bowing so low that one did not see him. And so the conception one had of the emperor was largely subjective, having more to do with the power he wielded than with the personage himself. This analogy is especially apt when one

considers that Motherwell's painting *Emperor of China* prefigures *The Homely Protestant (Bust).*[6]

Forcing himself to incorporate the elements of chance even to choosing the title of this painting, Motherwell opened a volume of either James Joyce's *Finnegans Wake* or *Ulysses*, both masterpieces of the free associational technique, and, without looking, put his finger on a page. The phrase beneath his finger was "the homely Protestant."[7]

When asked who the homely Protestant is, Motherwell has responded that it is a self-portrait.[8] Of this painting he has said that it is concerned with the

96 Robert Motherwell
In Grey with Parasol, 1947
Collage and oil on board,
47½ x 36½ inches
Art Gallery of Ontario; Gift from the
Women's Committee Fund, 1962

97 Jackson Pollock
Untitled, c. 1943
Ink and gouache on paper, 12½ x 13 inches
Collection of Mr. and Mrs. B. H. Friedman

essential loneliness that he feels from time to time.[9] In light of their development from the Picasso drawing, both *The Homely Protestant (Bust)* and *Emperor of China* have important psychological reverberations. They are transpositions of a dominant self-destructive female figure into a male authoritative figure. On the psychological level these paintings may reflect the change from an external dominant mother figure into an internalized, self-generated parallel. When one considers that the phallic-dagger in the Picasso drawing is transformed into a red emblem (scepter?) superimposed over the figure of *The Homely Protestant (Bust)*, this hypothesis gains some credence. An untitled drawing by Jackson Pollock (fig. 97) incorporates an iconography similar to Motherwell's stick figures of the forties. In this drawing a female figure, which is a variation on the mother and dead child in the left-hand side of *Guernica*, pulls out a phalliclike dagger dripping with blood that is emphasized in this drawing by red pigment. One wonders if Pollock, who suffered from a dominating mother as did Motherwell, was indirectly symbolizing a suppressed wish by having the female figure immolate herself?[10] Moreover, one wonders with reason if Motherwell, whose name was considered too Freudian by the Surrealists, transformed the self-destructive female of Picasso's drawing into a male symbolic self-portrait in *The Homely Protestant (Bust)*, especially since he was, in the forties, well read in

Freud and would have been open, even subliminally, to Freudian structures when he used psychic automatist methods.

RCH

98 Robert Motherwell
The Homely Protestant (Bust), 1947-48
Oil on canvas, 30 x 24 inches
Collection of the artist

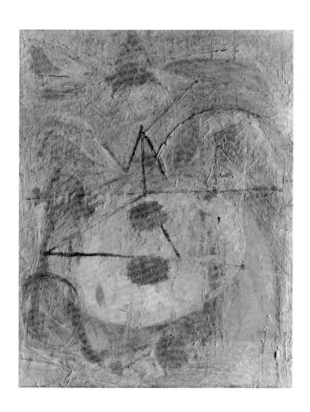

1 E. A. Carmean, Jr., *The Collages of Robert Motherwell: A Retrospective Exhibition* (exhibition catalogue, The Museum of Fine Arts, Houston, 15 November 1972-14 January 1973), pp. 15-17. On p. 41 Carmean notes, "Picasso made a number of drawings similar to this one in 1938. Motherwell has confirmed that the [Saidenberg] Gallery drawing was the source for his own *Untitled*. Letter to the author, dated July 27, 1971."
2 Motherwell, conversation with Hobbs. The analogy has cropped up too many times to give a strict accounting of its occurrence.
3 Max Kozloff, "An Interview with Robert Motherwell: 'How I admire my colleagues," *Artforum* 4 (September 1965): 34. Motherwell, "The Significance of Miró," *Art News* 58 (May 1959): 66.

4 This idea was perhaps reinforced by Motherwell's reading of Kierkegaard. Many times he has quoted the following statement by this Danish philosopher: "If anything in the world can teach a man to venture, it is the ethical, which teaches him to venture everything for nothing. . . ."
5 Motherwell, conversation with Hobbs, Greenwich, Conn., 15 April 1975.
6 Paul Goodman, "The Emperor of China," [October 1945], *Possibilities 1*, eds. Robert Motherwell, Harold Rosenberg, Pierre Chareau, and John Cage (New York: Wittenborn, Schultz, 1947), pp. 7-15. A source for the title of *Emperor of China* is a strangely hallucinatory, almost surrealist piece of the same title written by Paul Goodman and published in *Possibilities 1*. In this prose poem the emperor is described as a small man with an ocherous complexion, who dreams of immortality.

7 Robert Motherwell, notes in H. H. Arnason, *Robert Motherwell* (New York: Harry N. Abrams, 1977), p. [103]. *The Homely Protestant (Bust)* is the first in a series of figure paintings that include two other *Homely Protestants*, one in the collection of the artist on extended loan to the Metropolitan Museum of Art, New York, and the other in the collection of Mr. and Mrs. John Murray Cuddihy, New York.
8 Ibid.
9 Motherwell, conversation with Hobbs, Greenwich, Conn., March 1976.
10 This image recurs in the early fifties, albeit in a more abstract form, in *Echo* (*Number 25*, 1951) and in the left-hand section of *Portrait and Dream*, 1953. This reapperance of a motif after a period of eight years indicates its pervasive importance to Pollock.

Barnett Newman (1905-1970)

The complete story of Barnett Newman's early development is obscured by the fact that he destroyed all of his work done before 1944. He began to study art at the Metropolitan Museum during his high school days, and in 1922 during his senior year he enrolled in a class in antique drawing at the Art Students League taught by Duncan Smith. He continued to study there while attending the City College of New York.[1] At the League, he became close friends with another student, Adolph Gottlieb. After his graduation from college in 1927, Newman joined his father's clothing manufacturing firm with the understanding that in two years he could accumulate an income that would enable to him to be an artist. With the stock market crash in 1929, he returned to the Art Students League where he studied with Harry Wickey and John Sloan. During the thirties, he worked as a substitute art teacher in the city high schools.

By the early forties Newman was intensely interested in the study of botany, ornithology, and geology. In 1941, he went with his wife, Annalee, to Ithaca, New York, to study ornithology in the summer session at Cornell University (fig. 100). He pursued this interest the next several summers (fig. 101). He was a serious student of birds and nature, and this devotion later manifested itself in his earliest surviving crayon drawings of 1944-45.[2] He had evidently stopped making pictures around 1939-40 while he was struggling to find a new way of painting. Perhaps he was only half kidding when, in 1952, he criticized philosopher Suzanne Langer's discussion of the symbolic nature of art with the now famous rejoinder: "Esthetics is for artists as ornithology is for the birds."[3]

The crayon drawings are abstract with only resemblances to flora and fauna (fig. 99). Their lively colors and lyrical forms hint that Newman had been looking with interest at Kandinsky's early Improvisations at the Museum of Non-Objective Painting. This art may have seemed reasonably viable to him at a time when he was considering American Regionalist art narrow and isolationist.[4] On the other hand, Kandinsky's work, particularly the more recent geometric abstractions, must have seemed to Newman to have important limitations, chiefly

99 Barnett Newman
Untitled, c. 1944-45
Crayon on paper, 15 x 20 inches
Collection of Annalee Newman

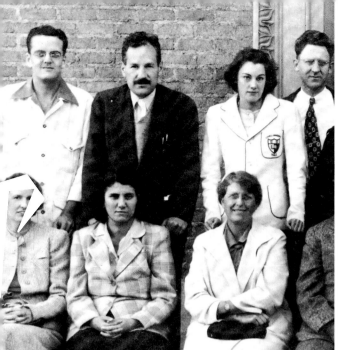

100 Barnett and Annalee Newman
(second from the left) in an ornithology
class at the Cornell University summer
session, Ithaca, New York, 1941

101 Barnett and Annalee Newman, 1942,
birdwatching in Rockport, Massachusetts

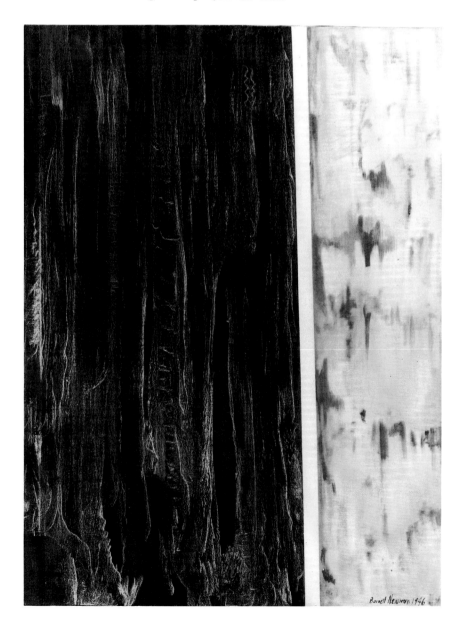

102 Barnett Newman
The Command, 1946
Oil on canvas, 48 x 36 inches
Collection of Annalee Newman

an absence of necessary meaning. Newman wrote, about 1943-45, in an essay entitled "The Plasmic Image":

The painter of the new movement clearly understands the separation between abstraction and the art of the abstract. He is therefore not concerned with geometric forms per se but in creating forms which by their abstract nature carry some abstract intellectual content.[5]

The need for a viable subject matter, distinct from the outdated "dream world" of the Surrealists was essential to Newman's concept of his art.

Newman's crayon drawings of the mid-1940s appear to be based on images

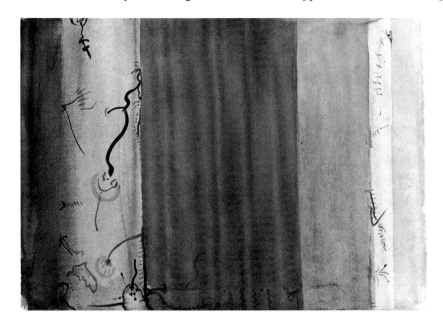

of seeds sprouting and growing and parts of fantastic birds. The bright coloring conveys a sense of nature exploding in springtime fertility. Several of these crayon drawings have backgrounds textured with rubbed chalk, somewhat reminiscent of Max Ernst's technique of frottage. A similar textural quality is also evident along the left side of Newman's painting *The Command*, 1946 (fig. 102).[6] Newman, like his friends Rothko, Gottlieb, and Stamos, was interested in mythology, and he gave several of his drawings of 1945 mythological titles: *The Song of Orpheus* (fig. 19), *The Slaying of Osiris*, and *Gea*.

About 1945, Newman also did some untitled abstract watercolors which are delicate and lyrical in their color and images (fig. 103). Although the vertical band motifs seem to predict his later compositions, it is possible that they were originally conceived as seed and growth motifs and that we are now seeing them sideways. An untitled oil painting of 1945 (fig. 34) is also related to the image of growth with its sprouting or exploding ball of line that appears on the right side of the picture. The left side of the composition is textured with red over blue, recalling the rough surface of tree bark, and is emphatically separated from the pale right side by a crisp bent vertical which might relate to a root form.

By 1946, Newman's art indicates that he seems to have been influenced by the biomorphic imagery and by the automatic gestural technique of the Surrealists. He also shared their interest in primitive art. His *Pagan Void*, 1946 (fig. 3), has been interpreted as a commentary on "contentless Mohammedan abstract art,"[7] but it might also refer to the absence of spirituality before the creation of man, particularly since Newman was painting other works with religious themes like *The Command* (Let there be light) and *Genesis—The Break* in the same year.

By 1947, the promise of Newman's most individual creations was now implicit in works like *Death of Euclid* and *Euclidian Abyss* (fig. 104). Although small in scale, both of these pictures give some indication of his mature art's concern with the sublime.

Newman's importance during the formative years of Abstract Expressionism extended beyond his painting. He did not exhibit his art until December 1946 at the Betty Parsons Gallery where in January 1947 he organized a show called "The Ideographic Picture," which included two examples of his own work. His presence was already felt, however, through his essays for exhibition catalogues and other writing and through his friendships.[8] Newman's abstractions would develop an emphasis on scale and on the color that would particularly distinguish his work in the context of Abstract Expressionism.

GL

104 Barnett Newman
Euclidian Abyss, 1946-47
Oil and gouache on canvas board,
28 x 22 inches
Collection of Mr. and Mrs. Burton Tremaine

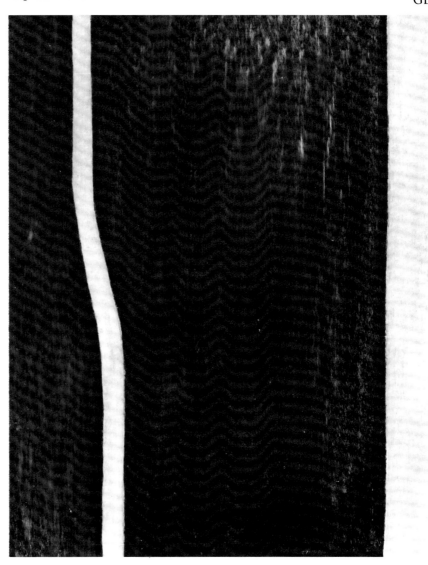

1 Chronological facts cited here are provided by Annalee Newman or are from Thomas B. Hess, *Barnett Newman* (New York: The Museum of Modern Art, 1971). This book also includes an extensive bibliography of Newman's own writings and those of his work.
2 Annalee Newman, interviews with Gail Levin, September 1977. Newman also studied at the Brooklyn Botanical Garden.
3 Hess, *Newman*, p. 26.
4 Ibid., pp. 34-37, reprints Newman's unfinished essay, "What about Isolationist Art?" (1942).
5 Ibid., pp. 37-38.
6 William S. Rubin wrote in *Dada, Surrealism, and Their Heritage* (New York:

The Museum of Modern Art, 1968), p. 180: *In its surrealizing phase of the early and mid-forties, American painting often exploited biomorphism. . . . The biomorphism of Barnett Newman's* Pagan Void *was exceptional in his imagery, which, in such visionary pictures as* Genetic Moment, *suggested distant affinities with Ernst's wood—frottage "Forests."*
In a letter of 28 May 1968 to Rubin (carbon copy, collection of Annalee Newman), Newman objected to "the distant affinities" Rubin cited between his and Max Ernst's art: *There are no rubbings in my paintings. Those falling forms are not the result of accidental rubbings. I created each shape. They do not have anything to do with the accident of frottage. Neither is there any*

connection with Max Ernst regarding line, color, form, shape, subject, schema, topology or even "milieu."
7 Hess, *Newman*, p. 52.
8 Newman wrote essays for exhibitions, such as some at the Wakefield Gallery, New York, where he worked with Betty Parsons: "Adolph Gottlieb," 7-19 February 1944, and "Pre-Columbian Stone Sculpture," 16 May-5 June 1944. He also wrote the introduction to the catalogue for "The Ideographic Picture," Betty Parsons Gallery, New York, 20 January-8 February 1947, and for the Theodoros Stamos exhibition there, 10 February-1 March 1947. Newman also wrote for *Tiger's Eye*, 1947-49.

Jackson Pollock (1912-1956)

105 Jackson Pollock
Going West, c. 1934-35
Oil on fiberboard, 15⅛ x 20⅞ inches
National Collection of Fine Arts,
Smithsonian Institution, Washington, D.C.;
Gift of Thomas Hart Benton

106 Jackson Pollock
Moon Woman Cuts the Circle, 1943
Oil on canvas, 43 x 41 inches
Marlborough Gallery, New York

Close examination of Jackson Pollock's early works suggests that the young artist was just as much of an eclectic as Arshile Gorky. Pollock's eclecticism, however, is usually less obvious, for he always translated the borrowed vocabulary into his own very personal idiom. Pollock's style of the early 1940s is consistently rough; rather than attempting a more exacting copy relationship of the artists he emulated, Pollock simply borrowed their forms and radically reassembled them in a new manner.

One formative influence on the young Pollock was certainly his teacher Thomas Hart Benton with whom he studied at the Art Students League from September 1930, just after he moved to New York City from his family home in Los Angeles, until December 1932, when Benton temporarily left New York to do a mural commission in Indiana. In 1930, Pollock posed for Benton who was then at work on the murals for the New School for Social Research. Their friendship and Benton's encouragement of his student continued, however, with Benton's return to New York from autumn 1933 to the spring of 1935, and through correspondence and visits by Pollock to Benton's summer home on Martha's Vineyard and once to Kansas City at Christmastime in 1937.[1] Pollock's interest in Benton's style and Regionalist subjects is apparent in his own works of the thirties such as *Going West,* about 1934-35 (fig. 105), once owned by Benton.

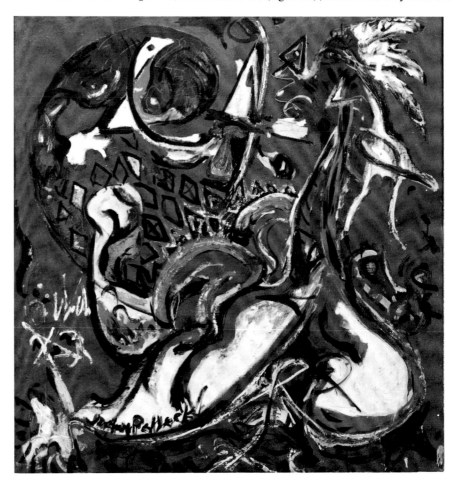

107 Jackson Pollock, c. 1943, in front of
mural commissioned by Peggy Guggenheim
for her apartment, now at the School of
Art, University of Iowa, Iowa City

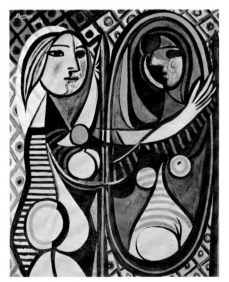

108 Pablo Picasso
Girl Before a Mirror, 1932
Oil on canvas, 64 x 51¼ inches
The Museum of Modern Art, New York;
Gift of Mrs. Simon Guggenheim

In it Pollock exaggerated Benton's baroque rhythms with which he was so familiar. The chiaroscuro effect in *Going West* suggests Pollock's admiration also for the work of Albert P. Ryder.

Like Gorky, de Kooning, and Krasner, Pollock explored the possibilities inherent in Picasso's painting, yet he did so with a crude intensity not apparent in those artists' early work. *Moon Woman Cuts the Circle*, 1943 (fig. 106), reveals Pollock's careful study of Picasso's *Girl Before a Mirror*, 1932 (fig. 108).[2] Pollock appropriated Picasso's forms, while rotating the strict vertical axes into a near circular arrangement of forms which seem to float together on the surface of his painting. Although Pollock's forms do not have the clear, precise delineation of Picasso's composition, one can find many instances of Picasso's shapes directly transposed by Pollock. Immediately apparent are the diamond shapes of Picasso's background, which reappear in the upper left of Pollock's painting. Jumbled traces of Picasso's girl and her reflection are evident in Pollock's moon woman; the lower part of the painting contains similar white abdominal shapes while a striped torso is evident on the right side of Pollock's painting. Just above the striped torso, Pollock painted a profile head complete with two eyes, one above the other. To the right of the head is a white featherlike cluster similar to the one found near the head of Picasso's female image on the left side. Pollock also utilized the heavy black outlines found in Picasso's *Girl Before a Mirror*. The original approach of Pollock's composition is more important than his borrowing of Picasso's forms. Almost all the forms in *Moon Woman Cuts the Circle* appear to float directly up against the picture plane rather than existing in an illusionistic space, as they do in *Girl Before a Mirror*. The blue ground in Pollock's painting actually begins to assert itself as groups of positive shapes rather than as negative space. The diamond shapes, which formed Picasso's decorative patterned background, now exist as independent, unconnected shapes floating on the same plane as some shapes and receding only slightly behind other overlapping shapes. This shallow recessional

99

space is already prophetic of Pollock's most ingenious work, the so-called drip paintings, executed four years later.[3]

Pollock stated on a questionnaire for the February 1944 issue of *Arts & Architecture*, ". . . the two artists I admire most, Picasso and Miró, are still abroad."[4] A careful study of Pollock's work of 1944-46 suggests that a year or so later he might have added the name of the recently deceased Wassily Kandinsky to his list of most admired artists.

Pollock's most intensive encounter with Kandinsky's art may have come in 1943 when he got a custodial job at the Museum of Non-Objective Painting. His

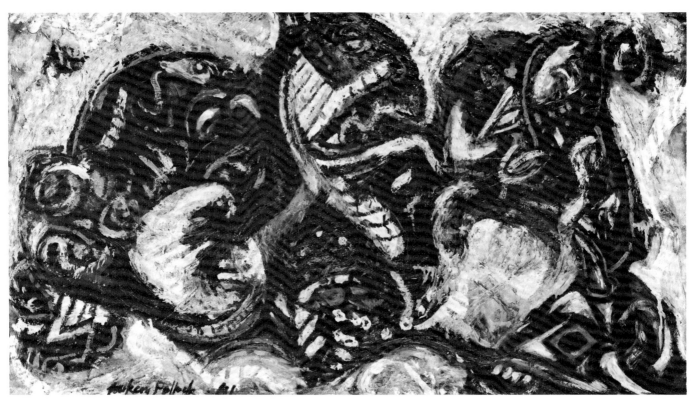

109 Jackson Pollock
Composition with Masked Forms, 1941
Oil on canvas, 27¾ x 51 inches
Collection of Mr. and Mrs. Frank
Barsalona

employment on the WPA Art Program was terminated on 29 January 1943, and beginning in May, after having decorated ties and lipstick cases for a living, he worked at the museum until mid-summer, when Peggy Guggenheim gave him a year's contract, scheduled a one-man show at her gallery, Art of This Century, and commissioned a mural for her entrance hall.[5] Pollock's duties at the museum included running the elevator and working on frames,[6] and he must have seen numerous paintings by Kandinsky there.

Pollock, "a regular museum and gallery goer,"[7] undoubtedly saw the Kandinsky memorial exhibition at the Museum of Non-Objective Painting in 1945. The catalogue of this exhibition remains at East Hampton among the books that Pollock accumulated over the years.[8] Certain of his paintings in the next year and a half clearly reveal the powerful impact of Kandinsky's work. *The Key* (fig. 35), one of Pollock's paintings from a series of 1946, is related visually to several of Kandinsky's works dating from 1924-26 when he was teaching at the Bauhaus. At least four of these paintings were in the 1945 retrospective.[9] Pollock pushed his forms very close to the picture plane; the forms are similar in shape to those in Kandinsky's paintings, but Pollock seems to have smashed them to flatness. His surface, unlike Kandinsky's, is characteristically rough. Yet Pollock's vocabulary of forms appears too closely related to Kandinsky's to be merely coincidental, indicating a personal and powerful assimilation.

Deep Brown, 1924 (fig. 110), by Kandinsky, has on the lower right side a blue jagged mountainlike form (and a white crescent with a yellow spot just below it) like that in Pollock's *The Key*; similarly, both forms are just above a

hill-like formation, blue in Kandinsky and green in Pollock. Both compositions contain red semicircles and varicolored arched lines around circles.

Kandinsky's *Lighter*, 1924 (fig. 25), is close to *The Key* in color; in both, rust orange, dark blue, yellow, and dark green predominate. Both have a central dark green triangle and heavy black lines (each has a black X) superimposed throughout. The triangle in *Lighter*, however, forms part of a three-dimensional wedge, while Pollock's large green triangle lies flat. Pollock adopted Kandinsky's use of overlapping one translucent shape onto another and blending their two colors into a third (for example, the light green intersection of a white polygon

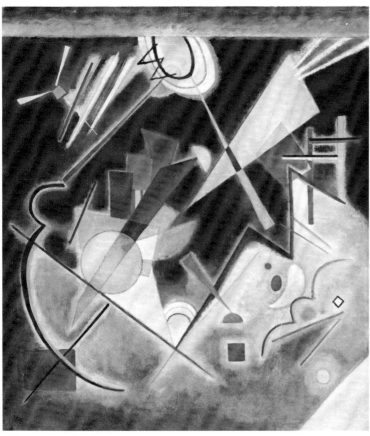

110 Wassily Kandinsky
Deep Brown, 1924
Oil on canvas, 32¾ x 28⅝ inches
The Solomon R. Guggenheim Museum,
New York

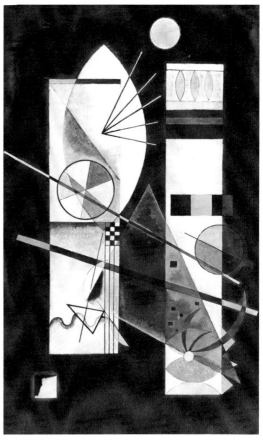

111 Wassily Kandinsky
Green Connection, 1926
Oil on canvas, 33 x 22⅛ inches
Marlborough Fine Art, Ltd., London

on the left side of the central dark green triangle in *The Key*).

Green Connection, 1926 (fig. 111), has a large dark green triangle and also the horizontal hill-like form of *The Key*. There are many mandorla-like shapes in this Kandinsky and crude approximations of them in *The Key*. A crescent form appears in both paintings—lying on a diagonal, half pink and half white.

There are similar instances of Kandinsky's influence on Pollock in still others of his works of 1944-46. To understand Pollock's most original artistic endeavors, the great "drip" paintings of the winter of 1946-47, one must first grasp the genesis of these transitional paintings, for it is from them that paintings emerged which would profoundly affect the evolution of contemporary art.

GL

101

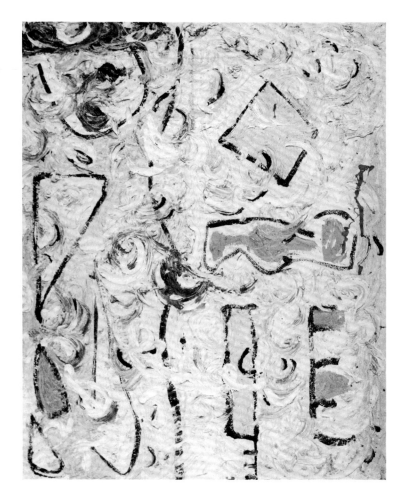

112 Jackson Pollock
Shimmering Image, 1946
Oil on canvas, 24½ x 20¼ inches
Collection of Mr. and Mrs. Stephen D.
Paine

1 The visit to Kansas City in 1937 was the last time Pollock spent time with Benton. For a complete chronology, see Francis V. O'Connor, *Jackson Pollock* (New York: The Museum of Modern Art, 1967).
2 Picasso's *Girl Before a Mirror* was acquired by the Museum of Modern Art in 1938. William Rubin has observed a similar model for Gorky's *Enigmatic Combat*, c. 1936 ("Arshile Gorky, Surrealism, and the New American Painting," *Art International* 7 [February 1963]; reprinted in Henry Geldzahler, *New York Painting and Sculpture, 1940-1970* [New York: E. P. Dutton and The Metropolitan Museum of Art, 1969], p. 379).
3 Clement Greenberg, "The Jackson Pollock Market Soars," *New York Times Magazine*, 16 April 1961, pp. 42ff. William Rubin has developed Greenberg's assertion that the shallow depth in the drip paintings is related to the Analytical Cubist paintings of Picasso and Braque before 1912 ("Jackson Pollock and the Modern Tradition: Part III," *Artforum* 5 [April 1967]: 18-31).

4 Jackson Pollock, "Answers to a Questionnaire," *Arts & Architecture* 4 (February 1944): 14; reprinted in O'Connor, *Pollock*, pp. 31-33. The questionnaire was formulated by Pollock with the assistance of Howard Putzel. To the question, "Do you find it important that many famous modern European artists are living in this country?" Pollock responded, "Yes. I accept the fact that the important painting of the last hundred years was done in France. American painters have generally missed the point of modern painting from beginning to end. (The only American master who interests me is Ryder.)"
5 O'Connor, *Pollock*, pp. 27-28.
6 Lee Krasner, interview with Gail Levin, 2 February 1971.
7 Francis V. O'Connor, "The Genesis of Jackson Pollock: 1912 to 1943," *Artforum* 5 (May 1967): 23; "Pollock . . . was also aware of the Museum of the American Indian in New York." Lee Krasner told Levin that she and Pollock saw

all the major art shows while they were living in New York City.
8 Lee Krasner generously permitted Levin to examine the books and clippings in Pollock's library. Pollock owned *In Memory of Wassily Kandinsky: A Survey of the Artist's Paintings and Writings*, ed. by Hilla Rebay (New York: Solomon R. Guggenheim Foundation, 1945).
9 In the Kandinsky memorial exhibition at the Museum of Non-Objective Painting in 1945 in New York, *Open Green* was no. 49, *Lighter* was no. 67, *Green Connection* was no. 99, and *Deep Brown* was no. 78. O'Connor (*Pollock*, p. 40) lists two series by Pollock exhibited in a one-man show, 14 January-1 February 1947. The series Sounds in the Grass included *Croaking Movement, Shimmering Substance, Eyes in the Heat, Earth Worms, The Blue Unconscious, Something of the Past*, and *The Dancers*; the series Accabonac Creek included *The Water Bull, Yellow Triangle, Bird Effort, Gray Center, The Key, Constellation, The Tea Cup*, and *Magic Light*.

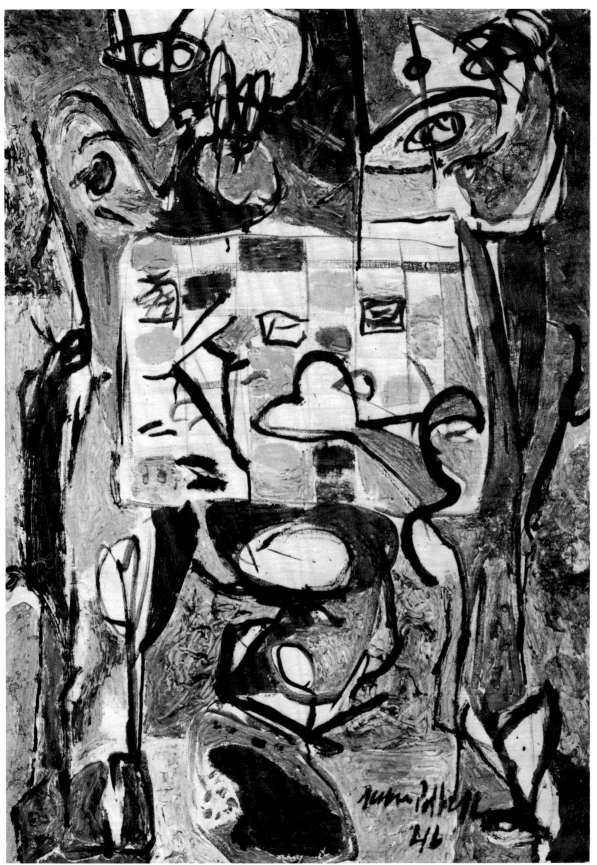

113　Jackson Pollock
Tea Cup, 1946
Oil on canvas, 40 x 28 inches
Robert Elkon Gallery, New York

Richard Pousette-Dart (b. 1916)

At an early age Richard Pousette-Dart wanted to be an artist. But it was only after his first few months in college that he decided to quit school and paint. During the late 1930s he painted at night and worked as a secretary during the day. And in 1939 he decided to give up everything but painting despite the fact that he had no possible means of income. Even though he only settled into full-time painting in 1940, he was far from being an initiate. He was fortunate in growing up in an atmosphere of artists and art, his mother being a poet and his father being Nathaniel Pousette-Dart, who was both a noted impressionist and an author who wrote about Childe Hassam, Robert Henri, and James Abbott McNeill Whistler among others. Almost by osmosis, Richard Pousette-Dart absorbed the language of painting. Today, when he states he is virtually a self-taught artist, his assertion may well be true for the technical side of painting but fails to take into consideration ideas with which he was conversant from childhood. A feeling for American impressionism and tonalism forms an important background to his art. Even in works of the forties a reluctance to freeze shapes by static contours and a feeling for crepuscular lighting is evident.

Among Abstract Expressionists' works, Pousette-Dart's are perhaps the clearest example of psychic automatist procedures. To get rid of the inhibitory whiteness of the canvas and also to prepare a surface conducive to creation, Pousette-Dart would begin with an imprimatura of spirals, lozenges, diamonds, lettering, and usually fish and flagella. For him painting is a slow process of secreting atavistic symbols on a surface that is a metaphor of being. His paintings can be compared to Freud's magic writing tablet—not the acetate shield on the surface, however, which only temporarily registers the marks of consciousness, but the wax surface beneath. A strict formalist would pronounce Pousette-Dart almost a cubist because he begins at an early stage to erect a cubist infrastructure which he overpaints, sometimes with thirty or forty layers. A comparison between *The Edge*, 1944 (fig. 115), and *Figure*, 1945 (fig. 116), indicates differences between a thinly painted cubist Pittura Metafisica in the former work with the scumbled encrustation of the latter, definitely a clearer example of this artist's early Abstract Expressionist mode. While Pousette-Dart often attains a cubist articulation of form at some stage of painting, he almost always destroys it, to create a surface of quivering indecisiveness. One might think his is a programmatic intent, except that he works intuitively to diminish the dictates of cubist grids in his art. By a considerable amount of reworking of surfaces, he arrives at a conflation of imagery similar to what Pollock achieved in the early forties with spontaneity and freneticism.

Pousette-Dart poises his images on a threshold appealing to the conscious and the unconscious mind. His intent, which he labels religious, however refusing to ally it with any known orthodoxy, is to achieve in painterly terms an oceanic feeling of cosmic consciousness common to many types of mysticism. What he does is to create a vibrating, hovering surface which both denies as it also asserts the tactility of the paint. He implants on the surface numerous uninterpretable ciphers that function analogously to the fleeting impressions a mystic apprehends during meditation, becoming the "halo" of consciousness, which Ehrenzweig indicates is "the playground of our unconscious imagination."[2]

Pousette-Dart's absolute belief in the magical properties of his work is problematic. Does one think of him as a primitive in our midst? Can his description of his small brasses, which are meant to be worn, as "living things"

114 Richard Pousette-Dart in his studio

with magic in them, be simply regarded as an overzealous religiosity on his part?[3] Is his use of such titles as "presence" to be regarded as a metaphor in spite of his protestations that they were given those titles precisely because they are beings? I think Pousette-Dart's attitudes toward his own work can be explained by comparing them with Matisse's reaction to *The Dance*. According to Alfred H. Barr, Jr., who recounts this incident,[4] Matisse was disturbed by the tremendous liveliness exhibited by the figures during twilight. So upset was he by the seemingly magical movement of the figures that he asked Edward Steichen to visit his studio at sunset. With his knowledge of color photography which he was

studying at the time, Barr relates, Steichen was able to explain the phenomenon in terms of complementary reflexes of the eyes. In my estimation, the reason for the painting's unusual vitality at dusk depended as much on the peripheral nature of Matisse's vision at that time as it did on the colors or forms of his painting, an opinion partially confirmed by Hans Puremann's recollection of Matisse's startled reaction to *The Dance* when he glanced at it out of the corners of his eyes.[5] The same reaction that Matisse felt might be similar to Pousette-Dart's, and help to explain why he believes so strongly in the magical properties of his work.

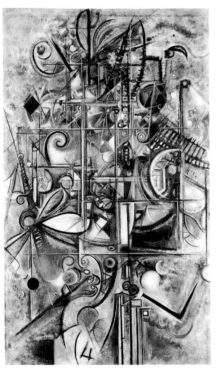

115 Richard Pousette-Dart
The Edge, 1944
Oil on canvas, 81 x 47¼ inches
Collection of the artist

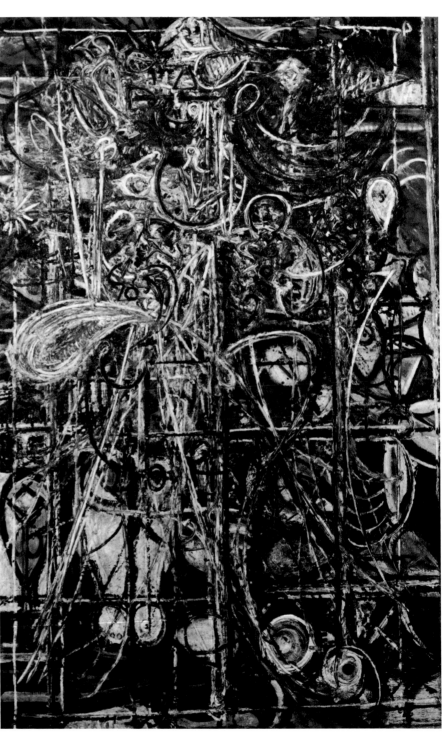

116 Richard Pousette-Dart
Figure, 1945
Oil on canvas, 80 x 50 inches
Andrew Crispo Gallery, New York

Pousette-Dart speaks of "tuning" his canvases and also refers to the "livingness of edges."[6] By "tuning" he is referring to the fine adjustments he makes in the process of painting to bring a work into a harmony such that no one element dominates the composition. "Livingness of edges" connotes his great concern for the transition of one form into another. To endow a work with presence, Pousette-Dart pays attention to juxtaposition and especially superimposition. His shapes are arranged contrapuntally, or as he expresses it, a painting is not complete when "the ground has not yet been danced on enough."[7] In the end, none of his shapes are fixed with hard edges, which would

117 Richard Pousette-Dart
Fugue Number 4, 1947
Oil on canvas, 92 x 62 inches
Andrew Crispo Gallery,
New York

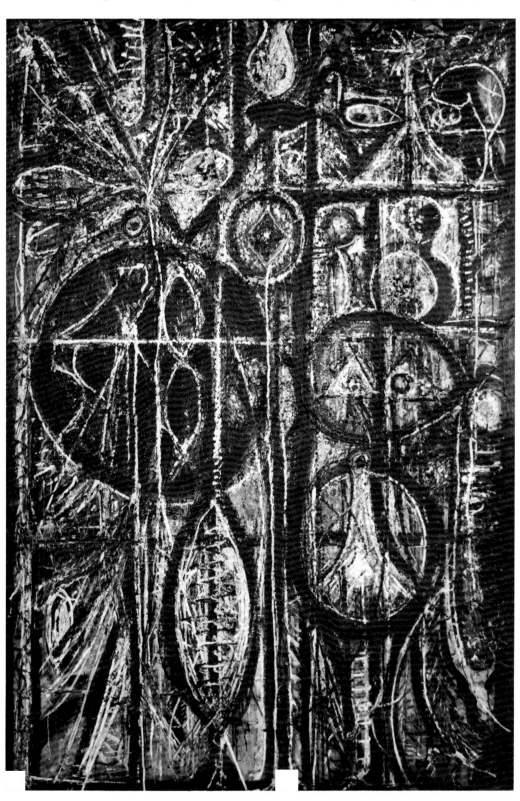

inhibit Pousette-Dart's proclaimed desire to get people "onto the thread of their own being,"[8] meaning his paintings, which picture the space available to peripheral vision, create an experiential tableau allowing viewers the possibility of looking intently at what is ordinarily subliminally available to them. By painting a large canvas with forms deliberately out of focus, *Symphony Number 1, The Transcendental* (fig. 119), Pousette-Dart became one of the first members of the New York School to create a format that was to become of crucial importance to later Abstract Expressionism.

When the history of the so-called "big picture" was being written,

118 Richard Pousette-Dart
Within the Room, 1942
Oil on canvas, 26 x 60 inches
Collection of the artist

Pousette-Dart had left New York City, and perhaps this is the reason why he was not included in the lists of those who had diverged from the strictures inherent in easel painting by creating all-over compositions. When Pousette-Dart painted *Symphony Number 1,* his contemporaries reacted negatively. In particular, he remembers Rothko asking him why he had painted it, and to whom did he hope to sell it, an interesting incident in light of Rothko's later works.[9] With the advent of the big picture, the implicit emphasis on peripheral vision that designates the concerns of early Abstract Expressionism almost became explicit, for looking at an expansive surface from only two, or at most three, feet away, the distance recommended by many painters of the big picture, places primary emphasis on peripheral scanning and minimizes the importance of focused vision.

RCH

1 Evelyn Pousette-Dart, conversation with Hobbs, Suffern, N. Y., 4 November 1977. Not only was Richard Pousette-Dart's family creative but they also, according to Evelyn Pousette-Dart, were mutually supportive, providing encouragement for a wide variety of creative endeavors.
2 Anton Ehrenzweig, *The Psycho-analysis of Artistic Vision and Hearing: An Introduction to a Theory of Unconscious Perception* (London: Routledge & Kegan Paul, 1953), p. 206.
3 Richard Pousette-Dart, conversation with Hobbs, Suffern, N. Y., November 1977.
4 Alfred H. Barr, Jr., *Matisse: His Art and His Public* (New York: The Museum of Modern Art, 1951; reprinted 1974), p. 136.
5 Ibid.
6 Martica Sawin, "Transcending Shape: Richard Pousette-Dart," *Arts Magazine* 49 (November 1974): 58.
7 Ibid., p. 60.
8 Ibid., p. 59.
9 Pousette-Dart, conversation with Hobbs.

119　Richard Pousette-Dart
*Symphony Number 1, The
Transcendental,* early 1940s
Oil on canvas, 90 x 120 inches
Andrew Crispo Gallery, New York

Ad Reinhardt (1913-1967)

An abstract painter since his student days at Columbia in the mid-thirties, Ad Reinhardt took up the banner of geometric abstraction and joined the American Abstract Artists in 1937. Like other members of this group, Reinhardt assumed the derogative labels "derivative" and "eclectic" and wore them as a badge of honor throughout his life. He espoused a belief in the eternal qualities of art common to many A.A.A. members, who wished to use basic elements of art—rhythmic proportions and rigorously simplified geometric elements—in their purest form in an effort to produce an art reflective of Plato's ideal realm. Certainly Reinhardt's later adage "art comes from art only" has its roots in geometric abstractionist concerns of the thirties.

Essentially Reinhardt was a classicist who perceived the beauties of the romantic's preferred terrain, was intrigued by it, and chose to evoke it in his art only after he had purged it of non-essentials so that it could belong to that paradoxical category "classic romanticism." In the early forties, Reinhardt moved from geometric abstraction, his "late-Classical-mannerist post-cubist geometric-abstractions of the late 30's" and began his "rococo-semi-Surrealist Fragmentation and 'all-over' Baroque geometric-Expressionist patterns of the early 'forties',"[1] his early Abstract Expressionist works.

Dark Symbol (fig. 120), painted in the early forties, was seminal to Reinhardt's development. His regard for it is clearly demonstrated both by his choosing to include it six years later as one of his two entries, the other being *Cosmic Sign*, in the important "Ideographic Picture" exhibition at Betty Parsons Gallery and by his decision to make the enlarged variation of it in black and white eight years later (*Untitled*, 1949, fig. 122). In *Dark Symbol*—the title itself seems to forecast the black paintings of the fifties and sixties—he

120　Ad Reinhardt
Dark Symbol, 1941
Oil on masonite, 16 x 20 inches
Private collection

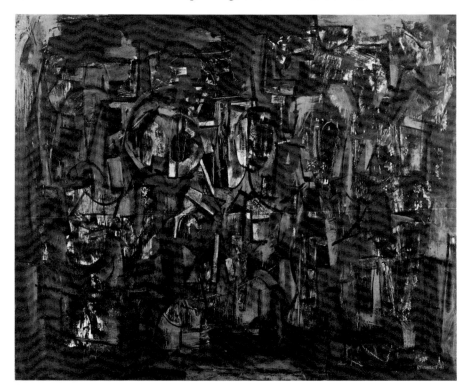

121 Ad Reinhardt, c. 1942, in his New York studio

attempted to synthesize cubist and surrealist elements. A cubist infrastructure is recalled but broken up, and incipient figures, almost hybrids, suggest a surrealist origin. In this painting black lines establishing a type of cubist grid begin to take on characteristics of automatic ecriture, and the merging of the two reflects the direction Reinhardt's art took in the forties. In *Abstract Painting*, 1943 (fig. 123), Cubism still predominates over automatism but its characteristic fractured web is partially dissolved as the signs, suggestively biomorphic, are grouped in clumps.

As the cubist grid seems to elicit a kind of automatic writing, so automatism

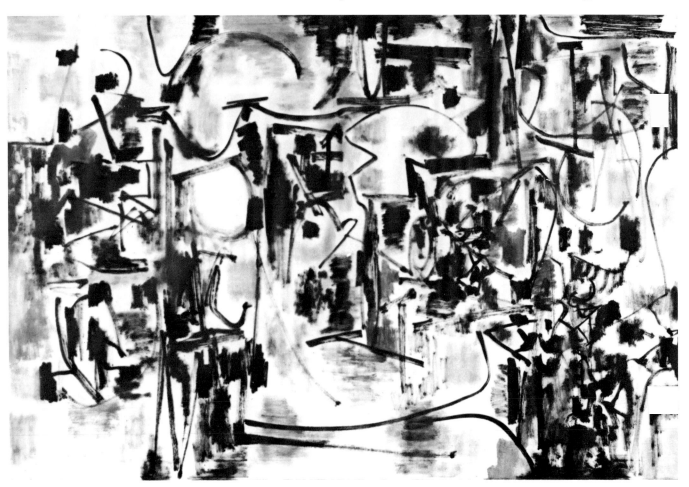

122 Ad Reinhardt
Untitled, 1949
Oil on canvas, 43 x 63 inches
Private collection

suggests calligraphy, and this in turn leads to evocations of Oriental art in which painting and writing are closely aligned. To achieve a synthesis between classic and romantic elements, Reinhardt turned to a different tradition, an Eastern one, where these polarities do not exist. In 1944, when he returned to graduate school and studied under Alfred Salmony, Reinhardt became interested in Chinese and Japanese painting and Islamic architectural decoration. An oriental mood predominates in the two paintings of 1946 (figs. 124, 125) as well as in *Number 18* (fig. 37). In these three works vibrating, intense hues are closely aligned in terms of value. They seem to be Chinese landscape paintings in mosaic or cubist paintings as interpreted by a Persian miniaturist. Parallels between these paintings and those of Mark Tobey abound. The designatedly Eastern ambience is reinforced in the vertical formats of the two paintings of 1946, reminding one of Reinhardt's statement in 1954, "vertical hanging scrolls are to be seen more publicly, statically, reverently, standing."[2] Characterizing these paintings is a shimmering surface. At times it looks like a fluctuant palimpsest in which forms magically come forward and then recede, creating the effect of a cycle of emergent order and dissolution. It is an eminently fluid realm that, like so many other early Abstract Expressionist works, calls to mind

112

a mystic writing tablet capable of manifesting a preconscious language. But with Ad Reinhardt, who lampooned the Abstract Expressionists' concerns with the self, the langauge is that of painting. In these works the vision produced is akin to the peripheral vision that occurs when one stares at an object so intently and for such a length of time that the object blurs and begins to merge with the background. Or as Reinhardt so aptly described it:

The Eastern perspective begins with an awareness of the "immeasurable vastness" and "endlessness of things" out there, and as things get smaller as they get closer, the viewer ends up by losing (finding?) himself in his own mind.[3]

123 Ad Reinhardt
Abstract Painting, 1943
Oil on canvas, 40 x 32 inches
Marlborough Gallery, New York

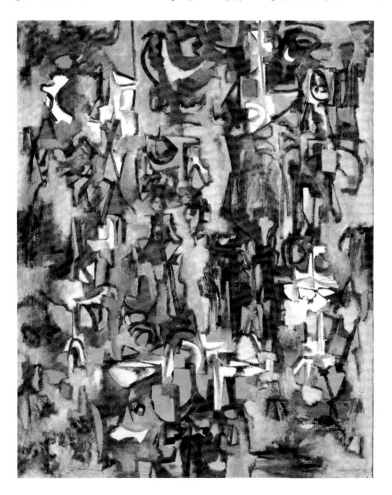

 Reinhardt's study of Oriental art, an important concern in the late forties, is reflected in the quality but not in the iconography of *Untitled*, 1949 (fig. 122). His gradations of black, at times even becoming gray, call to mind the familiar Chinese expression "If you have ink, you have the Five Colors," meaning color is not of necessity dependent on chromatic range or intensity of hue but is rather an inherent part of the character of the thing depicted and could even be represented in black and white.[4] Although *Untitled* exhibits an Eastern quality in terms of its "coloristic" use of black and white that may be a manifestation of Reinhardt's researches in Chinese and Japanese painting,[5] it is rendered in a composition designately Western, with shapes indicative of a cityscape.

 RCH

124 Ad Reinhardt
Painting, 1946
Oil on masonite, 24 x 11¾ inches
Marlborough Gallery, New York

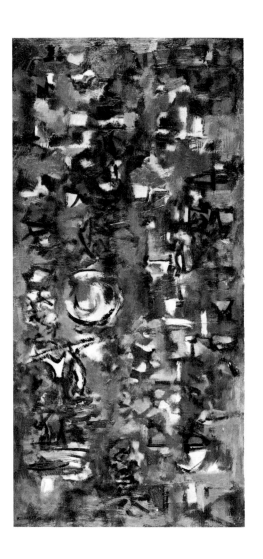

1 Ad Reinhardt, quoted in Lucy Lippard, *Ad Reinhardt: Paintings* (exhibition catalogue, The Jewish Museum, New York, 23 November 1966-15 January 1967), p. 15.
2 Ad Reinhardt, "Cycles Through the Chinese Landscape," *Art News* (December 1954); reprinted in *Art-as-Art: The Selected Writings of Ad Reinhardt*, ed. with introduction by Barbara Rose, Documents of 20th Century Art, (New York: Viking Press, 1975), p. 215.
3 Ibid., pp. 214-15.
4 Mai-Mai Sze, *The Way of Chinese Painting: Its Ideas and Technique* (New York: Vintage Books, 1959), p. 75.

5 During the forties, Reinhardt's art manifested concerns with Oriental art that also began to intrigue some of his peers. Motherwell and Baziotes avidly read volumes of *The Wisdom of the East* series and discussed at length Laurence Binyon's *The Flight of the Dragon* and Kuo Hsi's *An Essay on Landscape Painting*. Stamos also delighted in this series and in addition read Ernest F. Fenollosa's two-volume work *Epochs of Chinese and Japanese Art* and translations of Chinese poetry by Arthur Waley (for a fuller account of Stamos's interest in the East, see Barbara Cavaliere, "Theodoros Stamos in Perspective," *Arts Magazine* 52 [December 1977]: 104-15). Moreover Stamos was fascinated by Mark Tobey's art, and at the end of the forties started a series of black-and-white Chinese ink and wash drawings that paved the way for his Japanese Teahouse series of the fifties. And Tomlin at the end of the forties created paintings as *Number 12* (fig. 150), which contains signs reflective of Sanskrit, and drawings as an *Untitled* of about 1949 that bears a surprising resemblance to calligraphy (Jeanne Chenault, "Bradley Walker Tomlin" in *Bradley Walker Tomlin: A Retrospective View* [Hempstead, N. Y.: Hofstra University, 1975], p. 23).

125 Ad Reinhardt
Untitled, 1946
Oil on canvas, 50 x 20 inches
Marlborough Gallery, New York

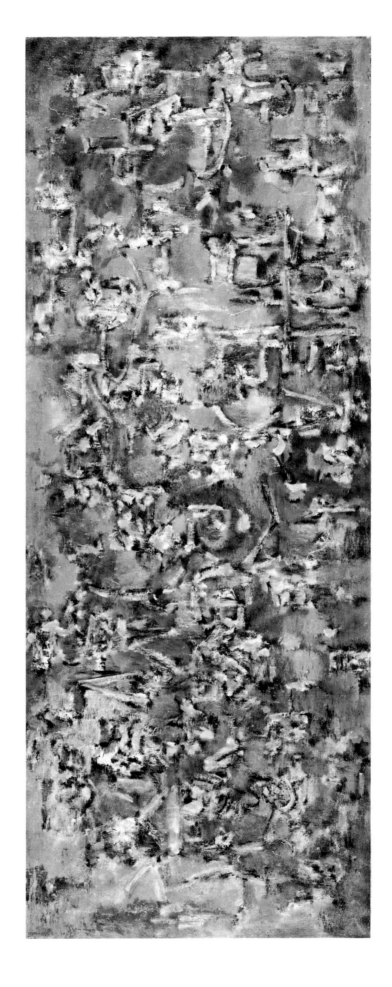

Mark Rothko (1903-1970)

When Mark Rothko wrote "The Romantics Were Prompted" for publication in *Possibilities* in 1947,[1] he was ending a period he later termed Surrealist, and beginning to develop his art along more abstract lines, occasioned first by dropping mythic titles and later by creating multiforms. In this essay, which marks the shift between his earlier and later Abstract Expressionist styles, his attitude is generally retrospective. He used the theatrical metaphor to explain the appearance of hybrids in his work of the forties: "I think of my pictures as dramas; the shapes in the pictures are the performers." His references to the impossibility of presenting his drama in the everyday world rely heavily on Nietzsche's theories on the origins of tragedy: the emphasis on the chorus of satyrs is paralleled in Rothko's hybrids, and the effect of creating an atmosphere to break down individual differences and establish a primordial unity is crystallized in his term "transcendent experience."

Rothko must have thought of the theatrical metaphor often when he worked. Brian O'Doherty recounts that Rothko sometimes said he had acted when he was young.[2] And Thomas Hess refers to his training as a scenery painter,[3] which he connects to Rothko's later use of "scenery paints cooked over a hot-plate" to stain his canvases. Robert Motherwell remembers that Rothko, who was so secretive about his methods of painting and usually worked from 5:00 AM until 10:00 AM, in a moment of weakness admitted to him that he painted under lights of high intensity that were arranged like stage lights.[4] Intense lighting would naturally have the effect of making every nuance blaringly evident. Also, it would bleed out the richness of his colors making them more opaque and less jewel-like when he was working. Perhaps this is the reason why Rothko once stated that the completed painting is as much a revelation to the artist as it is to the viewer, and once finished it begins an existence separate from its creator.[5] It is unknown exactly when Rothko began to paint in this manner, but we do know that for years he insisted on having his works viewed under dim lighting, a request with theatrical overtones that would have the effect of decreasing focused vision and intensifying peripheral scanning. Subtle changes in tone that were greatly exaggerated under stage lights would, under dimmed conditions, create an entirely different sensation. His chalky, generally pale colors of the forties—mostly conceived within a narrow range of values—would become richer. And the entire composition would subtly vibrate, creating the effect of an incipient presence hesitantly beginning to stir.

In his works of the forties, Rothko played on the theatrical idea even to arranging his biomorphic forms on a shallow stage, making them participants in some inexplicable drama. And the titles—such titles as *Implements of Magic*, *Tantalus*, *Vessels of Magic* (fig. 10), *The Entombment* (fig. 16), and *Nocturnal Drama* (fig. 128)—reinforce the mood of mystery and the distant past. Years after he created these works, Rothko told Peter Selz, "As I have grown older, Shakespeare has come closer to me than Aeschylus, who meant so much to me in my youth." Aeschylus, it should be mentioned, is the tragedian Nietzsche selected to exemplify the merits of tragedy in contradistinction to Euripides, who diminished its importance by stressing unnecessary realistic elements. Rothko's hybrids affirm the mystery of his work and keep it from being marred by prosaic elements. These beings have their origins in a microscopic world that serves as an analogue to man's inner realm; some forms call to mind ciliated protozoa, others flowing protoplasmic entities with pseudopods, and still others flagella.

126 Mark Rothko, San Francisco, late 1940s

Among the Abstract Expressionists, Rothko was one of the few who consistently appreciated the early work of Salvador Dali and Max Ernst.[6] Some of his figures, which are much more abstract than various Surrealist forms, are vaguely reminiscent in terms of their contours of the profiles defined by ingenious confluent figures in Dali's paintings. But Rothko follows more closely in the tradition of Max Ernst. Ernst's *Stratified Rocks*, 1920 (fig. 127), with its elemental shapes and encompassing fluids, is the type of work that prefigures many of Rothko's biological entities. Ultimately, Rothko's use of the biological metaphor may have a source in his studies at Yale University where he

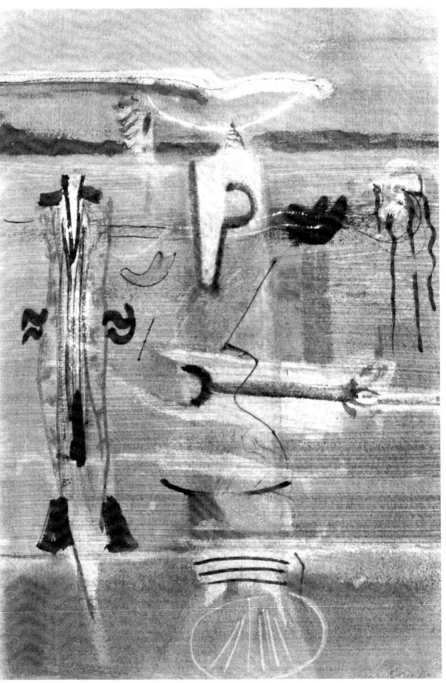

127 Max Ernst
Stratified Rocks, Nature's Gift of Gneiss Lava Iceland Moss 2 Kinds of Lungwort 2 Kinds of Ruptures of the Perineum Growths of the Heart (B) the Same Thing in a Well-Polished Box Somewhat More Expensive, 1920
Anatomical engraving altered with gouache and pencil, 6 x 8⅛ inches
The Museum of Modern Art, New York

128 Mark Rothko
Nocturnal Drama, n.d.
Gouache on paper, 21½ x 15½ inches
Private collection

matriculated as a science major, taking courses mainly in biology, math, and physics.[7]

Of all the qualities of Rothko's work, his lighting has occasioned the most discussion. In the forties he placed his ambiguous shapes in an ambient fluid that at first appears penetrable but on closer inspection is restricting and almost claustrophobic. Most of Rothko's paintings depend on the contradictoriness of both light and space. It is highly possible that Rothko's presentation of ambivalent light, which is both dark and glowing, muted and intense, and space, which is both airy and constraining, has a source in his infancy and childhood.

129 Mark Rothko
2 Sided Drawing, c. 1945
Ink on paper, 15⅛ x 20⅝ inches
Betty Parsons Gallery, New York

The constricting qualities of his work—shallow stages with figures encased in fluids—might stem from the fact of his being bound in swaddling clothes for such a length of time that he remembered it with resentment throughout his life.[8] This feeling of enclosure would certainly engender in him a desire for transcendence as it might well have reinforced the idea that one is forever constrained within one's own body as well as within one's own internal prison, one's mind. Another experience from his childhood that might have had a direct bearing on his concern with light is the glorious sunsets that he remembered in Russia[9] and the equally dazzling ones occurring in Portland, Oregon, where he later moved. While Rothko's special feeling for light may have stemmed from profoundly moving childhood circumstances, it could also have evolved from his intimate knowledge of Milton Avery's art with which his work shares an interest in flat muted forms with diffused edges, or from his own psychic automatist concerns in which he would start with a liquid medium that would naturally lead to the idea of underwater imagery. Also his light could have stemmed from his wife's costume jewelry plant that occupied the same space as his studio in the early forties.[10] Whatever the source or sources may have been

for his "cheerful" light, Rothko used it to communicate both ecstasy and tragedy. In view of this, it is of interest to note that Rothko regarded Mozart, his favorite musician, as a tragic artist.[11]

Rothko's assessment of his biomorphic hybrids as the actors in the drama that is his painting indicates a reliance on Nietzsche's theory espoused in his *Birth of Tragedy*. Only in Rothko's work the tragedy takes place on a stage that is the pictorial counterpart of the darkened passages of the mind, the unconscious. His light is both a symbolic and necessary ingredient in his art. By analogy the dim glow of his light serves as the little understood pathways of

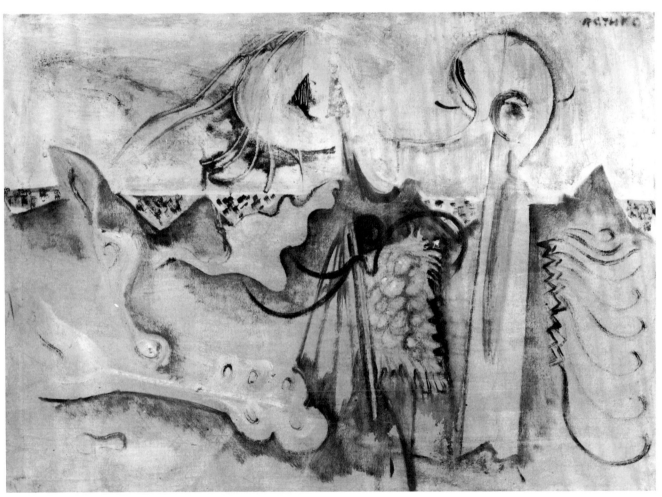

130 Mark Rothko
Landscape, 1945
Oil on canvas, 19¾ x 27¾ inches
Collection of Mr. and Mrs. Herbert Ferber

the mind, those areas approached only by indirection: by Dionysian empathetic intuition, not Apollonian reason. Deliberately vague and shrouded in semidarkness, his art causes the viewer to rely heavily on peripheral vision and thus his own unconscious reactions. Primitive drama, as Nietzsche conceived it, was similar to Rothko's paintings; it was an event with the precise aim of focusing a viewer's attention on himself. The spectator imagined himself a part of the chorus, and according to Nietzsche "the chorus in its primitive form, in proto-tragedy [was] the mirror image in which the Dionysian man contemplates himself."[12] By extension Rothko's paintings with their satyric hybrid choruses and darkened stages are mirrors in which the Dionysus in modern man is reflected.

RCH

131 Mark Rothko
Entombment I, 1946
Gouache on paper, 20⅜ x 25¾ inches
Whitney Museum of American Art,
New York. 47.10

1 *Possibilities 1*, eds. Robert Motherwell, Harold Rosenberg, Pierre Chareau, John Cage (New York: Wittenborn, Schultz, 1947), p. 84.
2 Brian O'Doherty, "The Rothko Chapel," *Art in America* 61 (January 1973): 15.
3 Thomas B. Hess, "Editorial: Mark Rothko, 1903-1970," *Art News* 69 (April 1970): 29.
4 Robert Motherwell, conversation with Hobbs, Greenwich, Conn., November 1975.
5 This idea also parallels Baudelaire's statement, "Next to the pleasure of being surprised, there is no greater pleasure than to cause surprise" (taken from Marcel Raymond, *From Baudelaire to Surrealism*, Documents of Modern Art 10, [New York: Wittenborn, Schultz, 1950], p. 214), meaning the most pleasurable aspect of art

for the creator is being surprised when he takes his actions on faith while working and reserves judgment for a later time in order to encourage chance to enter and free him from the constraints of reason.
6 Herbert Ferber, conversation with Hobbs, New York, April 1977. Gottlieb also was interested in Dali's early work. Mary R. Davis, "The Pictographs of Adolph Gottlieb: A Synthesis of the Subjective and the Rational," *Arts Magazine* 52 (November 1977): 142, 146.
7 I am indebted to Debbie Gee for this information. I would like to thank Ms. Gee and also Mollie McNickle, students in a seminar I was teaching at Yale University, who met with me regularly in 1975 and

1976 and who always came with searching questions that have helped me enormously in analyzing this period.
8 Motherwell, conversation with Hobbs. Motherwell has recalled that Rothko would speak with rage whenever he repeated the story of his infancy.
9 Ibid.
10 Joseph Liss, "Portrait by Rothko," n.d., typescript in Artist's File, Library of Whitney Museum of American Art, New York.
11 Ferber and Motherwell, conversations with Hobbs.
12 Friedrich Nietzsche, *The Birth of Tragedy* in *The Birth of Tragedy and The Case of Wagner*, trans. by Walter Kaufmann (New York: Vintage Books, 1967), pp. 62-63.

Theodoros Stamos (b. 1922)

The distinctive quality in Stamos's art of the forties is its telluric identification with the inner rhythms of natural phenomena, with the secret struggles for survival and freedom that take place in the cloistered abodes of those vague, rudimentary creatures and forms inhabiting our everyday world which are too often ignored or trampled underfoot. Even in his earliest works, Stamos had revealed the visionary's instinctual ability for spontaneous expression of such subject matter. He was drawn to Milton Avery, Arthur Dove, Albert Ryder, and the Hudson River School, whose pantheistic views of nature stimulated his deepest interest. In the art and literature of the Orient, Stamos found a conception of man's union with nature most compatible with his own.[1]

Recalling his first one-man exhibition at the Wakefield Gallery in 1943, Stamos later commented: "I entered the world of echinoids, sea anemones, fossils and the inside of a stone. . . . To free the mystery of the stone's inner life my object."[2] Penetrating seemingly impassable matter, he took up residence with the insect in its chrysalis, with the kernel of the seedling, with the fetus in its placental covering, seeing such habitats as consanguineous with the craggy chambers of the darkest human emotions.

Stamos's commitment to visual stimuli led him to take an active interest in the natural sciences.[3] *Movement of Plants*, 1945 (fig. 39), was named for Darwin's *Power of Movement in Plants*, a preferred book in Stamos's library. It is an arrangement of simplified signs that resembles the way artifacts and fossils are found by archeologists embedded in a fragment of petrified rock. The angular blue-green line which meanders erratically across the surface, looping and twisting into triangular configurations, is strikingly similar to Darwin's diagrams, "cryptograms" as he called them, which represent the circumnutation of plant parts in irregular patterns, and the phenomena of heliotropism and geotropism whereby plants move toward the sun and the earth, the two sources of food necessary for life growth, evocative of the human's twin hungering for flesh and spirit. A crusty white leaf form shares the field, its delicate veins

132 Theodoros Stamos
Ancestral Flow, 1945
Oil on canvas, 14 x 22 inches
Pinacotheque Nationale Musée,
Athens, Greece

133 Stamos, 1947, in the Sandia Mountains, New Mexico, after discovering a boulder covered with petroglyphs

resembling those on the leaves collected by the artist and pressed between the pages of his books on mosses and ferns. Klee-like arrows of direction aid in the sensation of oscillatory, jerking motion—the stirrings of life in forms held captive through long geological ages.[4]

Even as he excavated into the roots of plants and into the spiral caverns of shells, he also penetrated walls of time, going back to the antediluvian roots of man, to our primeval progenitors who performed rituals of incantation to the sun and believed in guardian spirits inhabiting the stone. As he read the stories of homoeopathic magic and demons in Sir James George Frazer's *The Golden Bough* and in the Greek myths, Stamos was reminded of the tales he had heard from his own parents as a child.

Ancestral Flow, 1945 (fig. 132), an oblique reminder of Elihu Vedder's *The Lair of the Sea Serpent*, 1864, is dominated by a writhing form suggestive of the rhythmic motions of Hokusai's *Wave* (a favorite of Stamos's), of the quarter-tone beat of Greek peasant music, and of ancient tribal dances to ward off evil spirits. In *The Sacrifice*, 1946 (fig. 134), a similar shape becomes a five-legged sacrificial victim, the many-breasted stone idol of Diana, goddess of fertility, represented in ancient sculpture. One of the phallic legs is piercing a yellow, spheroid form; Diana was often visualized as a yellow harvest moon.[5]

123

Frazer tells the story of the New Caledonian wizard who, desiring to make sunshine, took a bundle of skeletons, plants, and corals up on a mountain and hung it over a flat stone on which he placed some plants and a branch of dry coral. In *Archaic Sentinel*, 1947 (fig. 135), Stamos evokes such ceremonial rites, the lower form resembling the sacrificial stone and the form hovering above resembling the bag of magical fetishes as well as a beaked profile, perhaps the "soul stone" of animal/human shape which is wrapped up with the destiny of its owner. The fish skeleton form that appears within the rock is a recurrent image in Stamos's art—partially his recollection of Friday night fish cooked by

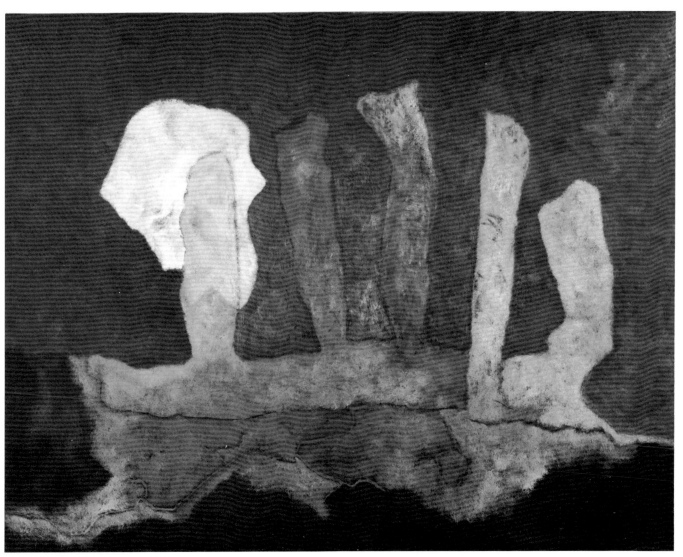

134 Theodoros Stamos
The Sacrifice, 1946
Oil on masonite, 30 x 39½ inches
Collection of Dr. and Mrs. Louis Savas

his mother in such a way that the bones stayed intact, while also alluding to skeletal effigies used by the primitive to animate the spirits to provide live game for their tables. Among the multiple associations in *Moon Flower and Surf*, 1946 (fig. 136), is the ritual calling forth the sun to the fig tree under which a flat stone has been placed for enacting orgiastic rites. This small but powerful work also strangely alludes to the Zen art of archery; the upper form is like a target pierced by the Zen master's arrow, a reference that could easily have been known to Stamos through his readings on the East.

The brittle, scumbled surfaces, dark tonalities, and mat finish in Stamos's art of the forties are in keeping with his evocation of the mysterious regions of mind and past. The coarse, stony textures are reminders of his work as a prism grinder and as a framer who worked in roughhewn woods (as seen, for instance, on *Altar* and *Altar #1*), and they recall as well his beginnings as a sculptor. They suggest the grainy surfaces of Atlantic rocks, the crumbly brittleness of

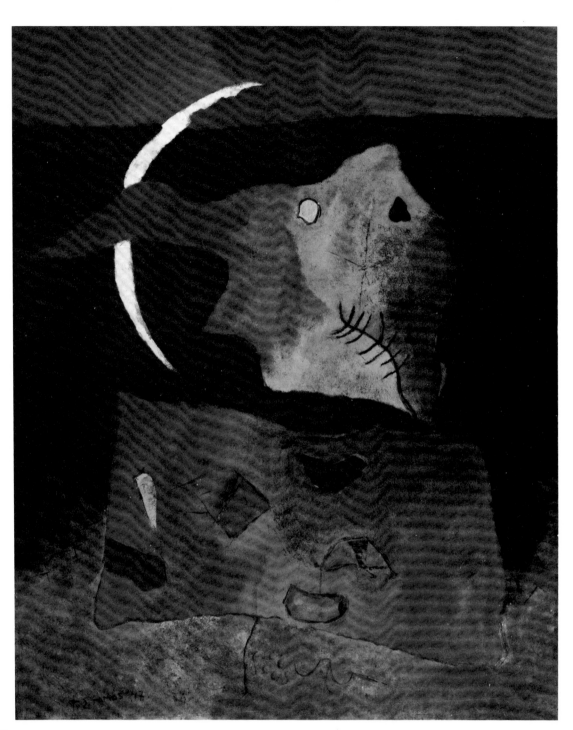

135 Theodoros Stamos
Archaic Sentinel, 1947
Oil on masonite, 36 x 30 inches
Collection of Dr. and Mrs. Louis Savas

pressed leaves, and the worn surfaces of the petroglyphs and stone dwellings which he visited on a trip to the western states in 1947. Darwin observed the movements of plants in darkness or with a feeble light from above; Stamos painted most of his pictures at night when reliance on touch becomes necessary. But most of all, the dark, threatening atmospheres of Stamos's works are remembrances of the hazy, dateless past whose specters dance in the dim interiors of the mind.

> *Like the shadow of the moon on time to come,*
> *Falls on time out of mind and time,*
> *In whose bleak reaches shine the dim*
> *Lights of millenium.*[6]

BC

136 Theodoros Stamos
Moon Flower and Surf, 1946
Gouache on board, 18 x 14 inches
Private collection

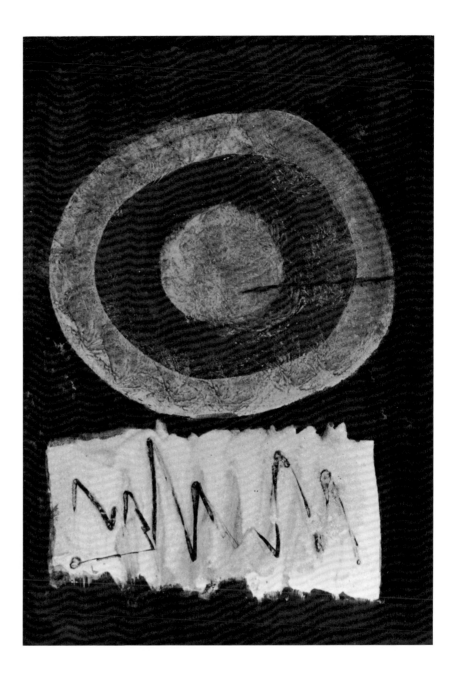

1 Stamos collected books on Oriental literature and poetry as well as books on Japanese and Chinese art. He was particularly attracted to the translations of Chinese poetry by Arthur Waley, whose work he knew from at least 1943. For further information on the sources and readings of Stamos, see Barbara Cavaliere, "Theodoros Stamos in Perspective," *Arts Magazine* 52 (December 1977): 104-15.
2 From a statement by Stamos, on a questionnaire from the Whitney Museum of American Art, [1955], 7 Artist's File,

Library of the Whitney Museum of American Art, New York.
3 Stamos collected and studied books on marine biology, botany, and geology, especially ones published in the late nineteenth century. Many of his paintings of the forties found their most pertinent sources in these books.
4 Between 1941 and 1948, Stamos ran a small frame shop on East 18th Street in Manhattan. During this time, he framed a number of Klee's works.
5 The stories of ancient myth and ritual

are from Sir James George Frazer, *The Golden Bough: Study in Magic and Religion* (New York: Macmillan Publishing Co., 1922). This book was widely read during the forties, and Stamos has pointed it out as an important source for his early work.
6 John Malcolm Brinnin, "Song for Doomsday Minus One," *The Sorrows of Cold Stone, Poems 1940-1950* (New York: Dodd, Mead & Co., 1951). Stamos illustrated this volume of poems by his friend with pen and ink and wash drawings in the mid to late forties.

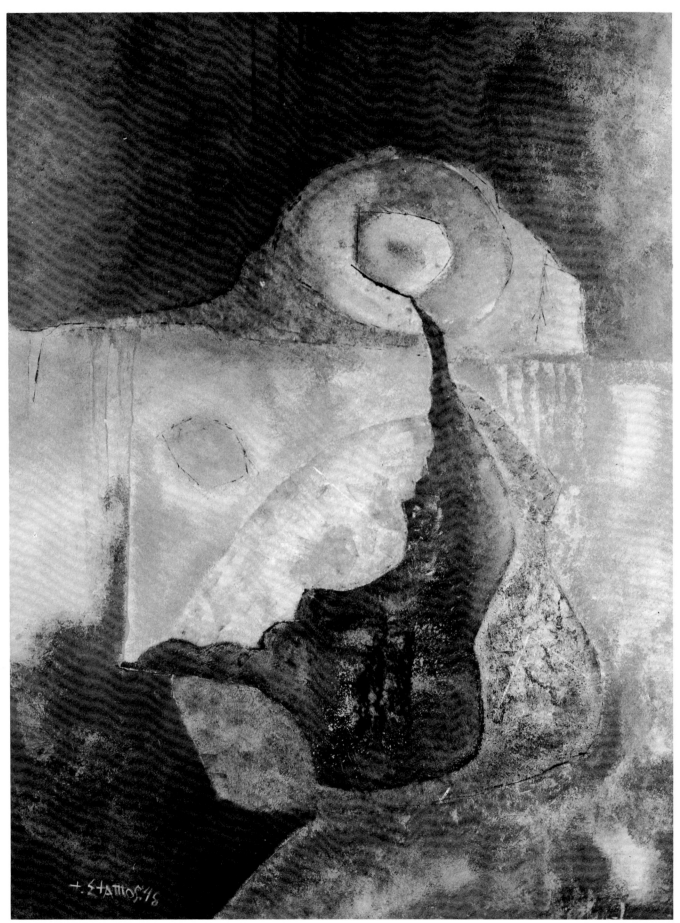

137 Theodoros Stamos
Altar, 1948
Oil on masonite, 48 x 36 inches
Private collection

127

Clyfford Still (b. 1904)

The early work by Clyfford Still now available to us differs significantly from what was created in the thirties and forties. With a firm grasp of those elements he considers representative of his style, Still has reorganized and reworked his early œuvre, even though he has—at least to my knowledge— not repainted a single passage in them. By reacquiring and destroying some early paintings, as his flower pictures, he has clarified the focus of his early work. Moreover, he has gotten rid of mythic titles, replaced them with dates, letters, and numbers, and blamed gallery personnel for giving allusive labels to them.[1] Whenever possible, Still has attempted to have early works exhibited with his later ones, no doubt with an intent to magnify their precursory elements. With great prudence then, he has weeded out all aspects of his art for which he is unwilling to assume full responsibility.

What he upholds is the freedom of the works, unmediated by verbal exegesis except for occasional proclamations attesting to their uncompromising abstract qualities and alluding to their capability of evoking sublime feelings. But in his rigorous attempts to preserve the purity of his work, Still has changed his early pieces by adjusting the context surrounding them so they will be understood in the same manner as later works. In stressing the cohesiveness of his approach, he has minimized the tentativeness, arduousness,

138 Clyfford Still
Untitled (Fear), 1942
Oil on canvas, 24½ x 18½ inches
Betty Parsons Gallery, New York

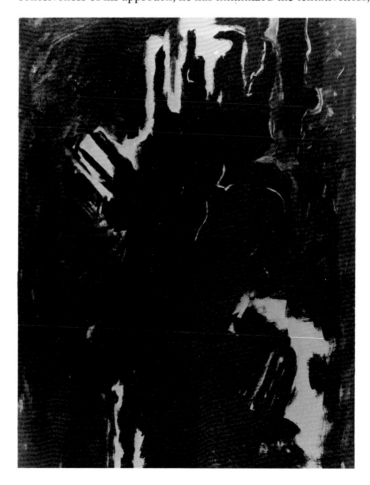

128

139 Clyfford Still
Self-Portrait, 1940
Oil on canvas, 41½ x 38 inches
Collection of the artist

and risk involved in coming to grips with his distinctive style, although he
has tried to make up for this in his writings. By replacing mythic titles with
numbers, he has taken away associations once accorded to his art, thus
preventing viewers, from correlating, for example, *Nemesis of Esther III*,
Buried Sun, and *Theopathic Entities*, titles of 1946, with paintings of that year,
perhaps paintings included in this very exhibition. Among the few retaining
their original designations are Peggy Guggenheim's *Jamais*, the San Francisco
Museum of Art's *Self-Portrait*, and Betty Parson's *Fear* (fig. 138). Since
one's approach to Still's early work is largely determined by the artist's
retroactive decisions, it might be beneficial to look at Clyfford Still, who in
1935 wrote a masters thesis evaluating Paul Cézanne and his art.[2]

 The first striking aspect of Still's thesis is the way Cézanne is presented.
He seems to have chosen Cézanne as a paradigm, for he began by lauding
the French master's so-called weaknesses—provinciality, tentativeness, and
awkwardness—which have become positives in Still's art. Cézanne painted
with heavy hand; he even loaded his brushes with too much paint in
his early works; and his attempts to emulate the grand style only served
to emphasize his bumbling manner. Still indicated that these drawbacks were
crucial to the ultimate greatness of Cézanne's art because they forced him to

129

question traditional objectives and to reevaluate them in terms of his own inabilities. Echoes of Emerson, coupled with tinges of American Regionalist posturings seem to be reflected in this evaluation of Cézanne: only by working within limitations of ability and circumstances is the artist able to be himself. And being truly himself, it follows, he consequently becomes greater than himself since he ennobles his own weaknesses in a manner reflective of humanity at large. Cézanne's uncompromisingly earthy approach, his flickering edges, and his broad outlines are among the qualities receiving Still's approbation. Even though the main focus of Still's erudite thesis is in the realm of formal innovations, I think his personal attitudes toward Cézanne as another provincial, who found himself only through acceptance of his limitations, his crudeness, is crucial to Still's own art. This opinion is corroborated by Still's paintings together with his statement, "I fight in myself any tendency to accept a fixed, sensuously appealing, recognizable style. I am always trying to paint my way out of and beyond a facile, doctrinaire idiom."[3]

The sources of Still's art appear to be those abstract shapes existing on the periphery of Cézanne's and Gauguin's paintings. The crude, black shadows emphasizing the tablecloth in Cézanne's early painting *The Black Clock* (fig. 141) are analogous to the dark outlines of Still's

140 Clyfford Still
Brown Study, c. 1935
Oil on canvas, 29 15/16 x 20¼ inches
Munson-Williams-Proctor Institute,
Utica, New York

141 Paul Cézanne
The Black Clock, 1869-71
Oil on canvas, 21¾ x 29¼ inches
Collection of Stavros Niarchos

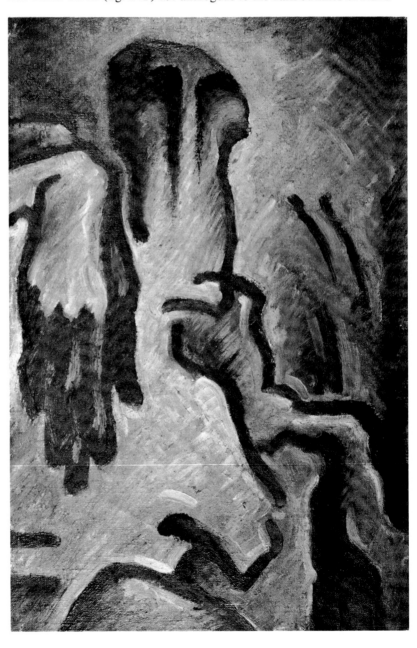

Brown Study, about 1935 (fig. 140), while the penumbral outlying scumblings of many Cézanne sketches open the way for Still's flickering silhouettes and scabrous surfaces. Later, in the forties, Still perhaps augmented Cézanne with Gauguin, adding stylistic characteristics of a self-proclaimed primitive to those of a provincial by choice. Still's organic, contorted shapes bear an astonishing similarity to Art Nouveau and to decorative passages in Gauguin's paintings, as the background of *Two Tahitian Women* (fig. 145) demonstrates. When Still takes elements from the art of another artist that become durable characteristics of his own work, he appears to choose them not only on the basis of style but also on the grounds of content: who used them, why, and how do they relate of his background and interests.

Constantly Still's aesthetic yardstick during his formative years was a certain intransigence that results from his espousal of his provincial background. Still disclaimed landscape references to his art when he said, "The fact that I grew up on the prairies has nothing to do with my paintings, with what people think that they find in them. I paint only myself, not nature."[4] It should be pointed out, though, that inhabitants of Pullman, Washington, where Still lived from 1933 to 1941, think the surrounding fields of tilled black earth have a great deal to do with the texture and color of his tenebrous paintings.[5] Still's assertion

142 Clyfford Still
Untitled, c. 1943-44
Oil on paper, 27½ x 21½ inches
Collection of Earle Blew

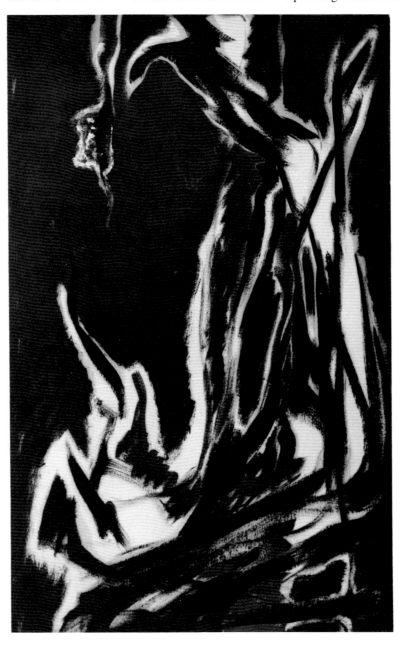

that he paints only himself leads one to the conclusion that he paints what he is, a Westerner and by choice a provincial. A Western artist, an intermittent interloper in New York artists' circles, Still may have studied French painters in reproduction during his formative years, except for his brief trip to New York City in 1924, but he appears to have looked mainly at that variety of fifth-rate art available to him in which surfaces are clouded with murky paint and brown varnish. Out of this dearth, he managed to create a first-rate art. In his hands dead surfaces of provincial painting were regarded as a positive force: they showed him the way to strip color bare of sensuous qualities, to exaggerate clumsy manipulation of paint until he achieved a scabbed, poignant, dead surface, and to refine and abstract late nineteenth-century chiaroscuro until he arrived at scintillating highlights that flicker from the edges of ponderous, dark, and brutal shapes.

RCH

143 Clyfford Still
Untitled Drawing, 1943
Oil on paper, 18 x 12 inches
Collection of Dr. and Mrs. Irwin Makovsky

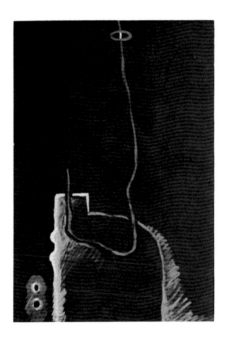

1 *Clyfford Still* (San Francisco: San Francisco Museum of Modern Art, 1976), p. 111. In the artist's biography, for which, according to Henry T. Hopkins, Still provided extensive new scholarly information, there is the following statement regarding the use of mythic titles for Still's exhibition at Art of This Century: "The titles were invented and attached by gallery assistants for their own amusement and picture identification." But on p. 106, Mrs. Clyfford Still, in a letter of 11 July 1975, refers to Still's title for a painting of 1938: "To identify it for public convenience, he gave it the innocuous title 'Totemic Fantasy.'"

Also, in a letter to Betty Parsons, 3 March 1947 (Betty Parsons Papers, Archives of American Art, Washington, D.C.), Still decided to use numbers instead of poetic titles to distinguish individual works because he wished to give the viewer a wider vantage point from which to experience his works, and in addition did not wish to misguide him. When he mentioned that his new approach might be considered artificial by many, his tentativeness implies that poetic titles had formerly received his endorsement.

Betty Parsons, in telephone conversations with Levin, December 1977, and with Hobbs, 19 January 1978, reported that she was responsible for giving the title *Fear* to

Still's painting. But as the above letter by Mrs. Still testifies, Clyfford Still at times did choose to identify his works with mythic titles.
2 Clyfford E. Still, "Cézanne: A Study in Evaluation," (M.F.A. thesis, State College of Washington, Pullman, 1935).
3 Cited by Mary Fuller McChesney, *A Period of Exploration: San Francisco 1945-1950* (Oakland, Calif.: The Oakland Museum Art Department, 1973), p. 37.
4 Ibid., p. 43.
5 Dr. Harvey L. West, Director, Washington State University Museum of Art, Pullman, telephone conversation with Hobbs, March 1976.

144 Clyfford Still
1947—H No. 2, November-December 1947
Oil on canvas, 63½ x 40¾
Menil Foundation Collection, Houston;
Jermayne MacAgy Bequest

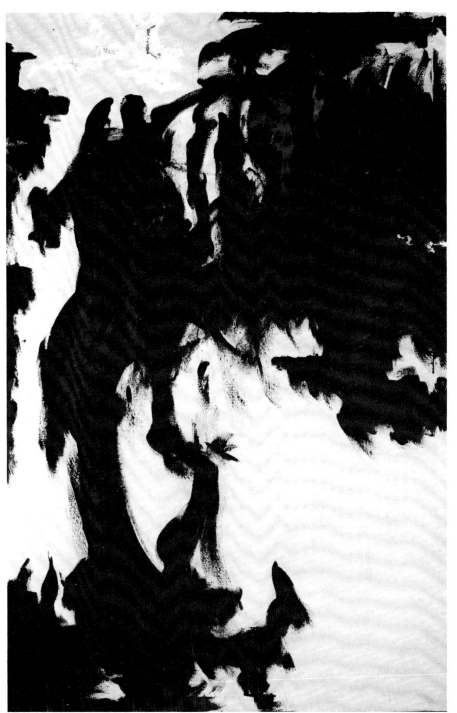

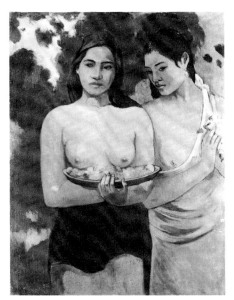

145 Paul Gauguin
Two Tahitian Women, 1899
Oil on canvas, 37 x 28½ inches
The Metropolitan Museum of Art,
New York; Gift of William Church
Osborn, 1949

Bradley Walker Tomlin (1899-1953)

It has become common practice to describe Tomlin's change from Synthetic Cubism to Abstract Expressionism in the second half of the forties as a complete break with his earlier style. Not only critics but also friends of the artist have been responsible for creating the myth that Tomlin denied his former pursuits when he espoused Abstract Expressionism. Even James Brooks agrees with this approach when he relates that Tomlin during this period wanted to get rid of his prized Victorian furniture and antique silver, replace it with contemporary pieces, and in addition update his signature and use numbers instead of allusively poetic titles.[1] While Tomlin may momentarily have thought a drastic break would be salutary he did not in fact change so drastically. He did alter his signature in 1949 and did start using numbers for titles intermittently in the late forties. But in the early fifties when he moved to a Ninth Street loft, he had not replaced a chandelier and fine damask draperies[2] with Japanese shades and plain white blinds. Likewise in his paintings, he retained many elements from his cubist works.

The main difference between Tomlin's cubist paintings and his Abstract Expressionist ones, aside from the obvious fact that he chose to work in a more modern abstract style, is the intensification that the elements lying along the edges of his earlier paintings receive. If one compares *To the Sea*, 1942 (fig. 146), with *Number 10-A*, about 1947 (fig. 41), there are some surprising relationships. In looking at *Number 10-A* Tomlin appears to have retained the same compositional format of *To the Sea*, only he cleared the deck of realistic paraphernalia and superimposed a curvilinear grid over the remaining abstract shapes. The underlying structure in both these works is noteworthy for striking parallels in color, even to the repetition of the block of orange and small patch of purple. Obviously in *Number 10-A* Tomlin is consciously working out problems of changing from Cubism to Abstract Expressionism. One imagines him surveying his earlier work, as one cleans a closet, deciding what he will retain and emphasize and what he will discard. If one looks closely at the

146 Bradley Walker Tomlin
To the Sea, 1942
Oil on canvas, 30 x 37 inches
The Benton Collection, Southport, Connecticut

147 Bradley Walker Tomlin, c. 1949

foreground of *To the Sea*, Tomlin has only summarily defined the water with
wavy black lines. These lines also appear at the top of the classical head, and a
variation on them occurs in a purplish red ribbon attached to a wreath on the
left. These lines could be considered the origin of the curvilinear grid occurring
in *Number 10-A* and most definitely a source for the squiggling ribbonlike
calligraphy in paintings like *Tension by Moonlight* (fig. 148). But it is worth
remembering that whatever Abstract Expressionist formal innovations Tomlin
appropriated, his earlier entrenchment in his own cubist style enabled him to
test new ideas against his own former attainments. In his Abstract Expressionist
works, Tomlin attempted to retain the control evidenced in his earlier work
and to liberate it some with automatist techniques. As Philip Guston described it,
Tomlin's "temperament insisted on the impossible pleasure of controlling and
being free at the same moment. . . ."[3]

 Tomlin is the only member of the first generation of the New York School
who painted as though he were of the second generation. Unlike the Abstract
Expressionists who were resolutely individual and who would have difficulty
describing stylistic affinities with their peers, Tomlin viewed this new painting
primarily as a style. Too much the gentleman painter to give free reign to the
subconscious, Tomlin was more interested in the decorative potentials of

Abstract Expressionism—all-over patterns, loose scumbled areas, salient drips, and superimposition of shapes. In other words, his primary aims appear to be at odds with those of the Abstract Expressionists, even though he employed generally the same syntax, for he was primarily concerned with the end result, with good design, while they sloughed off the look of careful composition as too inhibiting. As in his cubist work in which he assimilated aspects of Picasso, Dove, Surrealism, and even a little I. Rice Pereira, so in his Abstract Expressionist works he assimilated various qualities from the other artists and seized upon them as a style. The fact that Jeanne Chenault, a specialist in

148 Bradley Walker Tomlin
Tension by Moonlight, 1948
Oil on canvas, 32 x 44 inches
Betty Parsons Gallery, New York

Tomlin's work, can confidently compare *Number 12—1949* (fig. 150) with Oriental calligraphy, then mention that the lower right portion more closely resembles Sanskrit,[4] and at other times even point to the style of a particular Chinese master as the possible source for Tomlin's calligraphs demonstrates the conservativeness of his approach. Furthermore it indicates that his handsome paintings result from a self-consciousness, admirable in itself but different from the determined free-associational plunge into the unknown taken by many Abstract Expressionists.

RCH

149 Bradley Walker Tomlin
Small Wind Disturbing a Bon Fire, 1949
Oil on canvas, 23 x 44 inches
Collection of Mr. and Mrs. Herbert Ferber

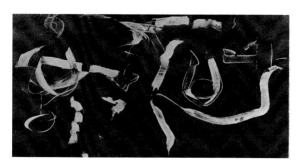

150 Bradley Walker Tomlin
Number 12—1949
Oil on canvas, 32 x 31 inches
Whitney Museum of American Art,
New York; Promised gift of Mr. and Mrs.
B.H. Friedman in honor of John I.H. Baur.
3.74

1 Jeanne Chenault, "Bradley Walker Tomlin," in *Bradley Walker Tomlin: A Retrospective View* (exhibition catalogue, The Emily Lowe Gallery, Hofstra University, Hempstead, N.Y., 17 April-25 May 1975; exhibition traveled) p. 19.
2 Ibid., p. 26.
3 In "Notes on the Artist," *Bradley Walker Tomlin* (New York: Whitney Museum of American Art, 1957).
4 Chenault, "Tomlin," p. 23.
The giant figure at the lower right of Number 12 *seems to recall a character in Sanskrit more than Chinese. Among*

Tomlin's most "Oriental" creations is the two-sided drawing (No. 48) owned by the painter, Calvert Coggeshall, who was a friend of the artist during the last years of his life. Although it is not possible to correlate side A directly with Chinese calligraphy because it is such a personal interpretation, Dr. Frederick Martinson of the Department of Art, University of Tennessee, notes that side B is very close to the "wild" draft script of the eighth century Chinese monk, Huai. The similarity is too close to be mere coincidence.

137

List of Illustrated Works

Photograph Credits

Photographs have been supplied in most cases
by the owners or custodians of the works, as
cited in the captions. The following list
applies to photographs, indicated by figure number,
for which additional acknowledgment is due.

Michael Andrews, 28
Oliver Baker, 17, 57, 117, 119
Kay Bell, 147
H. Bowden, 121
Mrs. André (Jacquelin) Breton, 58
Lee Brian, 2
Rudolph Burckhardt, 7, 50
Barney Burstein, 52
Geoffrey Clements, 4, 20, 37, 38, 40, 48, 49, 74, 75, 112, 131, 132, 148
Prudence Cuming Associates Ltd., 64
eeva-inkeri photographers, 109
Lloyd Lózes Goff, 133
Greenburg-May Prod. Inc., 62
William R. Heick, 126
Bruce C. Jones, 53, 97
Peter A. Juley & Son, 46, 90
William Kahn, 137
Francis Lee, 42
Aida & Bob Mates, 123, 124, 125
Robert E. Mates, 13, 14, 65
Robert E. Mates and Mary Donlon, 47
Herbert Matter, 107
Gwyn Metz, 103, 129
Hans Namuth, 6
Otto E. Nelson, 45, 68, 70, 85
Eric Pollitzer, 5, 16, 19, 54, 72, 102, 130
John Reed, 77, 78, 79, 84, 86
Jon Reis, 120
John D. Schiff, 44
Aaron Siskind, 67, 101
Steven Sloman, 92, 98
Adolph Studly, 87
Gail Swithenbank, 69, 71
Malcolm Varon, 3, 29, 99, 104
John Waggaman, 128